Innocent Eye

Elena Karina Canavier,
"Botticelli," 1979. Porcelain clay, 13 x 12 inches.

Tupelo Press is grateful to the Antonia and Vladimer Kulaev Cultural Heritage Fund, Inc., for a generous grant in support of this book's creation and publication, in honor of artist Elena Karina Canavier

Innocent Eye

A Passionate Look at Contemporary Art

PATRICIA ROSOFF

Best Wishes
Patricia Rosoff

TUPELO PRESS

North Adams, Massachusetts

Innocent Eye.
Copyright 2012 by Patricia Rosoff. All rights reserved.

Library of Congress Cataloging-in-Publication Data
Rosoff, Patricia
 Innocent eye : a passionate look at contemporary art / Patricia Rosoff. — First [edition].
 pages cm. — (Tupelo arts series)
 Summary: "Contemporary painting, sculpture, photography, and mixed media have
sources in the works of such radicals as Monet, Kandinsky, and Cornell, who are now part
of the official tradition but who continue to catalyze artistic innovation, especially among
conceptual and abstract artists" — Provided by publisher.
 Includes bibliographical references and index.
 ISBN 978-1-936797-16-5 (pbk.) — ISBN 978-1-936797-17-2 (clothbound)
1. Art, Modern—21st century. I. Title.
 N6497.R66 2012
 709.05′1—dc22

 2012040336

First edition: January 2013.

Cover and text designed by Katherine Kimball.
Cover art: "Pull and Rollback with Mixed Pods" (2011), Polaroid 20 x 24 photograph
by Ellen Carey, copyright 2011. From the series *Photography Degree Zero* (1996–2012).
Collection of David Evangelista, New York, New York. Used by courtesy of the owner and
the artist (http://www.ellencarey.com).

Tupelo Press
P.O. Box 1767
243 Union Street, Eclipse Mill, Loft 305
North Adams, Massachusetts 01247
Telephone: (413) 664–9611 / Fax: (413) 664–9711
editor@tupelopress.org / www.tupelopress.org

Tupelo Press is an award-winning independent literary press that publishes fine fiction,
nonfiction, and poetry in books that are a joy to hold as well as read. Tupelo Press is a registered
501(c)3 non-profit organization, and we rely on public support to carry out our mission of
publishing extraordinary work that may be outside the realm of large commercial publishers.
Financial donations are welcome and are tax deductible.

Art is not what you see, but what you make others see.
—EDGAR DEGAS

Art does not reproduce the visible; rather, art makes visible.
—PAUL KLEE

I think art is a total thing. A total person giving a contribution. It is an essence . . . In my inner soul, art and life are inseparable.
—EVA HESSE

CONTENTS

PREFACE

I have been an art educator for thirty years, and an artist even longer. I was formally educated at professional art schools—the Rhode Island School of Design and the Hartford Art School—from which I hold undergraduate and graduate degrees, respectively. I teach art and art history and have served as chair the visual arts department at the Kingswood Oxford School in West Hartford, Connecticut, the independent school where I began my career in teaching in 1975.

For the past fifteen years, I have been an art critic and contributing writer for a number of periodicals, including *Arts* magazine, the *Hartford Advocate, Art New England,* and *Sculpture* magazine.

This book, which is generated from some of that publication work, is intended to accompany you into the sometimes tricky terrain of contemporary art—that often contentious area in which I have found myself engaged as a teacher and as a writer, and for which, over the long course of my own education, I have developed considerable appreciation, enthusiasm, and affection. I hope by this book to loan you my eyes and my empathy, professional and personal, as I bring you with me through the galleries and museums in which I have grappled with ideas and questions that are not yet codified into art history books.

While it is certainly true that an art reviewer needs to come armed with substantial knowledge of what came before, the trouble with looking at contemporary art is twofold: the field is crowded and the context is fluid. More than this, our perspective is necessarily myopic. Only in the future will we discover what was influential, and even then we may have to leapfrog a few generations to see it. For most of the work I'll discuss here, my job has been making sense of what I experience. It is necessarily subjective work.

This book represents a visual journey, scholarly and personal. I cannot imagine that you will fail to be as affected by some of this work as I am.

I assure you that the work of the present is as interesting, beautiful, and complex as any that has been done in the past, but its scope and significance hasn't been filtered out for us yet—which makes the experience of looking doubly interesting. The questions posed, like the answers proffered by the contemporary generation of artists, keep the dialogue of culture alive, and there is nothing more lively and entertaining than that vigorous and sometimes contradictory world of thought.

I have learned that this is the heart of the experience of living with art; this is the reason I've written *Innocent Eye.*

Innocent Eye

Beyond Pretty Pictures

Claude Monet

*If you search the historical records on Claude Monet, the man is revealed
as anything but the stereotypical sweet and easy soul who made beautiful
pictures all the day long. His fortune was to live long enough to see
his profoundly radical revolution take hold. What he didn't live to see
was how his work has become a new canon, not only in art circles but
especially with the general public. His "genius" is fairly earned, but his
success was a matter of timing—and finding an audience in sync with the
new forms and subjects that he painted. He caught a foothold in a rapidly
changing world, then opened a door through which generations of rebels
would pass without looking back. Brilliant, complicated, and as stubborn
as they come, Monet's accomplishment had nothing to do with making
merely pretty pictures, and he retrained our eyes to see. The challenge in
writing about him is to lay this out—and to reintroduce this marvelously
tough old bird to his doting Hallmark greeting card public in terms of the
revolution he spawned.*

The 1998 exhibit Monet in the 20th Century *at the Museum of Fine
Arts, Boston, was an opportunity to examine this towering artist's role, not
as an Impressionist master (this is something that goes without challenge),
but as an equally important influence as a twentieth-century modernist.*

Claude Monet (1840–1926) was sixty years old at the turn of the twenti-
eth century, and by that time both his artistic fame and his fortune were
secure. He had bought himself a place in the country, and there he built a beau-
tiful water garden complete with a Japanese footbridge—images of which may
now grace posters in half of the dormitory rooms in the United States.

But the 1998 show *Monet in the 20th Century* at Boston's Museum of Fine

Arts reveals, in its eloquent and exhaustive study of the best of more than four hundred and fifty canvases painted by Monet in the first quarter of the twentieth century, that he was not the sort of personality to settle into formula, no matter how marketable. Here was a man just as determined in his eighties to construct a new way of looking at art as he had been as a starving young whippersnapper in his twenties. What he really teaches is that maybe the kids in those dormitories ought to take a harder look at what they have tacked to the wall.

You have to love this edginess in old Claude Monet. His art is a reflection of his courage, of course, and his persistence as he managed to maintain the tough-minded, physical robustness that marked his work from the beginning—even as he entered the last two decades of his life, plagued with the physical infirmities and personal losses that slow down the rest of us mere mortals. To the end of his life he remained as stubbornly skeptical of theories and conventions as he had been at the beginning. Even the fact of the beauty of the work is something many people completely misunderstand; for as beautiful as these pictures are, they were never prissy-assed, sofa-matching, decorative accessories. To the artist himself they were a means to get at what absorbed him obsessively throughout his career—a way to render the *act of seeing* visible.

This may seem strange to say, but although Monet painted landscape—indeed, he is the most significant painter of landscape in the modern age—it was never landscape per se that interested him. Nor was he ever a romantic—although the Romantics (including the Englishmen Constable and Turner) first taught him what unblended hits of the color spectrum, mixed in the retina (not on the painter's palette), might do to suggest outdoor light. Monet was no "studio painter," content to take things back to his atelier, where he might artificially control the lighting, gracefully arrange the physical elements, or otherwise artfully manipulate the impact of an experience; rather, Monet was a hardened realist who never took license with a composition or inserted a gratuitous "happy tree" in the corner.

Seeing mattered to Monet, and understanding seeing. Consequently, he employed the most neutral of subjects, without people and respondent to real live outdoor light. And over days, months, years, decades, and eventually a half-century, he painted the outdoors again and again, in a hundred different seasons and lights, so that he might truly begin to translate what seeing means.

Monet's contribution to the history of art was not pretty pictures, but his break with the entirety of academic convention for all landscape painting that came before him. He accomplished this by trusting his eye, and only his eye.

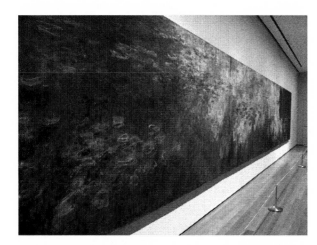

Claude Monet, "Water Lilies," 1914 to 1926. Oil, 6 x 41 feet, in three panels. At the Museum of Modern Art in New York, NY. *(Photo: Kari A. Reed, http://TheArtofMaking .com)*

Convention be damned. He might as well have come from Missouri. He went about this by standing in one place and actually paying attention to what he saw, and that meant noticing that a change of light was a change of everything. That at fifteen different times of day, or fifteen different changes of season, or fifteen different weather conditions, the "same scene" was never the same.

By the time he was sixty, he had figured this out, and in the process he got to as many questions about painting as he had about seeing. *Monet in the 20th Century* demonstrates that for this complex genius there was still so much more to learn; for these twentieth-century works are about painting itself, which is an art that could not be further removed from sugary, picturesque fantasies that people flocking to see them might assume.

The glory of this show is its richness. Rather than a sampler of his works, we are given a vast expanse, which is the telling aspect of his approach. In a whole room of the earliest water lilies (1899–1901), for instance, we can stand at the center of the gallery and scan what the painter strove at again and again in shifting formats, in shifting light. In that circle of bounce-back color, you cannot fail to feel the squint of his intensity—and the furious patience of his art. What a shock to see a nineteenth-century landscape painter look away from the land itself, searching instead into its reflection in the water—where the land is suddenly superimposed with the sky above and the water plants in the murky world below.

Here is where he, and we, entered the world of seeing that we have come to know in the twentieth century. What Monet saw emerge on that surface—and

what he transposed in color on canvas—was a three-dimensional ether gathered and delivered to us like too-vivid stitchery on a flat surface. His color has the kick of broad daylight; his hand the assurance of decades of working; his eye the relentless honesty of optical sensation. His mind's eye embraces the further truth of the canvas as its own simple fact: a flat surface, receptive of an amazing kind of spatial gestalt, which he entirely liberated from academic schemes of illusionism—of perspective, chiaroscuro, rules of composition. As an old man, at seventy, at eighty, he forged a new language of painting as if with a giant's hand, on huge canvases that wrap a room like the world surrounds us.

Seeing to Monet was an act of light itself, registered on nerve endings and burned into the mind's eye—and that was the science, and the modernism, of his art.

Claude Monet. *Monet in the 20th Century,*
at the Museum of Fine Arts, Boston, Massachusetts. 1998.

John Walker

The first "rule" of formalism (where form is everything) is that what you see is what you get: to read a work of art, no explanation should be necessary. This is a pure-minded premise. A work should be read subconsciously, stirring associations so universal that they speak to the heart and mind without mediation of a narrative, religious, historical, or sociopolitical context. The prohibition against explanation was considered a safeguard against the kind of celebrity marketing (Van Gogh and his ear; Gauguin and Tahiti; Michelangelo and the Agony and the Ecstasy; Pollock as Jack-the-Dripper) that passes for art appreciation (or art bashing) today.

It would be ingenuous and idealistic in the extreme, however, to believe that meaning can be wholly intuitive, without some common basis in experience between the viewer and the artist. An artist is not a tabula rasa; our collective social experiences color our viewpoints and make us ready for certain types of form and leave us blind to others. My experience with John Walker (1939–) was a case in point. In 1999 I stood in front of his big, gloppy paintings at the Yale Center for British Art and found myself frowning, and found the works themselves largely inaccessible. And

yet through the context of the surrounding exhibition (Doomed Youth: The Poetry and the Pity of the First World War), *as well as through a conversation with the quiet old artist himself, I found a footing from which to comprehend these works.*

> ... Rain, guttering down in waterfalls of slime,
> Kept slush waist-high and rising hour by hour,
> And choked the steps too thick with clay to climb.
> What murk of air remained stank old, and sour
> With fumes of whiz-bangs, and the smell of men
> Who'd lived there years, and left their curse in the den,
> If not their corpses ...
> —*Wilfred Owen, from "The Sentry"*

John Walker's prints and paintings in "A Theater of Recollection," a subsection of the Yale Center for British Art's exhibition about the experience of World War I, *Doomed Youth: The Poetry and the Pity of the First World War,* are not so much concerned with history as they are with the graphic evocation of sound. Not the literal sound of patriotic music and the marching of soldiers, as in the exhibition as a whole, but the contemporary sound of this moment of painting.

This is a sound that is deeply colored by the experience of the past, discordant and raw, stripped of narrative cohesion and given directly, in tangled bits and pieces—like a fitful dream. Unlike the rest of this highly cogent and moving documentation of an era, Walker's pictures do not illustrate a time and place but rather re-envision time and place as sensation: as mud, as desolation, as a grudgingly spoken word.

Walker's work reaches back: as a love song to his father, who experienced the war. It is also a documentation of the death of innocence, not only for one man, but for an entire generation and nation. The work reaches forward, as well, touchingly, to embrace the artist's young son, whose demons are as yet still innocent ones, and whose childlike drawings of his father's monsters are playfully set down in a hand unshaken by the real truth of monstrosity, then are borrowed back by the painter and incorporated in these paintings.

Doomed Youth is an affecting documentary exhibition, made up mainly of poems, memoirs, and memorabilia—including letters from the front, recruitment posters, documentary photographs, and a loop of original newsreel

John Walker, [no title], from
the series *Passing Bells*, 1998.
Etching and aquatint on paper,
10 x 8 inches, approximately.
*(Copyright 2012 Tate Images,
London.)*

footage. A soundtrack offers subtle background color—popular music from the time, the sounds of marching, bomb fire, sirens. A selection of audio tracks offers readings from the poetry displayed from publications in the center's rare books collection, as well as oral reminiscences of World War I veterans.

John Walker's "Theater of Recollection" is a counterfoil to the rest of the exhibition and in many ways serves as its climax.

Walker's paintings—which sprang from his relationship with his father, and through his father, his relationship to that era—make a noise that not merely illustrates, but *implicates* in contemporary forms the events of the war. One cannot read nor fully understand this history (although one can certainly hear it) through Walker's work alone. Like Walker's father, who survived the trenches in Belgium (unlike eleven of his brothers and brothers-in-law, who did not), his son tells a "story" in pungent fragments.

This was a story that might easily have been swallowed, but for the war poetry that kept it alive—which is the surprising revelation of the exhibition. For Walker, again as for his father, this was a story in which horror and disillusion can be measured in buckets of silence.

In our interview, Walker relates that when his father was wounded at Sommes,

one of the two bloodiest battles in the war, "he was brought home and placed in a chair outside the front door, dressed in uniform by his mother because he couldn't lift his arm . . . The women in the neighborhood who had lost husbands or sons—told only that they were missing or killed in action—queued up to ask this nineteen-year-old what had really happened to them . . . a horrendous thing to have to do."

This was a story that John Walker did not hear until he was in his twenties, when he felt a desire to know, firsthand, of his father's experiences, which surely had formed him—experiences that the son, like every other schoolboy in England, knew from the grim and powerful poetry of such soldier-writers as Wilfred Owen and David Jones.

"It wasn't so much that he was a tale-teller," Walker said to me, speaking of his father. "He certainly wasn't one who sat and told war stories. One had to kind of extract from him by direct questioning at exactly the right opportunity. I would ask him very direct questions. Sometimes he'd answer them.

"We started to have these conversations about the time he bought me my first pint of beer," says Walker. "[I was] around twenty-one when we really started to talk. He'd take me to the pub, but it was funny, he still wouldn't buy me a real beer—it had to be laced with lemonade. Which is exactly the same way it happened to him after he was badly wounded at Passchendaele. When my father was recuperating, my grandfather, who was much more of a serious soldier, came back to England to take him out for a drink. And *he* would only buy his son beer laced with lemonade.

"I had to ask him a very direct question and then he might come up with an answer . . . always quite matter-of-fact. He didn't tell stories.

"So if I said to him, 'What did you do when you came out of the trenches?'"

"'What do you mean?' he'd say.

"'For recreation.'

"'Well, we used to play a lot of soccer.'

"'Did you have soccer balls?' I asked. 'What did you use?'

"'We'd go and pick up a skull.'

"'That could have been one of your friends!' I said.

"He just said, 'No, we made sure they were *squarer*, because those were German skulls.'

"It was all said so matter-of-fact," said Walker, a quiet man himself, soft-spoken: "and you realized that these people were able to dislocate themselves from the situation they were in. Otherwise they could not have survived.

"I asked him once," said Walker of his father, "'Did you have any really good friends?'

"'Yes,' he said. 'John Walker.'

"'The same name as you?'

"'Yes,' he said, 'we grew up together, we went to school together, and then we went in the army [together].'

"And I asked him what happened to John Walker.

"'His head fell into my lap.'

"And that," said Walker, "was the end of the conversation."

Like so, the artist remembers his father, and these are the kinds of experiences that now inform his work. Walker's father died in 1974. It was another fifteen years before "A Theater of Recollection"—inhabited by a solitary uniformed figure—took shape. Walker had attempted the topic while still in his twenties, but destroyed that series. What triggered the new work, Walker explained, was rereading the World War I–era poetry, particularly the poems of David Jones and Wilfred Owen.

"When [I] read sentences from their poems," Walker said, "occasionally it sounded just like my father talking. Not that he could have written it, because he wasn't a writer. [But] the poetry makes me feel—because of the shared experience—very close to my father, in the sense that he couldn't articulate . . ."

For a viewer, moving between Walker's prints and his paintings—the former small-scale and delicate; the latter massive, encrusted, and weighty—is like moving between the written page and the spoken word, between poignancy and belligerence. The prints draw you close in to read them, like books demand, and for all their grimness they offer the comforts of books: the softness of paper, an intimacy of scale, the manageable privacy of a handheld object. In Walker's graphic images, crude and mutilated figures are rendered in a childlike hand and stamped into a fragile, crumbling, and atmospheric space, contradicting the innocence of their touch with the violence of their representations.

Whereas the prints beckon one closer, the paintings make the viewer back off. The paintings are overwhelmingly overt, inundating when you get near. The paintings' surfaces are unrelenting, tarry, tectonic movements of material across vast expanses of surface that demand you take a step back. Long ago, Walker told me, he became fixed in the notion that paint is like mud, and the silted, gummy, earthen walls of his paintings are a kind of battleground for the artist's need to transform that muck into air and light, and also sound.

Walker employs repeating signifying motifs; for instance, a gaunt figure with

a sheep's skull for a head interwoven with the suggestive materiality by which paint can render the effect of haunting, bitter poetry. He uses the words of the poets literally and figuratively, as script inscribed in the paint and as "sound," the echo of his father's voice. The words are also a kind of mud, of course, and mud is the image that permeates all the reminiscences of the larger show—the rains that never stopped in 1916 and 1917, so that the bomb craters and the trenches filled with water, inculcating a fear of drowning nearly as deep as the fear of the gas or the bullets. The mules were mired down, the bodies were slimy and half-submerged, the skulls were picked clean—the only things clean in those fields of mud.

And the paint on canvas, and the words of poetry by Jones and Owen, are smeared wet-on-wet into earthen color, with black pigment dredged up, dragging through the paint. Walker's brush is a tool as brutal as a plow, and the paint itself, matter made of pigments silted into wetness, is like so much mud.

"There's always been text, for a considerable amount of time now," Walker told me, explaining the role of words in his works. "I'm not sure whether it's successful. But with these pictures I didn't just want to illustrate the words, I wanted to *paint* them—to try to feel . . . with a brush. It seemed to me that was much more honest than trying to turn their poetry into another form of illustration."

John Walker. "A Theater of Recollection," part of the exhibition
Doomed Youth: The Poetry and the Pity of the First World War, at
the Yale Center for British Art, New Haven, Connecticut. 1999.

Noncomposition

In my dealings with the art world, I've come to respect the contribution good curators can make to the progress of ideas. When you're talking about contemporary art, you're talking about matters on which judgment hasn't been settled. Especially when artists' work is conceptual or minimalist, and the ideas are subtle or challenging, how a work gets presented can make all the difference in an audience's comprehension.

In "contemporary art," which often embraces a strategy of being deliberately unmarketable, ephemeral, and archive resistant, the role of the artist and the curator may seem oddly inverted.

The artist makes workaday forms out of non-art materials in order to contend with real-life issues and pressures and at the same time embrace non-aesthetic ideas.

The curator's job, then, is to "frame" such work by exhibiting it in gallery or museum situations, venues that offer an aura that pronounces pieces to be "art." The new generation of contemporary art museums— like the Museum of Contemporary Art (MOCA) in Los Angeles or the Guggenheim Museum in Bilbao, Spain—are often dramatic architectural showcases in their own right, setting a stage for art, providing astonishing conditions of light as well as unfamiliar and idiosyncratic spaces for display. The art may be plebian and unpretentious, but the stage managing and setting are grand.

In many cases these days, the curator makes the argument that the artist disavows, seeking to establish context in a thoroughly global way and leading viewers through a complicated mix of issues and questions. The best curators are historians of art's visionary negotiators, able to sift through the chaos of "anything goes" and pull together a coherent view. The following essay is a nod to a gifted contemporary curator, Nicholas Baume, who in 1999 was at the Wadsworth Atheneum Museum of Art in Hartford, Connecticut, and is now Director and Chief Curator of Public Art Fund, a nonprofit organization in New York City..

The trouble with trying to figure out what's going on in contemporary art is that when you're standing smack in the middle, your perspective on the Big Picture is very likely confused. Since the invention of "art history" in the eighteenth century, the challenge for the would-be know-it-all has been to try and figure out what is important enough in what's going on *now* to have *lasting* influence on future art. Truth is, such prediction has always been specious.

For instance, who knew, in the middle of the nineteenth century, that Impressionism would turn out to be the cat's meow—and not the death—of art? What credible critic would have said, if he had met them in Arles in 1888, that Gauguin or Van Gogh were anything but a couple of self-deluded lunatics on the way to artistic nowhere?

Certainly, in the free-for-all that is contemporary art, the difficulty is to find any connection within a chaos of styles, influences, cross-influences, and impulses. As art critics, we're largely like the seven blind men evaluating an

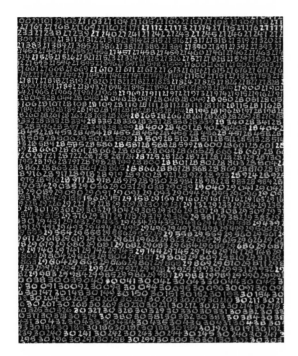

Roman Opalka, from the series "OPALKA 1965/1–∞," 1965–2011. Paint on canvas, each "detail" or successive canvas 196 x 135 centimeters, the size of the artist's studio door. *(Photo: http://www. jointadventures.org/ opalka/.)*

elephant ("very like a rope," says one; "very like a wall," says another), working from hunches and salient encounters, guided by the past and a limited glimpse of the present but without a true compass on the future.

Especially impressive, then, in a show such as *Noncomposition: Fifteen Case Studies* at the Wadsworth Atheneum Museum of Art, is how clarity of curatorial insight can glean coherence from a cacophony. What this show does so wonderfully well is to find a connection between a seemingly irreconcilable disparity of styles (minimalist, conceptualist, and pop art); modes (representational and abstract); and media (painting, sculpture, architecture, music, photography, poetry, and performance)—and to do this within the fuller context of art history.

To do so, Nicholas Baume, who is the Emily Hall Tremaine Curator of Contemporary Art at the Wadsworth, selected fifteen "case studies" and identified one stunningly simple thesis: *noncomposition*.

Baume's premise makes an astute and persuasive point about the dialogue between art of the past and art of the present. Taken together, these case studies dramatize a twentieth-century debate between myths about art and artists and the often abrupt, intellectual austerities of the artists in this show. Further-

more, the exhibition is not only very smart but also wry, tough-minded, and, more surprisingly, as muted in its beauty as a city street caught in a sudden snowstorm.

The point of Baume's assemblage of works is a purposeful denial of subjectivity. Spontaneity, invention, inspiration, gesture—the historically endorsed attributes of creative "genius"—are raked out of the gathering with a fine-toothed comb. Instead, the showcased artists appear to have consciously and stubbornly restricted themselves to mechanical systems and industrial materials; to repetitive, even obsessive processes; to grids and formulae, tables and diagrams (notice that I don't call them "drawings"); and to mathematical notation. These are artists who, in their argument with culture, deny themselves the glory and the flourish of "self-expression." Instead, they shackle their forms to encumbering processes, to chance, to system, to the luck of a draw.

And yet, amazingly enough, despite all this contrariness to the precept of individual "creativity," what we end up with are objects that look like art, that feel like art, and that satisfy the mind while making the eye glad. The driver of the vehicle may have changed, but once you get to your destination, you still find yourself *somewhere*.

Take for example Carl Andre's *Sixth Copper Corner,* which greets us at the entrance to the show—twenty-one manufactured copper plates arranged in successive rows of six, five, four, three, two, and one. You'll see no "hand of the artist" here—nor will there be an overt artist's hand in any of the works in this show, which abjure the heroic gesture and insist on the uninflected, plain-spoken fact of fact itself.

How can this be beautiful? Well, how is the surface of a lake, under a certain light, beautiful? Because—simply—it is. Because copper is ruddy and mottled, warm and cold at the same time. Because instead of standing up in the age-old phallic assertion, Andre's sculpture stretches out flat upon the architectural plane of the floor, where we can walk on it, thereby dryly and insistently denying that art is apart from us, from the world, from the truth of its materials.

Likewise, Daniel Buren's yellow striped wallpaper claims the vertical surface of the gallery wall. Just that—its location signifies that "art" is present. To underscore this fact, he hangs an empty picture frame in the middle of the expanse. Why? We may not know what art is, but we know art when we see it, right? Well, here are (literally) the *signs,* but Buren won't let us divide "art" from the real world in which we—and art—coexist.

Eva Hesse built art from industrial junk she found—stitching together per-

forated metal plates with latex tubing, laying out armies of metal washers on square automotive dollies—respecting the rigidities of metal, insinuating it with the degradable flexibility of fleshy rubber and resinous fiberglass. Her process, like factory work, like women's work, was obsessively repetitive, labor intensive, and small-motor driven. Her "products" are sensuous in an amazingly organic sort of way, like amber pigskin; like egg yolks trailing endless umbilical cords; like cubic, cilia-lined receptacles; like metal washer gooseflesh on steely squares of sheet metal.

Sol LeWitt pursues every possible combination of elements in simple arrangements of architectural forms. The light plays over these open and closed forms, creating a symphony of shadows whose final "impression" comprises a random extrapolation of possibilities but is poetic nonetheless.

Andy Warhol borrows a famous person's face (Marilyn, Jackie Kennedy, Mao), then, borrowing strategies from advertising mass-production, enlarges and multiplies the images like products on a shelf. Eliminating "uniqueness" as an artistic factor, he instead works out a rotating schedule of silkscreen color combinations, making sure that the registration is a little off (better to make clear that this is production, not creation). Lastly, he makes no pretense of doing the work himself. Instead he sets his "factory" of celebrity-wannabes into execution mode. No hand-of-the-artist can be detected here, since lackeys execute the art, although the artist (personally deadpan, tongue-in-cheek, impenetrable) sets the topic, provides the formula, signs the work, and collects the profit. Warhol more than any of his contemporaries made art that a consumer culture would buy. What happens may be beguiling, but Warhol himself would have it that he was as surprised as anyone at how it turned out. Which is pointedly the point.

Roy Lichtenstein, like Warhol a harbinger of change who comes on the scene during the golden age of American abstraction, gives us figurative images, but, lest we settle into our easy chairs of convention, he transposes the realistic narrative, comic-strip fashion, into something inescapably trivial. He even paints a jumbo-size schoolboy "composition" book, just in case we weren't getting the message about the highfalutin aspirations of formalism.

And then there's Roman Opalka, who set out in 1965 on what became a lifetime project: depicting the chronology of numbers from one to infinity. His first canvas was covered in pure black, on which he then painted (in white paint) the successive numerals 1, 2, 3, 4, 5, 6, 7, 8, 9, 10, 11, and so on. When he finished that canvas, he took up the second, painted its surface a minutely paler shade of

black, then picked up the numbers where he'd left off on the first canvas. In the *Noncomposition* show, Opalka's piece is on a pewter-gray canvas. The number sequence is by this point in the millions. (See photo, page 13.) The artist kept painting, like some absurd manifestation of a medieval monk—painting for the glory of God, but in this case driven by the compelling "machine" of time itself.

"To work with a plan that is preset is one way of avoiding subjectivity," Sol LeWitt wrote in his seminal "Paragraphs on Conceptual Art." There can be no more pithy summary of the focus of the works in *Noncomposition*. Moreover, the work gathered here by Nicholas Baume reflects a second of LeWitt's influential assertions: "The artist cannot imagine his art, and cannot perceive it until it is complete."

Which is exactly how it plays out, with each artist here squaring off against the notion of the artist/hero, and each artwork setting out for resolution unknown. The unifying premise of these works sets the very idea up for insouciant ridicule.

For a final example, take John Baldessari, who in black block letters across a pristine white canvas quotes smug little passages from a "how to" manual for becoming a professional artist. He hired a "professional" sign painter to execute this piece for him. And there you have it—Baldessari's tongue-in-cheek presentation of the definition of art: flawlessly executed by hand, by a professional; didactic and definitive at the same time. What more can one ask? Baldessari's painting says it all, greeting you on the museum wall, bland but confident, confidential, and brimming with grinning, post-painterly, post-heroic, post-humanist humor.

Noncomposition: Fifteen Case Studies, at the Wadsworth Atheneum
Museum of Art, Hartford, Connecticut. 2002.

Mierle Laderman Ukeles

The lengthy telephone interview I did while working on the following preview was one of the most fascinating I've ever experienced, and this conversation gave me a respect for "performance art" in ways that I would never have anticipated. I knew of Mierle Laderman Ukeles's work because of my contact with performance artists Janine Antoni and Ben Kinmont, both of whom had wanted to do pieces at the Wadsworth Atheneum

Museum of Art because Ukeles had originally created her Maintenance
Art Performance Series *under the auspices of the Wadsworth in 1973.*
That performance, described below, was a seminal work of the modern
idiom, and I already had a basic sense of its form and of its importance.
But what had not occurred to me, prior to this upending talk with the
artist, was how profoundly simple and humane its conception was—and
how resonant the ideas it investigated would prove to be. This was a
conversation that did not evaporate quickly.

Mierle Laderman Ukeles is the most radical artist you are ever likely to
meet—and the most dear. I make no apologies for the use of either term.
And if you find my epithets dismissive, then you'd better look up her 1973 per-
formance *Maintenance Art Performance Series* at the Wadsworth Atheneum
Museum of Art. Because what you'll find in Ukeles's first appearance at the
Atheneum (her first anywhere) more than thirty-five years ago is one of the
simplest, strangest, and most profound challenges to the definition of art to
arise in the twentieth century.

Looking back, I find it remarkable how insistently this early work questions
what art is and what it should be. Utterly without cynicism, in *Maintenance*
Art Performance Series Ukeles washes the floors and rethinks the function of
museums in the same broad but intimate strokes. Ukeles's ongoing work (she is
the unpaid "artist-in-residence" of the New York City Sanitation Department)
continues to be, like that of the much more famous Christo (who does projects
like "wrapping" in fabric Berlin's Reichstag or certain islands in Florida's Bis-
cayne Bay), at once wry, wise, workaday, and grandiose.

Unlike that great master of the public eye, however, Ukeles manages to
marry the mundane to the heartbreakingly visionary. She believes that the art
world can serve as a model for what society should be—an inclusive place and,
dare I say, a loving place. She is determined to raise the standard of art to life-
sustaining human values. She begins, consequently, right where we forget (or
refuse) to look, at that work she calls "maintenance," which no one else ever
thought to call "art."

Touched by the dedication of New York City's sanitation workers during the
fiscal crisis and major blizzard of 1978, for instance, when the "sanmen" (the
DOS term for sanitation workers) worked around the clock for eleven days to
remove first snow and then the piled-up, frozen garbage, working in freezing
weather and bearing the brunt of public anger and derision, she conceived of

Mierle Laderman Ukeles, from *Maintenance Art Performance Series,* 1973. Installation/performance at the Wadsworth Atheneum Museum of Art, Hartford, Connecticut. *(Courtesy of the artist and Ronald Feldman Gallery.)*

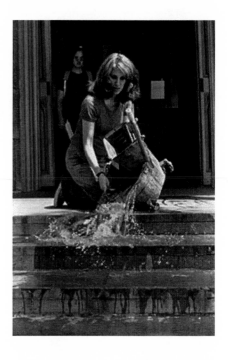

a project in which she personally sought out and shook hands with each of 8,500 sanmen, thanking them individually for keeping New York City alive. Inspired by watching the 1978 Saint Patrick's Day parade, in which the "invisible" sanitation workers followed (and swept up after) parade horses, for the Saint Patrick's Day parade five years later she choreographed a "ballet" for giant street-sweeping machines.

"She makes herself 'at home' in the world," says Andrea Miller-Keller, former Emily Hall Tremaine Curator of Contemporary Art at the Wadsworth Atheneum, who guest-curated Ukeles's 1998 exhibition at the Wadsworth's MATRIX gallery. This is how she has established herself, says Miller-Keller, "as one of the most radical and deeply revolutionary artists I have ever collaborated with."

The lessons Ukeles took from her experience as a struggling young artist—"that half of a culture is supported by so many others who were told, in effect, to shut up and keep out of sight"—steeled her ultimate subversion of such a definition of culture. What she had first bought "hook, line, and sinker," the artist explained to me in a phone interview, was the notion that art was about personal freedom, namely "freedom to act, freedom to name, freedom to cross over beyond this zone of reality . . ."—freedom to become an artist.

What she learned from her life, as a wife, mother, caretaker, was something incomparably different.

"By having a child," she has written of herself in the third person, "she became a maintenance worker, one who supports, who enables another, one who puts another first, not herself, nor her emotions first, nor her creative needs first, but the living wondrous and utterly dependent baby, first. The grand personal pure journey forward lurched, got stuck in repetitive task work, cycling back again and again . . . Shocked, she looked around. Jackson [Pollock], Marcel [Duchamp], and Mark [Rothko] didn't change diapers. Don't even talk about it in company. The canvas ripped. She fell out of the picture."

And there you have the gulf that Ukeles bridged, not by whining and playing victim, but by drawing a larger definition of art, one that put her—and that "other half" of humanity—back in the frame. And Ukeles sees her task (which she characterizes as "washing our face")—as the crux of her campaign to transform art into a loving dream.

The genius of her career is that she continues to design performance pieces that "flush up to consciousness" the repetitive, presumably unimportant, caretaking acts that are considered the province of the disempowered—those who do those inglorious jobs that must be done and who are therefore not "free." Ukeles does not visualize these people that way. Her work brings the street sweepers into the parade, rather than allowing people to pretend that those who are sweeping up behind the horses are invisible. She has also put mirrors on the parading garbage trucks, lest we should forget that we had everything to do with the refuse they handle.

In her *Maintenance Art Performance Series* at the Atheneum, Ukeles moved into the museum as if this were her home. "Mine was an innocent, naïve notion of a museum," she says. "I saw it as a home for art, a place one can trust, one with loving values. Art is cherished there, they will take care of it . . . not a dysfunctional home, but a place where you can be cherished."

In a simple series of acts, the artist performed certain common tasks, manually and without fanfare—housekeeping, really—Ukeles washed the vitrine of the museum's Egyptian mummy; she got down on her knees and washed the Main Street steps of the museum, and then the marble floors of the Avery courtyard; she moved throughout the museum with a set of the master keys, locking and unlocking the entrances, galleries, and offices at will. She made herself at home.

Does this sound simple, really, or pointless? That is precisely what it's not,

even if people insist on getting all riled up when "art" won't look or act like art. What Ukeles did was anything but mindless. Rather, she set out in the quietest possible way to challenge a museum's conventional role in a democracy.

"I wanted to deal with the biggest idea of a museum . . . from the belly," she says. "Exercising the hidden functions up front. Art can be a locus for transformation, where we invent what we want to be. It can happen inside a museum. It can be an outer manifestation of the creative enterprise, asking Who are we, and what can we possibly do?

"People who feel locked out have to be made to feel [included]. This isn't automatic; you have to work hard at it. If museums don't work hard to invite people in, museums will die. Are you only an interior temple? Are you a model? Are you [culture's] most refined form? I actually think a museum should be."

Echoing Miller-Keller's assessment that she makes herself at home in the world, Ukeles says, "I think about the whole city [of New York] like that now."

As she speaks to me concerning what her 1973 opportunity at the Atheneum provided her so many years ago, Ukeles sounds realistic and objective—two qualities that seem closely linked in her way of working.

"I am grateful they gave me this opportunity to puzzle it out," she says. ". . . I refused to cut off so much of what was in me. This institution responded. They gave me the keys to the joint!"

She goes on to explain that this couldn't be done today. "Now it's really fancy stuff. You can see it in their eyes: 'Oh god, please don't . . .' 'We're not at liberty to describe our security methods.' Things today have become highly technological and very proprietary.

"Looking back now, it seems remarkable that they let me do these things . . . but then again they didn't pay all that much attention."

Indeed there was no record kept of Ukeles's 1973 performance; hers was such a new form that seemingly no one thought to document the event.

Ukeles is philosophical about that aspect of the work.

"In terms of [the museum] seeing itself as an institution giving the most freedom—that was something I was laying onto them," she says. "I was very naïve. There was an arrogance in people like me. In the 1960s and 1970s we felt that we were gonna fix it—and fix it right now. The 'right now' part was the arrogance. Who knew how hard this was?"

Or how influential it would become. *Maintenance Art Performance Series*, like Ukeles's "Manifesto for Maintenance Art 1969!" (which was published in *ArtForum* in 1971), has turned out to be a critical influence on contemporary

art. Even the artist herself is surprised to discover what long "legs" that quiet performance has had in the world.

"I find these images everywhere," Ukeles says, explaining that she sees photographs of that long-ago performance looking up at her from the cover of magazines and on the pages of books on conceptual art in places as far-flung as Israel and California. Ukeles's earlier work was, for instance, a key element in MacArthur Foundation "Genius" award–winner Janine Antoni's decision in 1996 to do a performance of her own, *Loving Care*, where she mopped the floor of the Wadsworth's MATRIX gallery in black hair dye, using her own hair as the mop (see page 164).

For Ukeles, art is a matter of a determined aspiration to convey not only what art is, but also what beauty is. For her, this is a matter of social responsibility: what you hope to make of the world.

"You learn a lesson from maintenance workers," she says. "Never give up and never expect the work to be done. Expect that a lot of things can go wrong. Don't lose it, don't run away—just say 'I'm not going away.'

"These are not," she adds, "values I learned in college."

Mierle Laderman Ukeles. *Mierle Laderman Ukeles / MATRIX 137,* at the Wadsworth Atheneum Museum of Art, Hartford, Connecticut. 1998.

The Question of Standards

Dale Chihuly

Purity is the spiritualizing element of abstraction, the filter that distills a perfect visual world from the mess of human interaction. But an artist may be pure in his or her approach to form, and the form can fail to reach a viewer. Likewise, sometimes a schnook can come up with a solution so vivid and elegant—even if its inspiration is mercantile or political—that a viewer cannot fail to be moved. There's a negotiation that constitutes the central truth of art: Gauguin called this "equivalence," meaning that an artist puts something in and a viewer takes something out, and that even if those two do not exactly match, there is a trade that is central to all art making. That "something" has come across the barrier between the artist and the viewer.

One's audience has to be ready for a certain form to hit home, and being ready doesn't always happen on schedule. Look at Van Gogh—who, according to legend, could not trade his paintings for a sandwich, much less make a living from them. Now everyone is impressed with the gargantuan numbers that those same paintings garner at Sotheby's. Or look at dreadful Thomas Kinkaid, who made an absolute fortune marketing his work in retail outlets. A winning element of his strategy was to present schlocky, nursery-rhyme fantasy pictures in the sort of sparkling, pinpoint lighting typical of jewelry stores. It takes time for the wheat to separate from the chaff and real quality to shine. Part of the job of a critic is trying to predict which is which, wheat or chaff, and the challenge is being honest about your value system; especially since your judgment as a critc, no matter how well schooled and experienced you might be, is subjective.

To employ a Kandinskian oxymoron, art writing depends on a certain "objective subjectivity." Which means, I've got to listen to my gut and try to

ascertain what I feel without mucking up my responses (and my thoughts about these) with what I want *to feel. As a writer, I begin as a viewer and try to pick up the artist's perceptive trail. Most often, this is a matter of distance—a certain removal as I climb back out of that "viewer's eye" and watch myself look. But sometimes, as here with the blown-glass forms of Dale Chihuly, no such shift is possible. After fighting a dozen or so false starts at analysis, I finally gave up and started over.*

One of the most irritating encounters of my adult life centered upon a colleague's assertion that he could not concentrate on the art in a museum—because, he claimed, all he could think about was how much the works were worth. I wanted to hit the man for his idiocy.

So imagine my annoyance when I entered the gorgeous exhibit of Dale Chihuly's blown glass at the New Britain Museum of American Art, and found myself distracted by precisely those considerations: not how beautiful these works were, but how expensive they must be. In their presence I became covetous, not curious; greedy rather than loftily appreciative; and I started to wish that I could take a whole moving van of these objects home and fill a room with them. Passing through the dramatically lit presentation of colored glass forms, each one breathtaking in its unearthly serpentine bloom, I found myself clutching my coattails and worrying about what would happen if I inadvertently knocked against one of the tables and broke one of these things. "You break it, you bought it" kept blinking like a fog light in the back of my mind.

Clearly, my appreciation is tainted by deep-seated notions about "art" and "craft"—and while "art" resides on some unadulterated pedestal in my mind's eye, "craft" seems to come with a dangling price tag. It doesn't help that Chihuly's marvelous forms are shaped like bowls and vases and are displayed under the magical light that stage managers of displays utilize for expensive jewelry and cut crystal. Neither does it help to know that the man is perhaps the premier artisan in the field of glassworks and that his forms grace an astonishing list of prestigious museums, galleries, and public spaces worldwide.

Taken as form, these works are as unworldly as molten color or luminous jellyfish poured freeform into a liquid atmosphere. They are not so much illuminated as inhabited by light. Turn one corner of the show and you are presented with an array of magnificent marigold blossoms, giant flower petals tumbling on the table as if one of Van Gogh's sunflowers had fallen from its canvas. A hundred separate curls of color like autumn's discards flare in color-

Dale Chihuly, "Daylight Pink Seaform Set with Ivory Lip Wraps," 2001. Glass sculpture, 8 x 18 x 17 inches. *(Photo: Scott M. Leen, courtesy of the artist; copyright Chihuly Studio.)*

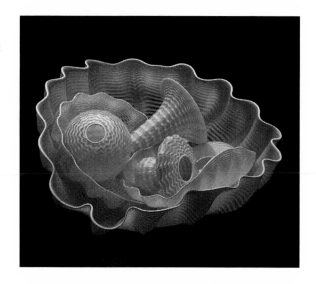

istic defiance on the table surface. In another piece, gourd-like yellow-necked pods with necks poke up from leafy piles, puckering their pointed lips in our direction.

What leaps to mind are questions of how these pieces are made, how long the process takes, how hard the work is. How does an artist "draw" on molten glass? How does he stitch these glistening waves with striations and speckles and bend their rims into scalloped roller-coaster edging? How do you persuade glass to flow where you ask, to bow its liquid neck and then stay there, just there, till the liquid hardens?

Furthermore, coveting their touch, I want to own not one, but many, as many as I can carry home, as many as can fit in my car, enough to fill a window of glass shelves or a showcase or even a secret attic room. This is not my typical experience with "art," but more like an addiction to pleasure.

So, what is art, I then have to ask—and what is wrong with me that I make this distinction between art and craft? Czar Nicholas, so fond of Fabergé eggs, wouldn't have this problem, nor would any one of those patrons and customers who made Tiffany such a rich man. John Paul Getty (as the new museum with his name so lavishly attests) knew about the gorgeous, gaudy decorative "objet d'art."

But Chihuly's works are certainly not utilitarian.

All I know is that I must shake my Puritanical head and look at these wonderful, magical glass sculptures and try to be satisfied with taking them home

in my mind's eye rather than in a shopping bag. I'm a democrat at heart, which means that I can allow myself to at least gaze upon what my poor purse will never allow me to own. Is that not what a museum is for? For those of us who are neither czars nor kings nor investment brokers?

Most of the time I do not begrudge my poverty, for the largesse of "art" is that it cannot be owned, precisely, but is carried home in the heart.

But here, in these rich rich rooms, I do feel poor. This is not Chihuly's fault; these are only yearnings that his brilliant sea-forms conjure. French gothic cathedrals, which illumined their spaces with pure, twice-molten glass, were a gift to the spirit (and paid for by the church). For the artist, I am sure, these sculptures by Chihuly are also a gift. Yet I realize that gift is one I do not want to share with anyone.

> Dale Chihuly. *Chihuly: Seaforms,* at the New Britain Museum
> of American Art, New Britain, Connecticut. 1999.

Carl Pope

*Carl Pope presented one of the most difficult-to-swallow approaches
I ever encountered as a critic. Although the man himself is mild and
soft-spoken, his "art" in this instance (MATRIX 138: Palimpsest, at
the Wadsworth Atheneum) was extremely hard to watch. The tension
between Pope's words and his works—video recordings of acts performed
on his body—tests the boundaries of how far intercultural appreciation
can stretch. Although in these days when body piercing and tattooing are
de rigueur fashion statements, perhaps it's just that I'm generationally
impaired. Yet the more I listened to what Pope had to say about how he
derived the "imagery" for this work, the more I had to concede that he
had an intriguing (if ever so painful) point: namely, that beauty is not the
only criterion for art, no matter what our Greco-Roman leanings would
have us believe. If the only means of access to a work of art is beauty,
entire realms of feeling are closed off. What you encounter in Carl Pope's
Palimpsest is not just beauty, but some other quality, much more difficult
to define.*

Throughout the Middle Ages, until wood pulp–based paper arrived on the European scene, books were laboriously inscribed on "parchment"—

animal hides scraped thin and often dyed deep purple or red so as to better show off the gilding and colored inks of illuminators. This illumination work was spiritual in nature and in practice, carried out in monastic enclaves removed from the world and dedicated to preserving the word of God and humanity. Writing was a holy act; transcription, therefore, was a kind of spiritualized magic in a dark, brutal, illiterate age.

A great deal more than the beauty of old parchment is at stake in the installation *Palimpsest*, which features a seven-minute video of artist Carl Pope undergoing branding, tattooing, and surgical scarring. Pope explodes any quotidian definition of skin, capitalizing on its associations by taking skin as metaphor as well as fact. In doing so, he manages to create a work of intimacy and distilled objectivity, layering the spoken word, the moving picture, and the personally felt with surprising eloquence.

Be forewarned, this is not a work for the casual viewer; Pope's work has the power to be deeply disturbing, although not, perhaps, in the way one might think. We see far more gruesome images in popular movies, which peddle the gore and brutality of physical torture in the name of "entertainment." How many times have we seen scenes in which a black man's skin is lashed into ribbons or branded? Likewise, how many times have we listened or watched from an objective distance as tales were told of the ravages of slavery, or, in journals like *National Geographic,* have we been shown the marks of ritual scarification in cultures more "primitive" than our own?

Palimpsest, by contrast, deals with transcription. An obscure word in the dictionary, the term "palimpsest" denotes a piece of parchment that has been written upon and imperfectly erased several times, leaving prior inscriptions partially visible. With Pope, the term treats the history of racism as a text to be first owned, then erased and reprinted with a meaning he gives to it himself.

In the *Palimpsest* video, three separate acts are documented. In the first, Pope's back is branded with the *adinkra*, which means "I am not afraid," a symbol of resistance among the Ashanti people of Ghana, West Africa. In the second, the same symbol is cut surgically into his forearm; this process reveals the white sub-skin under his pigmented epidermis. In the third act of the video, accompanied by the audiotaped recitation of a poem written by Pope's twin sister, we watch as the poem's text is tattooed in a spiral up one of the artist's legs.

Each segment is handled with restraint and objectivity and is revealed in measured, voluntary actions; these incisions were collaborative procedures, administered by friends and former professors. It was important, Pope explained

to me, that these acts—in conscious contrast to the victimization inherent in theatrical dramatizations—are seen as expressions of his own impetus and conviction. That the pain—which is evident—is real, he does not deny; "any form of transformation is painful. Psychological, spiritual, or physical change will all be painful and travailing."

"I had to make sure viewers saw me as a *subject* and not an *object*," says Pope. "Freedom is not flying away to Tahiti; it's a matter of changing the relationship to my body. I wanted to do this because I really wanted to decorate my body in a particular way," he says, suggesting that for young people today the impulse for tattooing is a reflection of their sense of a loss of control in the outer world. "By taking control of the boundaries of our bodies," he says, he intends "to flip the dehumanization" of branding (which made people into cargo) or surgery (which makes us into medical experiments) toward defiance, erasing the old narrative of black skin.

"My body is a battleground," says Pope. "My body is the parchment, the palimpsest."

His art is not, however, an indulgence in sadomasochism. He is not asking us to "feel his pain" nor to watch the causing of suffering, but is seeking rather to make pain graphic (in the visual, not the lurid, sense of the word) and thereby couch the body's experience in a larger context: one of victory over pain.

This is site-specific work; the artist's own body is inseparable from the room in which the video is installed and the path the viewer takes through that room. The spatial considerations are important, setting up a salient juxtaposition of elements. The video image (overlaid with Pope's own voice and that of his twin sister, Karen) is projected against an end wall of the darkened gallery. On the opposite wall (behind the viewer as he or she faces the screen), the poem Karen composed and they both recite is written out in silvered, reflective paint. A viewer's attention progresses through the three narrative segments of the video and, during pauses when the screen goes white, is likely to shift to focusing on the faintly illuminated text across the room.

In theory, the concept constitutes a poetic whole; in reality—that is, as witnessed by an observer—perception is put to the test, and considerable effort is needed to bring the elements to coherence. Curiously, the spoken word component (which one would expect to make sense out of the other parts) is the least explicit aspect of the installation: a listener hears the voice instead of the words—the timbre rather than the lyrics. Pope's sister, Karen, cries audibly but calmly as she speaks; her phrases lift up from a running drone but never quite

settle into rational sense. Similarly, we witness Pope's pain without immediately understanding it. The wall offers us the poem in written, observable form, but only dimly visible, and we come to reading that text most likely stunned by the impact of the visual and auditory context that accompany it. Ultimately, it is Pope's skin—and the markings there—that provide the most vivid and inescapable impression.

In its MATRIX version, *Palimpsest* was a piece caught in mid-evolution. In this early iteration, the artist had still been working out the balance of elements—sound, text, images—adjusting the three-dimensional aspects of the presentation. After the Atheneum, the installation would move on to a showcase in the 2000 Whitney Biennial.

Pope, from Indianapolis, Indiana, is known around central Connecticut for *Silent Wishes, Unconscious Dreams and Prayers . . . Fulfilled,* commissioned in 1996 by Real Art Ways. In this outdoor piece, a site-specific work situated in Hartford's North End, he memorialized young people killed by drugs, AIDS, and domestic and urban violence.

"I was never the same after that project," Pope said to me. "That process informed [*Palimpsest*]. It astounded me how much, when you love someone and remember him, you incorporate that person's psychology into your own. Also how we all create consciousness from the repetition of fiction."

Pope explained that one of the murdered youths whose testimony is included in *Silent Wishes* had written: "'when I was fourteen, I never thought I would live to see twenty. When I was nineteen, I was sure I wouldn't . . .'" According to Pope, that young man was making the fictitious true. He was killed.

"Hartford was pretty hopeless, at least it believed its own fiction of hopelessness," Pope continued. "[*Palimpsest*] is the antithesis: resistance, not fatal passivity. Claiming a future is a way of wholeness."

In *Palimpsest,* Pope's strategy is abstract, the audiovisual media intentionally hypnotic, directed at the viewer's subjectivity. By layering sound over sight and underscoring both with suggestive meaning, he means to get to his audience through a kind of back door.

"When you go blank, things get in your head," says Pope. "Hypnosis is a heightened sense of susceptibility. In her poem, my sister is talking about how her identity, her sense of self, comes from within. How people look at her (a black woman in dreadlocks) and chalk her up, but they haven't really seen her. There is pain in that."

That is why she shed tears, and why her voice is used to overlay the filming

of his physical transcription. To the artist and to his audience, skin, particularly black skin, is a field of associations. No one, black or white, can look at an image of black skin without knowing how much more there is to any story written on that surface. This is a difficult and at the same time deeply pensive exhibition, one that probes our nerves even while seeking a higher ground.

Carl Pope. *MATRIX 138: Palimpsest,*
at the Wadsworth Atheneum Museum of Art,
Hartford, Connecticut. 1999.

Alexander Mittelmann

Many pieces of art catch our attention, and it's extremely difficult to guess what's going to last and even more difficult to predict what's only going to make sense temporarily. An artist puts the work out there and hopes to make a mark, yet who will remember twenty, forty, or one hundred years later? As a gallery-goer, you can decry the awful and point out a fraud, prognosticating about what will retain power and significance "for the ages." The same goes for critics, after all—hell, I don't always agree with myself after a decade or two of further thought. Even so, there are artists who seem to be just asking to be criticized.

Alexander Mittelmann grew up in West Hartford, Connecticut, went to Europe and became an artist, and then came back home to let us see what he's been up to. We should have figured he had something to prove when the first sign of his artistic return was a 20-foot inflatable nylon penis ("Joystick XL") that gleefully raised its pink head over the roof of Hartford's ETC Gallery, which was showing his work under the exhibit title *Sons et Lumieres* in early July 1996. In August of that year, a couple of miles away, Mittelmann followed up with a second exhibit called *C'est la Vie* at the Clubhouse Gallery of the West Hartford Art League.

While Mittelmann's work may not represent the most coherent thinking, at least the work is cheeky. Cynical, and a little condescending, but cheeky. My suspicion is that he's one of those folks who believe that a joke is dirty just because it names body parts. The giant penis was reprised with a cheerful trail of fluorescent spermatozoa into the darkened back room of his Clubhouse Gal-

lery show. (Hush, we mustn't let the children know . . .). Here, out of sight of the main gallery space, the swimming squiggles led us to a black-lighted funhouse full of jumbo faces with mouths gaping and tongues unfurled (ooh, so naughty), painted on window screens and dangling suggestively like giant tarot cards on guy wires from the rafters.

Mittelmann's homecoming—he took his first art lessons at the West Hartford Art League but by the mid-1990s was living and working in Paris—was well publicized. Gushy press releases declared him a multimedia artist "in the forefront of the young, up-and-coming underground art scene." Certainly the term "multimedia" is correct. His Hartford shows were a confusing potpourri of subjects and styles, media and methodologies.

The work displayed in both these exhibits (with almost no overlap) was created in a single summer, an impressive accomplishment in terms of sheer fecundity. Rather than being an expression of some overwhelming philosophical or aesthetic point, however, this work is more a glitzy sampler. Some of the works are figurative; for instance, frame-filling faces and nudes of both genders. Some are abstract, made up of swirling, turgid color smears, and some are realistic, as if to prove that he can draw. He delves into high-tech media, too, using digitally mixed electronic music and slides projected on walls from across the room. At ETC Gallery he used an image of the Grand Canyon; at the Clubhouse he used an abstract swirl of color. Was there a discernible logic for the light or sound? You tell me; the artist seemed to have no opinion.

This is clear: Mittelmann gets a kick out of anatomy. Enthusiasm for the particulars of recreational penetration is his most consistent theme. Perhaps surprisingly for an artist whose resume of Parisian exhibitions is salted with titles like *L'Art et Erotisme* and *Pornographie,* there is a refreshing absence of carnality in his Hartford images, despite the giant penis.

Perhaps because his style is so rapid—broad strokes, deftly applied—there is no sensuality of surface, no sense of skin, no suggestion of smelly intimacy. Aside from a spread-eagled female rendered in neon (oh, please) and one vague penis/candlestick image titled "Lick Off," the graphic nature of his nudes is more celebratory than obscene.

Although Mittelmann is fascinated by private parts, both male and female, there is a misogynistic gulf between his treatments of the two sexes. Men get the more dignified send-up. He steals anatomical grandeur from no less than Michelangelo—the Renaissance master's Sistine Chapel Adam is unapologetically pilfered, along with a number of decorative figures. An artist who appar-

ently can't be bothered with backgrounds, he plasters these onto wooden doors and blank canvases, whichever strikes his fancy.

For women, on the other hand, he turns out generic Playboy-ilk nudie-girls with flowing hair, upturned nipples and Barbie-doll waistlines.

In the end, the point seems to be that Mittelmann mainly likes putting paint down, slapping surfaces with wide sweeps of garish pigment, often laid on, apparently, with a plasterer's trowel. He also likes giving interviews and making things happen. He probably enjoyed shaking up the old hometown with his giant penis blimp. Fun enough, but important? Probably not.

Alexander Mittelmann. *C'est la Vie,* at the Clubhouse
Gallery, West Hartford, Connecticut. 1996.

The Critical Problem of Holocaust Art

Historical events find their way into art all the time. Expressing yourself is one of the chief draws of creative work, after all. Certain events, however, maybe particularly the events of the Holocaust, constitute an experience of such resonance for so many people that artwork centering on that epoch can seem to constitute an "untouchable" subject for objective criticism. A critic may be wary about venturing an opinion that might be taken as anti-Semitic bias—especially since the mantra of "never forget" would seem to endorse the tiring recycling of time-worn and even clichéd touchstones. The following pair of exhibitions presents artwork that has a painful history to relate; the differences I describe in their effectiveness is a matter of comparison, not meant as a judgment about the relative tragedy of the situations they depict.

In conjunction with the dedication of the Senator Thomas Dodd Archives and Research Center, in 1995 the University of Connecticut–Storrs mounted a year-long series of exhibitions relating to issues of human rights. Running concurrently were *The Holocaust Wall Hangings* by Judith Weinshall Liberman and *Threading History: the Japanese American Experience,* a joint installation by multimedia sculptor Mona Higuchi and video artist Richard Lerman.

Each of these exhibitions deals feelingly with experiences from World War II, putting the viewer into the position of detainees, peering as if from behind

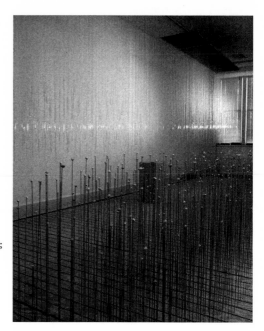

Mona Higuchi, "Threading History: The Japanese American Experience," 1995. Installation, with sound and video by Richard Lerman. Wood platform, 32 x 12 feet x 3 inches high, with 1,000 white shells mounted on wood dowels and 1,000 stainless steel needles hanging by silk threads from screens suspended from the ceiling; two video monitors were mounted in wood boxes. Photo shows installation at Cambridge Multicultural Art Center, Cambridge, Massachusetts; there was a second installation at the Atrium Gallery, University of Connecticut in Storrs, where black thread was used to hang the needles. *(Courtesy of the artist.)*

barbed wire, although upon decidedly different sources of oppression. The Liberman work commemorates the bleak genocidal ambitions of World War II Germany; the Higuchi/Lerman work commemorates America's xenophobic incarceration of Japanese Americans during the same period.

Political art such as this is a product of the modern era. Its particular aim is persuasion. Its power lies in its capacity to cause a viewer to look at an otherwise familiar history from a new perspective. For me, moral rightness is not enough. Art needs to transcend preaching and linger in some inner eye like remembered truth. Treating a theme as emotionally laden as the Holocaust—a tragedy of such immense proportion, and one that occurred in living memory—therefore carries a double necessity to distance and to approach.

In Liberman's wall hangings, the attempt to tell a tale interferes with the work's impact.

In *The Holocaust Wall Hangings*, the artist appropriates a now-familiar glossary, verbal and visual, of Hitler's "final solution"—the names of the death camps, the wistful visage of Anne Frank, the boxcars, the ovens known to us from countless documentary and filmic recreations—all of which carry well-established associations. Citing this imagery again and again creates impact

for those who can be sobered by the mere mention of the topic. But despite the patience and sensitivity that went into the making of Liberman's quilts, this history is an already known entity and the feelings that it arouses are also familiar. That familiarity diminishes our capacity to read these images; they beg for abstraction, so a viewer will be drawn *away* from their ubiquity, or be drawn *in* to their physicality, in order to find fresh insight.

Although there is a stern, embroidered sumptuousness in these works, there are few surprises and little poetry. Maps are a recurring motif—World War II Europe unwinds across rich broadcloth expanses, the sites of the concentration camps jeweled in red, the railroad links between them articulated in metallic threads.

These works are most expressive in the artist's choices of materials; for instance, muted, coarse-weave woolen cloth or the ridged, scar-like seams of the topstitching. Close up, they offer a sensuous profusion of textures, and yet from a distance the quilts read like stock market report tables. Only in finding ways to see beyond stereotypical images can a viewer find the deeper metaphor—the relentlessness of memory, recalling the needle-sharp persistence of Madame LeFarge from *A Tale of Two Cities*, stitching, stitching, and remembering.

By contrast, in their work Higuchi and Lerman "tell" very little. In a small narrow room, one wall of which looks out to an enclosed garden, a pathway of fresh planking divides the space lengthwise down the middle. Small video monitors, encased in bare plywood podiums, are placed at waist height in two spots along the boardwalk. On the viewer's left, above that resin-fragrant horizontal plane, a field of slender dowels rises from the floor like stalks of wheat, each dowel topped with a snail shell. On the right, from above, anchored to a gridwork of screening, falls a delicate shower of long needles on black strings.

What is provided is the sparest imagery, yet through the room's bareness, sensory deprivation becomes a feast of experience. The impression of grass and rain is reinforced by the recorded sound of wind singing desolately through electrical wires. The video screens' upturned faces flicker with emptied landscapes, showing parallel electrical lines and railroad tracks extended into infinity, filmed at Dachau and at Tule Lake, California, where, in 1942, less famously, more than eighteen thousand Japanese American citizens were herded into an American relocation camp.

This sound environment, paired with the quiet fall of light, opens the small space to an almost aching reverie. The smell of the planking underfoot, likewise homespun and accessible, evokes a sadness that plays idly in unrelieved emp-

tiness. There is Zen-like beauty in this quiet, sad, invented-and-remembered place, derived from an artistry that so gently touches the senses. Wall text gives simple clues to the imagery—a grandmother's recollection of how she passed the time in a desert landscape, collecting snail shells, sewing.

The vivid contrast between the two exhibitions is in the way they tell their stories. Each calls upon the familiar and the tactile in order to evoke empathy, but the difference is between private versus conventional imagery. One tells a story from a concentrated, wholly reflective, personal perspective; the other bombards us with so many narrative elements at once that it is impossible to discover a satisfying continuity. The overriding aim of each of these exhibitions is the humanization of moral issues; the difference in their impact is a direct corollary to their capacity to evoke and to distill that humanity through a viewer's senses.

> Judith Weinshall Liberman. *The Holocaust Wall Hangings,*
> in the Jorgensen Gallery, University of Connecticut–Storrs.
> Mona Higuchi and Richard Lerman. *Threading History:*
> *The Japanese American Experience,* in the Atrium Gallery,
> School of Art, University of Connecticut–Storrs. 1995.

A Word About Graffiti

The following essay was a companion piece for a longer investigation of tagger art (graffiti). Another form of "outsider art" and a cause célèbre in the rebellious 1960s, this was a way of working that seemed to me to reprise medieval attitudes about the meaning and process of the making of art. If one wants to seek a self-perpetuating visual tradition in the present day, one need look no further than an ordinary underpass or concrete retaining wall to see where the torch of culture is being passed.

Reduced to its simplest form, "tagging" is naming. Tagging or graffiti marks out territory and claims for a self-proclaimed artist a piece of public territory—a piece that nobody much wants but nobody will let you have, either. This is art that demands a whole wall, thank you, and will not be confined to some 8½-by-11-inch sheet of school-grade construction paper.

Graffiti is art that is determined to be seen. The remarkable truth about Hartford's tagger art is that it looks interchangeable with graffiti art from thirty

years ago. Each generation comes at the walls as if for the first time, rediscovering what their predecessors took years to learn, and mastering received techniques yet always believing that their art is brand new.

Graffiti's practitioners, by any standard, are dedicated. Formally trained or untrained, these artists have a vocation that they value more than any formal recognition. Equal parts ambition, daring, and competition, this form of art making is decked out in vivid, macho display, both an arrogant challenge and a preening come-on.

And of course, public murals are an important and long-standing tradition in human culture. Assertive political and social protest splashed onto the walls of the city is particularly associated with Mexico in the early part of the twentieth century; for example, such potent muralists as Diego Rivera and Jose Clemente Orozco. Prior to the 1960s, these kinds of monumental works were always created under official sponsorship; graffiti, by contrast, is outsider art.

The official art world "discovered" graffiti art in the early 1960s. This was a watershed period not only politically, but also in art. Pop art, conceptual art, and performance art were all born in this period and all railed against accepted conventions, such as ownership and standards of taste. Graffiti's grassroots vitality is what has made the art so compelling and, ultimately, influential. As highbrow art cloistered itself in pristine museums, graffiti channeled the excitation of the street.

More than its specific forms, graffiti's audacity—its bawdy, threatening, invasive surprise—reinvigorated the fading energies and tame aesthetic surfaces of minimalist abstraction. Street artists risked jail, not the sniping of art critics and not their careers. And while taggers practiced their craft presumably unconcerned with what was going on uptown, the uptowners took notice on their rides home in the subway.

Since the 1960s, there has been a somewhat fluid interchange between street art and "official" art circles. Legitimate artists have embraced street forms, and street artists have gone legit.

Irreverent Andy Warhol paved the way for this exchange, springing open the hermetically sealed doors of the aesthetic elite and fostering a whole new attitude about what constitutes art. Warhol embraced popular culture—the crass, commercial, and mass-produced—lifting it up to challenge what we perceive as our so-called culture.

In Warhol's famous workshop, such artists as the late Jean-Michel Basquiat and Keith Haring (who had some formal training) imbibed Warhol's irreverence, moving into their own enthusiasms and bringing graffiti onto canvas,

thereby bridging the gap between insiders and outsiders, between the street's guerrilla warfare and the elitism of the galleries. This appropriation was far from naïve in attacking the status quo from every side. Graffiti artists challenge the notion that art has to be pictures, just as Christo refuses to accept the idea that art is a solitary, finite, and marketable commodity. Artists like Basquiat and Haring brought the vigor and exuberance of graffiti to the official art world, in the process legitimizing some of the self-taught primitives whose art education occurred entirely in the streets.

By 1985, at least a half-dozen of New York's prominent galleries represented painters who began as graffiti artists. In that year the prestigious Sidney Janus Gallery, for instance, showed artists who called themselves by names like Crash, Daze, Bear, A-one, and Toxic. Hartford's resurgent taggers' art is in this tradition. The boldly outlined calligraphy, rendered vibrantly and with floating colors, commands the wall. Often impenetrable, both as language and as image, a tag compresses imagery to the bursting point, a knot tied as tight as a Hiberno-Saxon illumination.

Audacious, preemptive, and intrusive, graffiti creates and codifies a language of signs, immortalizing its makers in directly graphic ways. Graffiti reenacts the whole length of human artistic history. Graffiti is cave art all over again. For the taggers, as for any dedicated artists, there are long apprenticeships in craft; there are rites of passage and cultural representation. Although unrecognizably altered in form and materials, graffiti paintings incorporate cultural conventions we might be loath to admit we valued. We can pretend that art is confined to the rarefied world of galleries, but the real culture we Americans have includes *The Simpsons,* commercials, and video games.

Perhaps the media, not the gallery or the university, is the universe of our collective visual education. The graffiti artists have spilled out into the urban world attitudes learned from billboards, posters, bumper stickers, and designer labels that they have appropriated and made their own. The resulting images are not traditional pictures, but "signifiers" in calligraphic form. Graffiti puts the word out literally, posting its artists name by name, bombarding the environment in a kind of spectacular "advertising campaign."

Like conventional gardeners, maybe we wish we could keep our land free of such weeds. And yet weeds have a biological imperative to grow, just as the human spirit will find a way to surface, even in the most blighted corners of a city.

Graffiti is an affirmation, a "why not?" in answer to society's continual "No:"

Making It Up from Scratch

Chuck Close

*You can think that you know an artist, that you are familiar with the
kind of work he or she does and the sorts of images they use, but when
you're faced with the task of writing about someone's work there's a big
difference between thumbing through reference books or magazines and
meeting the art face to face. Even if you've encountered the work before,
in a museum or gallery, this is not the same as arriving with your pencil
sharpened, ready to really pay attention, and knowing that you will be
held responsible for what you think.*

*In graduate school I had a professor who shepherded us down to the
Yale University Art Gallery and sat us in front of a suite of Mark Rothko's
gorgeous living windows, then made us pick one. "I'm going to give you
one of these pictures," she said dryly, "but only one. You have got to decide
which of these you would take."*

So she made us choose.

*I had always loved Rothko, right from the first, even as a high school
student on one of those obligatory field trips to the Big City Museum. I
hadn't learned anything about him, yet, and knew nothing about abstract
expressionism or color field painting. But I loved Rothko's work straight off,
and I didn't need to know why.*

*Yet my professor's command to choose was disorienting. She challenged
us to assess a painting or sculpture not on the basis of the somewhat flabby
consideration of whether or not we liked it, but instead from the riskier
standpoint of whether we would want to live with it. What was stunning,
really, was to discover that I chose differently in this context: if I was going
to take it home, I wanted the tougher, more difficult, and feistier picture.*

It is this "innocent eye" that I try to bring with me, along with my

*notebook, into a gallery. Appraisal and response is not a matter of
ownership, really, but of depth—your own and the work's. Achieving that
shift in perspective informs my encounters even with artists I already
thought I knew something about or had some appreciation for—Chuck
Close, for instance, whose approach, seemingly direct and representational,
turned out to offer quite another experience altogether.*

A rtists know—and viewers most often do not know—that art is a process
of translation. The more "realistic" a painting looks, the further this may
be from the truth. A stretched canvas is flat, after all, and anything that appears
to have volume or depth in it is an artifice. The truth about painting is that the
results are merely paint on canvas; the truth of drawing is that what you see is
nothing more than lines or smudges on paper. Any image of a face that emerges
from such raw materials, consequently, is the artistic equivalent of smoke and
mirrors.

What is so fascinating about the work of Chuck Close is how he unveils the
magician's secrets—and still manages to keep them secret. He works both ends
of a pictorial spectrum that for most of us is impossible to span, and makes us
wonder how anyone can do that. Cause and effect are both revealed, but just
how this happens remains as much a miracle as it ever was; for these are works
that, up close, dissolve into bits and dabs of colored matter but which, from a
distance, fall into place with magical representational precision.

His is a trick of vast proportion, and it made Close famous more than
forty years ago and has kept him prominent ever since. From his first successes
in the 1970s, he has created a kind of dialectical ambivalence that puts his work
in a class by itself. In the beginning, his staring, emotionally noncommittal
renderings of anonymous individuals (actually family and friends) stood some-
where between photo-realism and pop art, but, also, in the grid-divided, ex-
quisitely uninflected character of their rendering, somewhere between the all-
over approach of abstract expressionism and the supremely neutral cool of
Minimalism.

The man himself is something of a legend, a revered profile in courage. In
1988, at the height of his career, he suffered a spinal blood clot that left him
paralyzed. Even though he was left a near-total quadriplegic, he persisted in
painting gigantic canvases from inches away, his brush strapped by a harness to
his hand as assistants raised and lowered the canvas that he continued to work
from an intimate distance.

Chuck Close in front of "Gwynne,"
1982. Watercolor on paper laid down on
canvas, 74¼ x 58¼ inches. *(Copyright Chuck
Close, courtesy of Pace Gallery.)*

What is remarkable about the way Close accomplishes these huge paint-
ings is how clearly his ongoing procedure relates to the logic that drove his
early work. Their power stems from the way he gauges his effects, through a
mind's eye that seems even more uncanny considering the restraints of his con-
dition. His most contemporary works operate with a vivid freedom of palette
that hearkens to Seurat's brilliant divisionism and a sloshy "touch" as easy and
intuitive as Manet.

The 1998 exhibition *Chuck Close: Translations* at Akus Gallery, Eastern Con-
necticut State University, in Willimantic, Connecticut, is a coup for the gallery
and a treat for the viewer, a handsome and intelligent prelude to the major
Close retrospective that opened at New York's Museum of Modern Art that
same month. The Akus Gallery show consisted of portraits from across Close's
entire career, all of them based on photographs as blank and staring as driver's
license head-shots, but rendered in other media (much of it printmaking) with
all the dogged patience of an ant—or a dot-matrix printer. This body of work
demonstrates that the self-imposed limitations of working close to a surface,
concentrating with near-molecular focus, was a secure aspect of his approach
long before his current physical limitations necessitated it. And there, precisely,
was the gift of *Translations;* for these works were indeed acts of translation, ac-

complished inch by inch, step by step, and row by row across the gridded face of each picture.

Close's effects are at once obsessive and utterly neutral—a topography observed dispassionately, patiently, and with brutal factuality. Minute incidents are presented with democratic even-handedness, like notations in a lab book: the gaping pore, the wiry sprouting of a hair, or the empty vacuum of a gap between one mark and another are handled without discriminating emphasis. To an ant, each grain of sand has import; from so intimate a perspective, "significance" is probably imperceptible to an insect eye.

It is as if the artist can pull up a chair so near to his subject that it dissolves into particulate rather than solid form. Close's "Emily," for instance, is rendered in a network of fingerprints, and their swarming impression, like the cumulative effect of the little gray squares of "Robert 2," yield a portrait only if one steps back ten, fifteen, or twenty feet. The farther back the viewer stands, the more "detailed" the impression becomes.

One of the most interesting and revealing elements of the Akus Gallery show was a film Close shot in 1970 called *Slow Pan/Bob*. Here the artist puts our eye in his, as he scans his subject inch by patient inch. The square frame of the television monitor corresponds to one square of his portrait grid, each representing a still frame of observation. We must slow down and follow his rendering: first we find a passage of vacant white, which is then interrupted by a strand or two of hair, then a forest of hair, then on to the crater-pored topography of the cheek, bristling with more shafts erupting from missile-silo follicles. Each image is equally obscure from this range, and equally revealing—the great shadowed mystery of a nostril, or the thready horizon of a lip edge, and so on, as we are made to walk this ant-terrain "portrait." Here it is, then, the truth of exacting representation: Abstraction, bit by bit, gives us "reality."

To see a Close is to see closely. To experience a Close from afar is to consult the vivid images that pass by us unexamined every day. To move back and forth, close up and far back—as one must—is to glimpse the universe of artistic translation and to recognize for once what artists actually do and how this can hold them enthralled for a career.

Chuck Close. *Chuck Close: Translations*,
at Akus Gallery, Eastern Connecticut State University,
Willimantic, Connecticut. 1998.

William DeLottie

William DeLottie's work presented one of the first—though by no means the last—of the conundrums that confronted me the first year I took up writing about art. This was an encounter for which I was almost entirely unprepared; DeLottie's was the kind of work that was impossible even to call painting, yet his pieces couldn't accurately be called anything else. His work used pigment, light, and shadow in ways so literal (and at the same time so abstract) that I was stymied in trying to communicate what I saw.

I had no precedent for the way DeLottie combined elements, and no experience with the kind of effects he achieved. Even though his works presented just as flat paintings do, these weren't at all flat. His artistic accomplishment was to deconstruct painterly illusion, exploding line, shape, color, texture, form, and space—all the traditional design elements—into a Baroque-style pictorial environment, without relying on any of the representational techniques that gave Baroque art its convincing verisimilitude. DeLottie was definitely not a sculptor (since he framed a view for an audience standing in a fixed frontal position), but calling his strategy "painting" tests the limits of any conventional definition of the term.

DeLottie's work was both challenging and intriguing. You don't often meet such a genre-bender, and his approach forced me to reconsider some rather tired assumptions about what painting is supposed to do and to be. Fast-forward five years and I would get the chance to interview him and assess the evolution of his strategies as he was preparing his entry for the 2000 Whitney Biennial (that essay will appear later in this book). His work had changed in dramatic ways, but it was equally difficult to pigeonhole and equally interesting.

In a remarkable series of constructed wall hangings, William DeLottie turns traditional picture making inside out to establish an amazing new middle of things. He delivers a dramatic demonstration of how fact can contradict appearance and how appearance can defy fact, and he manages at the same time to invigorate one of the essential orthodoxies that define modern painting—that paint is, first and last, a matter of fact, which is to say, material, from which what most people call "realism" (i.e., illusion) is merely a by-product.

DeLottie does not paint. He uses pigment all right, but dry, without any kind of a binding medium to adhere it to a canvas. Instead, in pocketed constructions like huge plastic tea bags, he traps the colored powder between sheets of clear, heavy-duty industrial vinyl. The dry pigment defies gravity, bunching thickly in the airy gaps between sandwiched surfaces, swinging irregularly around its confining pillow in dusty movements, creating a kind of "drawing" within its vinyl envelopes. These are hung like narrow baggy laundry within and behind curtain-layers of additional vinyl that are sometimes left in sheets but often are interwoven in a regular grid.

There is nothing sacred about the way DeLottie makes these constructions, which he calls "systems" rather than paintings. They are glued with long oozy trails of silicone caulk, stapled with fraying fold-overs of scrap canvas, hung on cockeyed aluminum frames or rusty steel brackets that allow them to be positioned at various distances parallel to, but away from, the wall. His compositions are maneuvered and assembled in space rather than connected on a single surface. One must look *through* these constructions to find the "picture"—which is visually assembled by the viewer from the aggregate impression of clear vinyl,

William DeLottie, "WHT/RED+BLU+BLK," 1996. Shown installed at the Creative Arts Workshop, New Haven. Vinyl sheeting, constructed vinyl bags, aluminum rods, pigments, flour, clamps, and quartz lamps, 36 x 120 x 288 inches. *(Courtesy of the artist; photo: Michael Sundra.)*

powdered pigment, metal scaffolding layered in front of the bare gallery wall, unified and transformed via reflective highlights and delicately cast shadows.

The activating element in these works is light, which he handles like an irreverent stage manager. Mismatched lamp-stands are hauled into the center of the gallery to orchestrate the play of light upon these surfaces. The effects are surprisingly beautiful—all the more so because they are set against the decidedly unlovely construction. Like Monet gone industrial, light glints off saggy ripples in the heavy vinyl curtains and etches a delicate grid of shadows upon the cinder block surface of the gallery walls.

Overall, the tactile irony of these works is their most compelling feature. What can be seen cannot be touched, although every physical element is palpable to the eye. Dry powder is accessible to the fingertip as squeaky plastic; what is refracted on the surface of a work is precisely what appears as a ghostly shadow upon the wall behind it. Compound yet complex, factual yet illusory, visible yet impossibly distant, these works do what no single-surface, illusionist trickery might possibly accomplish, and suggest that perhaps "painting" (although the name is woefully insufficient here) has not exhausted its capacity to do something terribly new after all.

William DeLottie. Exhibit at Real Art Ways,
Hartford. Connecticut. 1995.

David Borawski

David Borawski is an example of one of the grassroots collaborators one can encounter in towns and cities everywhere in America. While he is a practicing artist, Borawski also is an opportunistic facilitator, looking to create exhibition venues on a shoestring, even if that opportunity requires cleaning out a grungy, abandoned industrial loft in exchange for exhibit time before he turns the place back over to the landlord. To such "venues," Borawski comes armed with a broom, a few reels of extension cord, and a database of colleague-artists whose work he likes.

In contrast to the pristine, tricked-out, pricey character of the commercial gallery scene that most detractors envision, this sort of enterprise— which is more of an "event" than a marketing venue—constitutes the lifeblood of the arts communities that exist everywhere but might fly

under the radar of the general public. Experimental, democratic, playful experiences, they are the glue that connects artists of every stripe in a supportive acknowledgment that it's not enough just to make art, one needs an audience to interact with, as well.

In the familiar trope represented by those old Andy Hardy movies, the kids would get together to put on a show, combining fresh young talent with a lot of ingenuity (and a stage set meant to rival Broadway) at the drop of a freckle-faced teenager's cap. In the fantasy of Hollywood movies, this process was simple enough, but if the truth be told, this isn't so easy in the real world.

What made such movies so much fun back in the 1940s is precisely what has made the local low-budget, moveable installations stage-managed by David Borawski so charming in the 1990s—except that Borawski's "shows" really *are* put together out of thin air, talent, and a dime or two. These are experimental group exhibits that magically appear in cruddy old industrial sites, places for which the curator swaps a laborious clean-up for a quick spate of free rent. *Voilà*, we have a place where contemporary art can have its day in the sun (or shall we say under a floodlamp on a very long extension cord?).

Under these conditions, even the frailest experiment takes on a kind of courageous whimsy. The setting is half of the impact. In huge brick-and-timber industrial spaces whose gap-toothed plank floors are embedded with ancient dust underfoot, a brittle little corner pile of what looks like brown wheat crackers takes on intriguing incongruity. Especially since you just watched the artist move that pile from one room to the other and pour it against the wall, kicking the pieces into just the right degree of insouciant disarray with her foot. *Dirt Poems* is the title of this work by Liz Zweibel, a collection of paper squares, each inscribed with a "line" or two of dirt and waxed into solidity.

Zweibel's other piece in the show, *Disappearing Acts,* is also a cluster of related objects, this one comprising floating columns of delicate wire disks, skinned over with latex like fleshy Shrinky Dinks. Linked together with thread, one above the other like smoke rings, they occupy their huge room as wistfully as spidery dreams or laundered nylon stockings. Zweibel's two works, considered together, make for a quick discourse on gravity. Where the *Dirt Poems* fall weighty upon the floor—with a kick, negotiating between meaning and substance—*Disappearing Acts* are bodiless, immaterial gossamer. Dusty poetry produced in a vacant factory space.

Paul Clabby, too, knows how to inhabit a room with bits of nothing. His

Sandra Guze, "Agendum/Agenda/Agendas," 1999. Site specific installation, with rug, table, crocheted tablecloth, wedding dress, billiard equipment and mixed media, 94 x 64 x 54 inches. From David Borawski's group show *DD–MM–YY*, in an old foundry. *(Courtesy of the artist.)*

collection of plastic bags, inflated and inscribed with black magic markers, scale an eighteen-foot brick wall like wacky giant bugs puffed up and pointy at the corners. Each one is hand-drawn—with dots or squiggles or a staggered grid of brick pattern—but not one pretends to be anything but what it is, a thing made of transparent plastic and black ciphers.

Part of the fun in these installations derives from their context in an old foundry space. The faded industrial history sets a tone; the dilapidation sets up a few challenges. A viewer has got to watch his or her step so as not to trip on the floor grating or back over a knee-high wooden beam. Wainscoting, clad in flaking police-barracks green paint, frames one room; bald-faced brick crumbles from the walls in another. The stairs are rickety affairs, but the height of the ceiling is lavish.

Borawski's efforts in putting this assemblage together reflect a playful entre-preneurial impulse: half serendipity, half colonization in a space found by hap-penstance. Essential unpretentiousness colors the effects. Colleen Coleman's little installation in a windowed inner office, for instance, takes on the character of a makeshift stage. A tin bathtub occupies the center of the space, which is

fenced off by a gauzy scrim. Shards of a broken mirror, a few peacock feathers, a bird's nest, a lady's fan, and a spiraling symbol written in baby powder litter the floor. Tiny bells and tendrils of hair dangle on long threads from the ceiling, as the installation appeals to hearing and touch as well as sight. The act of looking is carefully considered, too. As important as the objects and symbols arrayed before us is the way we are made to peer in through a broken window pane, through a creased and sheer drape. This is a staging strategy that forces the viewer to participate actively—made to assume the physical stance of looking, we find ourselves wondering what the hell is going on in there.

Likewise, in room after room, we stumble onto weird and compelling forms. Joseph Fucigna's chains of silky white globes—like onions or garlic, equally like milkweed strands—link like braided arms and hoist each other vertically among the ambulatory guests. Not everything works as might be expected. Conventional paintings, like Zbigniew Grzyb's huge elephant hide–textured canvases, richly loaded with saturated color, loom like inert screens of light against a wall. In this vast, color-deadening space, their pure hues (green, yellow, blue, red, violet) lose a certain affective dynamism, the paucity of the available light sucking them into ghosts. Here, less color might have been more; dialing back chromatic emphasis and allowing texture the forefront might have been a fitter foil for this vacuous, bedimmed space. Still, this very struggle of hue versus surface, as pigmented color is left sucking for light in a hushed space, creates a fascinating perceptual battle between intention and effect.

The difference between installation and theater is existential, in that the stage is set but the narrative is suggested only in abstentia—by perceptual inference. The strategy employed is three dimensional and multisensory, rather than strictly optical. Sandra Guze, for instance, sets a stage with a costume that is "read" through its posture: an empty wedding dress, pearly and pristine, slumps prettily in a chair. Across a table, her "partner," a billiard cue and its rake, lean slightly towards her, as if in conversation. The table gaps at the center, so that its lacy tablecloth, weighted by a scuffed cue ball, drapes like a flounced skirt slung between gapped thighs. Overhead, the artist employs an old billiards scorekeeper (numbered wooden disks threaded on a high wire), which runs like an elevated train between the dress and the cue stick and rake. Subtle wordplay (rakish, for instance) coupled with salient contrasts (clean and dirty, new and old, yielding and rigid) makes the case. The individual work speaks for the exhibition as a whole. For in this venue, a dusty, long-abandoned space, shiny

hopes and fate and chance are assembled, and set out in the viewer's own living space. Here, on this night, art is not a thing framed out or put upon a pedestal; it engages seamlessly with "reality."

This is a show about showing—about showing up, too, and taking a shot. Nobody's making money off such exhibitions, nor are they getting famous. This is a chance to remember just what play was like, when we were the little ones who were always ready to put on a show for the hell of it.

<div style="text-align: right;">

Group exhibition *DD–MM–YY,* 50 Bartholomew
Street, Hartford, Connecticut. 1999.

</div>

Hay House

I didn't go to the New Britain Museum of American Art to see David Brown's Hay House *installation; I stumbled upon this in the course of reviewing the work installed in a larger adjacent gallery. For the life of me, I can no longer remember the "more important" historical show that brought me to the museum. But* Hay House *remains vivid in my memory. Surprises like this installation—replete with juicy, authoritative painting and aromatic with mown hay, awkwardly oversized for the exhibit space, but compelling and memorable—are the impetus that keeps me venturing enthusiastically into some of the smaller corners of the art world.*

Despite the fact that it is shoe-horned uncomfortably into its exhibition space at the New Britain Museum of American Art, David Brown's *Hay House* installation is an experience not to be missed. I don't care if you're an art lover or an art skeptic, a nature lover or a nature-phobe—this is a quirky, accessible, and inspiring work.

I have difficulty telling you what it *is,* exactly, other than yard upon lavish yard of glowing, swashbuckling oil painting, hung over the framework of an actual straw-bale house. The artist refers to the paintings as "still life," although they reference a concept that is anything but still. The painting panels, assembled together here, form a continuous panorama that wraps the house inside and out, on all four sides. In addition, surrounding the construction on three of the gallery walls, the artist provides a series of 365 individual postcard-size

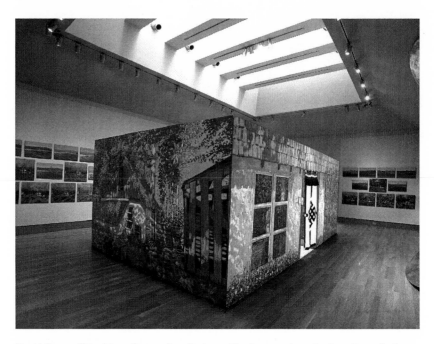

David Brown, "Hay House," 2000. Installation, with photographs, mixed media, and oil paintings on luan, MDO board, and cloth, covering a hay-bale wall structure. 7½ x 12 x 20 feet on the outside, and 9 x 17 feet on the inside. On the surrounding gallery walls were oil paintings on MDO board: the morning series, 24 x 20 inches each; and the afternoon series, 24 x 18 inches each. *(Courtesy of the artist.)*

paintings of sunrises, each one painted *en plein air* from wherever the artist greeted the morning on a particular day of the specified year. This gemlike series alone would be worth the visit, but the installation as a whole is like nothing you've seen before.

Of course, the artist's life that these works reference is also something out of the ordinary. David Brown graduated from Dartmouth in 1976 and then spent the next ten years of his life in India and Nepal working, variously, as a photographer for UNICEF and the Government of India Department of Tourism, teaching art, and establishing a handicrafts cooperative among Tibetan refugees. He returned to the United States in 1987, then taught for three years at the Hammonasset School in Madison, Connecticut. Since 1991 he has been painting and farming at the Hay House in Old Saybrook.

The painted house is a recreation of the artist's actual homestead where, for the past twenty-one years, he has lived without electricity and plumbing in the

middle of the acres of gardens that he planted and farms. Off the grid, Brown lives by the rhythms of the seasons, which he records in paint with the special kind of attention that such naturalists, immersed feelingly in the "now," can attain. In his artist's statement, Brown remarks that "I've seen people deeply moved by the tranquility and beauty of this environment and as an artist, I've wanted to replicate the atmosphere."

The challenge for all plein air painting is the translation of outdoor light, and its glowing dynamism, into pigmented color. Beyond this, the special challenge for Brown is mastering the difficulties of a 360-degree perspective illusion—a task that requires equal parts science and intuition. Every inch of surface of the 8-by-20-by-12-foot house structure, inside and out, is covered with painted panels that recreate the physical space in which the artist lives his life. The rendering is equal parts persuasive and magical. Step in the door, and everything falls into relation: the furniture, the bookcases, the cabinets, the dishes and jars glinting on cupboard shelves, and the views out the windows, along with a slouchy striped sofa and a profusion of pictures tacked on the walls.

The whole experience is a cunning demonstration of where "art" and reality seamlessly part company. Brown's "house" fills the gallery: a full-scale, life-size, believable "canvas." This bravura exercise in recreation goes utterly beyond that wily little parlor trick that is trompe l'oeil, because its effects are so boldly generous rather than merely tricky. There is no attempt to disguise the dancing facility of his brushstrokes (no airbrushed taint of photo-realism anywhere in evidence). The connection between glance and touch is immediate, the transfer from perception to rendition, instinctive. And the color! How does Brown find just the right yellow, for instance, to exactly match the real straw mats on the floor? From where comes his capacity to modulate the dancing radiance of incoming daylight and sweet comfort of ambient shadow?

Equally exuberant is the way he chronicles time, not only in the 365 sunrises on the walls surrounding the installation, but also by literally bending the ageless trope of the four seasons around the walls of his thick-walled abode. Each exterior wall presents a season: fall, winter, spring, summer. On one facade, blooming hollyhocks crowd a sunny wall. Leafy shadows dapple another. On another, snow lies deep around the propane tanks outside the kitchen and icicles drizzle, sparkling, from the eaves. All is fact, yet all is poetry.

I make no apologies for calling this work beautiful. There is a wonderful spirituality about this artificial place, lent by the artist's immersion in his momentary/daily/seasonal experience. Brown's work has a confident, lyrical,

radiant authenticity. The everyday is made transcendent by dint of the artist's eye and hand. What is most surprising about the work is that it is executed without a trace of cynicism. In a weird way—because it is presented in three dimensions and painterly in the extreme, because the viewer is directed to *occupy* the space the artist has created—*Hay House* is reminiscent of the installation work of pop artist Red Grooms, whose life-size cartoon worlds were rendered in papier maché. While Grooms toys with social commentary in a laughing, big-belly way, Brown's *Hay House* environment is like a prayer cycle—a book of glorious days.

David Brown. *Hay House: David Brown,* at the New Britain
Museum of American Art, New Britain, Connecticut. 2000.

Joseph Cornell

Joseph Cornell (1903–1972) was a reclusive, wholly original artist, whose small constructions have become an iconic form of assemblage—in which lovingly collected memorabilia are gathered together in quirky, poetic, diorama-like housing. Framed under glass like shallow stages, these layered, sculptural arrangements are products of private fascination and mysterious juxtaposition, placing this work well within the spirit of surrealism (irrationally driven and subconsciously read), although the man himself was part of no organized group. His embrace of the commonplace, however, employing everything from picture postcards to Victorian bric-a-brac, was neither an expression of irony nor a celebration of Pop culture (these impulses were yet to rise). Instead, his constructions reflected a shrine-like character, as he gathered the sometimes dog-eared remnants of objects that he rescued from oblivion and imbued with the reverence of an intimate canonization. There is something about the mystery and the handmade intimacy of these small, surreal stages that continues to find a connection with contemporary artists, and the influence of this unpretentious little man, who worked in virtual isolation for private reasons, remains remarkably widespread.

When the Wadsworth Atheneum's legendary avant-garde director A. Everett "Chick" Austin bought the museum's first Joseph Cornell box

Joseph Cornell, "Untitled (Paul and Virginia)," c. 1946–48. Construction, 12½ x 9¹⁵⁄₁₆ x 4⅜ inches. *(photo: Edward Owen / Art Resource; reproduced courtesy of The Joseph and Robert Cornell Memorial Foundation, licensed by VAGA and Art Resource, New York, NY.)*

construction in 1938 for a few hundred dollars, no one paid much attention, but when the Wadsworth Atheneum Museum of Art acquired twenty additional works by Cornell, some twenty-five years after the artist's death, the news sent ripples through the art world.

Back in 1938, of course, few Americans had heard of this modest man from Queens or were giving particular credence to the European art/literary movement called surrealism with which he would come to be associated. In fact, Austin's prescient purchase made the Atheneum the first public collection to include a work by Cornell. The museum's long history with the artist, aided by the efforts of art collector and Atheneum trustee Mickey Cartin, prepared the way for *Joseph Cornell: Recent Acquisitions*, featuring works from the full span of Cornell's career. The centerpiece for this exhibition is the work Austin purchased all those years ago, *Soap Bubble Set*.

This glass-fronted wooden box houses a carefully chosen array of peculiar yet mundane objects—a Dutch clay pipe, an egg, a doll's head, a map of the moon. Back in 1938 this piece must have seemed as puzzling and eccentric as the dream-weird paintings of Salvador Dalí that Austin also brought to Hartford (much to the chagrin of the Atheneum's more conservative trustees) in his campaign to bring modernism to the American public.

The piece is characteristic of Cornell. He created a world in the particularity and preciousness of familiar, life-worn objects, meticulously arranged and fixed into a geometric environment, and then hermetically sealed behind glass. Few could have predicted the way these quiet assemblages would become a seminal force in contemporary artistic practice, nor that by the end of the twentieth

century the telling juxtaposition would become a familiar form of contemporary expression.

Despite clear stylistic affinities with European surrealism and Dadaism (a culturally anarchic response to the bleak disillusionment that followed World War II), what separates Cornell from those artistic movements was a distinctly American philosophical bias. Whereas Dada arose from the socially conscious and nihilistic milieu of pre–World War II Europe, and surrealism celebrated the unrealities of dreams and subconscious processes being explored by the new science of psychology, the genesis of Cornell's imagery is decidedly more personal and individualistic and also transcendental.

Cornell lived his entire adult life in the small tract house in the Flushing section of New York's Queens borough, that he shared with his mother and his invalid brother, Robert. It has been suggested that Cornell's boxes originated in the artist's efforts to make cognitively interesting toys for Robert, who had cerebral palsy and used a wheelchair, which perhaps explains the lap-like scale of the boxes and the manipulative intricacy of the puzzles they contain. Each small object, each Victorian valentine or fragment of a map, is something one trips over, imaginatively, tumbling into whole worlds of association and memory.

Cornell has been called "the poet of ephemera." There is a deliberately fugitive quality in the objects he chose to incorporate in his box constructions— a sense of fragility, of vulnerability, of decay. These effects are no doubt consciously accomplished. The antique quality of his finishes, for instance, was painstakingly achieved by layering, staining, and distressing the surfaces. Cornell even baked his wooden boxes in the oven to simulate the effects of age. That the completed pieces seem so materially rich is surprising, since the artist collected his materials according to topic rather than for their physical properties.

Cornell's fixations are evident from the recurring motifs that weave through his constructions. Themes rise and repeat almost like an undertone, of which we only slowly become aware. Circles, a symbol of cosmic reverie for Cornell, come up time and again, echoed in the perimeters of the moon, in a scar-like cut into the surface of a framing mat, or floating on the face of a backdrop like the ghost of a soap bubble. And, intriguing in a life-long bachelor, his fascination with certain famous women—Emily Dickinson, a nineteenth-century Romantic ballerina, Victorian divas and Hollywood film stars—threads through this work in a trail of evocative physical references.

He invented a genre that can be described as dreamlike stages for inanimate

objects. Occasionally he provided limited movement (along a track of paired guy wires), or tucked a small mirror into a corner (to allow for a fuller view from a static viewing position). The cunning interplay reached past artistic conventions to private compulsions—and his strategies reflect the intimacy of his focus. Cornell's is not the kind of work that will wow most audiences. One must enter this sphere to "read" these assemblages, and the empathy they garner, once you have occupied his perspective, is surely the secret to their living appeal.

The over-simplified myth in which Cornell is sometimes pigeonholed is that he was an enigmatic, self-taught outsider. The truth is not so tidy. In fact, this shy, very private man was a familiar and welcomed member of the surrealist enclave in New York City, and he had strong personal connections with surrealism's proponents in Europe, although throughout his career he was careful to disassociate himself from their ideology. His work did not exactly correspond to the movements of the day, and the inexplicability of his approach is a large part of its enduring richness. That contemporary artists, responding directly, have found in his works a stirring source for new genres is a measure of Cornell's enduring appeal.

Joseph Cornell. *Joseph Cornell: Recent Acquisitions*,
at the Wadsworth Atheneum Museum of Art,
Hartford, Connecticut. 1997.

Ben Kinmont

Ben Kinmont's "performance" at the Wadsworth Atheneum Museum of Art Café one evening after hours was one of those seemingly spontaneous, opportunistic occasions for which contemporary art is famous. At once an awkward and puzzling experience, this was also ultimately an intriguing one. Inspired by two other circumstances—a new exhibit of Cornell "boxes" at the Wadsworth and the lingering memory of Mierle Laderman Ukeles's Maintenance Art Performance Series *at the museum some twenty years before (see page 16 in this book), Kinmont was expressing appreciation for the intrinsic humanity of those earlier artists' approaches to making art. Neither Cornell nor Ukeles claimed to be a celebrity or a divine creator; instead, their work constituted an extension to the way*

they live their lives rather more than a conventional art product. Both
created private forms, although Cornell's was a tangible object and Ukeles's
was the sort of repetitive-so-as-to-be-invisible act that she posits as a sign
of nurture. In each case, the appeal is not so much what happened to the
art after it was done as an engagement in making.

Ben Kinmont is an artist who positions himself as an heir to Joseph Cornell and Mierle Laderman Ukeles, seeking, by a kind of ritualization or "performance," to direct an audience to essential acts of humanity. He adds to this earnest effort a fey sense of serendipity and more than a little humor.

Kinmont's audience is invited to his performance as if to a party—a personal phone call lets you know when and where, and that you were welcome. David Borawski (see page 43) has been known to put together an "audience" in much the same way, which is necessary when the venue is a one- or two-night stand.

What's important to understand with an artist like Kinmont—whose "subject" is interpersonal relationships and whose "art" is the framing of those relationships in an art context—is trying to figure out where you stand (literally) in relation to the work. The tension is quite palpable, since you are standing inside a performance, participating but also feeling completely self-conscious. Kinmont's "piece" in this case was a perfectly natural act—washing the dishes that the museum café had purposely left behind for him—in the company of a cluster of invited guests—other artists, curators, collectors, critics, friends, and acquaintances of all of these. We stood around chatting while he did the work. He invited us to sign his arms with a black marker he provided, which we did. Someone took pictures. I took notes and made sketches, as I always do in these situations, and I made copies of these and donated them to the museum's archive. When the dishes were done, we all went home.

It was quite remarkable, then, in retrospect, to see those notes and sketches displayed in the museum as part of an exhibition, much as it must have been surprising for the maintenance staff of the museum to discover that once Mierle Laderman Ukeles had cleaned the vitrine holding their Egyptian mummy in *her* performance so many years before, they were no longer permitted to do that routine bit of maintenance, because by dint of her "performance" the display case had been changed into a work of art, and only curators are allowed to handle works of art!

Such acts of subversion are the stuff and substance of concept-based art, whose essential disaffection for the entangling mercantilism of high art (and

the marketing that goes with it) is its most striking feature. And if Kinmont and Ukeles share a specific quality, it is the humanity they bring to what they do. There is no posturing, no affected strangeness, no sense that the artist is watching him- or herself on a monitor somewhere. Their personal warmth is magnetic, and that they choose to perform acts of caretaking yields a compelling aura of comfort that one doesn't usually find in the normal course of social interaction. One thinks of the words Dickens puts in the mouth of his miser in "A Christmas Carol": Your business should have been humanity!

It's Easier To Talk About Art While Washing The Dishes was presented at the Wadsworth Atheneum Museum of Art on the same occasion at which a new Joseph Cornell acquisition was announced. Kinmont, who considers himself a sculptor—although his medium, in his own description, "is the space between you and I"—has a special affinity for his shy predecessor (it was Kinmont who informed me that Cornell made his boxes to entertain his disabled brother). Having his work come to the museum in conjunction with a Cornell was "titillating," Kinmont told me in an interview. Cornell was an influence and an inspiration, although, he says, "One couldn't make a Cornell box today."

"I feel a kinship. For every artist there is some influence that is inexplicably more important than a hundred other artists. Who can say why? Louise Nevelson was doing constructions about the same time [as Cornell]; so were Karl Schwitters, Man Ray. But for me, Cornell's work has a quality of implosion—you fall into his boxes, because of the scale. My own works are contained in boxes [on video tape and by way of documentary memorabilia], but they explode outwards. They are similar in that they create a narrative and they also depend on what you pick up or don't pick up of his details."

<div style="text-align: right;">

Ben Kinmont. *It's Easier to Talk About Art
While Washing Dirty Dishes*, at the Wadsworth
Atheneum Museum of Art Café. April 1997.

</div>

The Question of Sculpture—and Reality

Bryan Nash Gill

As a farm boy and an outdoorsman, Bryan Nash Gill's connection to landscape is visceral. What is so interesting about his sculptural forms is how they spring from things that already exist, things that he persuades to work with him without deforming them in any essential way. His inescapable naturalism is driven by a close connection with which the naturalist experiences the world around him. A viewer must enter his world, of course, and get over any conventional expectations of what sculpture is supposed to be (figurative and dramatic, say, like Rodin or Michelangelo), but once you do, the trade-off is gratifying.

I find it interesting how elements of installation, found objects, craftsmanship, and conceptualism all inform the idiosyncrasy of Gill's art. For example, his drawings of woods (which are not described in the essay that follows) are strongly akin to the panache of abstract expressionism—lavish, tangled muscular sweeps—although they are executed in such materials as turpentine and wood stain.

Every aspect of Gill's approach ties together the real world (nature, both material and contextual) and the abstract world (geometric simplicity, intellectual coherence, dialectical relevance).

"Wheels in the fields" was a descriptive phrase that struck a chord in one of Bryan Nash Gill's graduate school critiques at the California College of Arts and Crafts. Here was an image that resonated—old farm implements rusting amid the rising growth of a farmer's field—confirming a tie to the deepest roots of his experience. It was an image this Connecticut farm boy had carried in some forgotten back pocket as he peregrinated from New England to New Orleans (to study glass blowing), to Italy (to study stone carving), to California (where he sought to discover the difference between art and craft), and to

various primitive cold-water studio/aeries in Colorado deserts, on California mountainsides, in lower Manhattan, and in the northern extremities of Maine.

After sixteen years, it was a vision that beckoned him home to the farm in the western Connecticut hills where he grew up, which he has since bought and converted into a home and studio complex. For all the study and experience he gathered in his travels, returning to New England, to its woods and its history (both geologic and anthropologic), was to inspire his mature vocabulary as a sculptor by connecting him to the deeper roots of his native sensibility. His most telling work from this time—comprising forty-two Christmas trees suspended upside down in echelon, *in situ,* above the floor of the forest—contained many of the elements that would come to characterize his approach.

For the first time in his career, says Gill, "I wasn't making something for somebody to buy. I wasn't making something to please somebody else. And I wasn't 'making it big, painting it red, throwing it in the field and calling it art.' The only people who saw [that work] were people whom I brought to it, or who stumbled upon it, like my family when they cross-country skied or walked in the woods. This was very uplifting, very eerie."

Gill is a lifelong woodsman, hunter, and naturalist, and this approach directly incorporated the sensitivity of a life lived out of doors with the experience of making art, which for him was a matter of upending convention as a way of activating new awareness. His is art that explores not only how a piece of sculpture is encountered (via inadvertent surprise and in a real-world context; deconstructed in a gallery), but also how art stands (prone, inverted, or aloft). Metaphorically (as well as actually), such works also account for the poetics of time and the fluidity of transmutation: by the quiet shedding of dead needles amid towering living specimens; by demarcating the temporary scar a blown-down tree creates in the living fabric of a woods; by reconstructing a fallen timber from its bark; by translating organic forms into bronze or imprinting growth rings onto paper.

Since his return to Connecticut, Gill's art—its medium, its metaphor, its syntax, its meaning—has been grounded, in the most deliberate way, in nature, particularly the grown-over woodsy tangle that is still characteristic of much of the rural Northeast. But this art is equally engaged in his tireless investigation of the evidence of time, of life cycles, of human labor and its evocation in art.

Although he is also a printmaker, Gill works largely in wood, gathered in winter forays and sledded back to his studio over snow-covered ground. He takes apart logs and branches—even whole trees—and then reconstitutes them in the studio, employing any process that suits: splitting them, slicing them,

Bryan Nash Gill, "Blow Down," 2000. Fir bark, 42 feet long. *(Courtesy of the artist.)*

carving back into them, stripping them of their bark, flattening the bark, even casting elements in bronze. Gill's is an artistic language doubly informed—by nature, certainly, but also by the conventions of art history that he discovered as a student. His metaphorical subtlety, combined with his feeling for material richness, his capacity to deconstruct and recombine, coupled with a special sensitivity to physical setting are what set his work apart.

First and last, position is central to Gill's concept of sculpture, which he describes as paying attention to the way things stand up. In a work like *Twins*, a bronze that was cast in 2000, he conjoins two sapling trees butt to butt, laying the line of their married trunks laterally above the gallery floor. The choreography of the slender woody limbs presents itself in a kind of visual *pas de deux*—a double helix of extended "arms" and "legs," the center line of each crown arcing gracefully, the central passage balancing tippy-toe on slender branches. On the shiny gallery floor, the impression is doubly evocative: like a glimpse of mating dragonflies hovering over the reflective surface of water.

Frank acknowledgment of genesis, both actual and associative, is an enriching cornerstone of Gill's approach. He often employs bronze casting (a technique that creates a mold around an original form constructed in wax—or in this case, wood—which is burnt out, leaving a hollow to be filled with molten

bronze), an ancient technology first employed in prehistoric times. Because the mold is intended to be reused, it is constructed with seams by which the form can be taken apart and put back together. Leaks of the bronze in the pouring process create little flaps called "flashing" that are traditionally filed down to finish the form. For Gill, however, these delicate flaws, surprisingly leaf-like, are an aspect of the final form—evidence of the process that gave rise to them and also suggestive of the new growth that sprouts from the crusty surface of an old tree. In the same sense, Gill's sensitive manipulation of patina (tarnish that forms on the surface of bronze and similar metals, produced by oxidation or other chemical processes) orchestrates a credible organic impression, which is only enlivened by occasional glints of polished bronze.

"I like the [cast] objects to have flashing and I tell my [foundry man] to make the mold weak," says Gill, "Then I edit the flashings, or the air holes, or what have you. It gives the object its own history; it's not like this brand-new polished thing. Even though out in nature there are brand-new polished things emerging all the time, I like the decay, because it has that sense of the whole cycle: it was green and young and now it is dying."

Often Gill's work creates a dynamic tension between artistic processes and nature's. A series of Gill's early carved pieces manages to "free" melon-shaped balls within the sinuous branching of tree forms—creating "peas" in cage-like pods via a subtractive sculptural process, as well as providing a wry restatement of Michelangelo's great metaphor for the art of carving: that within each raw block of stone there exists a beautiful form, and the artist's role is to free that from a crude prison, to give it life.

In *Blow Down,* a work from 2001, Gill skinned an entire spruce tree of its scratchy hide, which, after being flattened under weights for a year, was then tacked to a series of wooden stretchers and mounted in a continuous 43-foot stretch to the gallery wall. In exhibition, this work is striking for the conflict between artistic foreshortening and the realities of a tree's living proportion: the diminishing circumference of the tree rising from root to crown (actual) is equated with the triangulating convention of perspective (an artistic device used to create the illusion of depth in a drawing or painting). By flattening the tree bark, the artist gives it back to us again, as drawing would do (appearing smaller and smaller as it "recedes") but also as we would experience it in the woods, tapering to the limit of our powers of sight as it rises out of view.

Back in the woods, near the studio that Gill built for himself out of hemlock and pine cut and milled off the property, the artist has marked the location of the fallen tree by laying out a garland of grape vines that circles the up-tilted

stump and its roots, "drawing" the gap on the forest floor. In so doing, Gill in a modest way continues his ongoing, personal conversation with the natural world, spiritually in keeping with the unnamed artists of Stonehenge on the Salisbury plain in England, the Great Serpent Mound in Adams County, Ohio, and the image of a hummingbird created by Nazca culture in Pre-Columbian Peru. These all constitute a silent artistic conversation with the cosmos, in this case marked by a spill of light created by the break in the overshadowing canopy of trees—acknowledging the gift of the tree in absentia.

Bryan Nash Gill. *Recent Works*, at Real Art Ways,
Hartford, Connecticut. 2001.

Nene Humphrey

When I first met Nene Humphrey, she was working in cast iron, fashioning leg irons and manacles, neck collars and "crowns" out of forged metal bands, referencing constraints devised during slavery times and creating objects that defied the usual definition of sculptural form. She did not sculpt the human figure; these were "figures" more evident in their displacement than by their representation, thereby implicating a viewer as the "subject." It is work that one reads with a twinge in the wrist and ankle; work through which viewers may sense how their own bodies would fit in the torturous cavities of the imprisoning devices that Humphrey suspended from the rafters and the walls of her studio. Over the years, her medium has changed dramatically, narrowing to an ever more subjective perspective. Still, she continues to beckon viewers to stand inside the work, to read it with their sense of touch. As a woman artist, Humphrey speaks to the course steered by a different voice, meaning other than what the conventional artist (historically a male) envisions as aesthetic experience: that is, objective, hierarchical, rational. Instead Humphrey strives to provide an interiorizing point of view, a place from which one can discover both the clear center and the unfolding reach of her art.

When you grow up outside the nexus of a big city, as farm kids know, there can be a kind of productive isolation—the freedom to explore the world while encumbered by less self-consciousness. For Nene Humphrey, who

was born in Portage, Wisconsin (population 7,000), childhood experience has translated to privacy of viewpoint.

Her notion of creativity was not fashioned by an academic model but by the example of charismatic relatives, among them a grandmother who spun fabulous stories ("Harry Potter had nothing on her," says Humphrey) and a Pied Piper of a businessman/uncle who carried a menagerie of toys in his briefcase.

"I grew up loving to draw and paint and make things, [but] I didn't have good teachers in high school," she says of her early encounters with art. "I was very much alone, although my parents encouraged me. It was my father who said, 'Try college.'"

There was a tug, however, to get somewhere. "I always had that thing," she says, "about going to New York . . ." This impulse took her to St. Mary's College in Notre Dame, Indiana, for a bachelor of arts, then to Goddard College, in Plainfield, Vermont, for a master of arts, and then to York University, in Toronto, Canada, for a master of fine arts.

In the fall after she earned her M.F.A. at York, a MacDowell Colony fellowship brought her, finally, to New York. A series of additional grants—a Rockefeller Foundation Fellowship, an Individual Artist Grant from the National Endowment for the Arts, and an award from the Anonymous Was a Woman Foundation—fueled her continued exploration.

Throughout this journey, she remained attached to the tactile as a means of entry. The recurring motifs of her sculpture are resolutely connected to the human body—to the circumferences of human form, its hollows and its surfaces, and the mystery of its outward appearances and inner universes. Her materials are commonplace and her forms deliberately accessible, but they are also haunted by the cosmic and full of cellular mysteries.

Hospitalization for a serious back injury and several months of subsequent confinement several years ago turned Humphrey's focus inward and returned her to sewing, which is the primary vehicle for her 2003 work *Small Worlds*, which was included in *Sight and Insight: An Assemblage of Artists* at P.S. 1 / MOMA in New York.

After an artistic orientation that has evolved from two dimensions to three, from optical to tactile, from external to internal, from embroidery hoop to blacksmith's shop and back again, Humphrey has positioned herself at a fluid point of intersection between absolutes. Her work wrestles with contradictory polarities: crimson lichen and old ladies' hats; petri dish colonies and astral constellations; red silk corsages and blood-tainted bandages. Her works vault

Nene Humphrey, "Around the Edge," 1993.
Installation detail. Steel and wire; 31 units, 104 x
67 x 33 inches. *(Courtesy of the artist.)*

between analogies in time and space, yet remain resolutely in our laps, confidentially close and unreachably far.

Humphrey's *Small Worlds* pieces do not yield to an objective glance. This is handwork, detailed and intricate, and you must look closely to see what's involved. Its mysteries are revealed in quiet ways. Her forms result from obsessive small-motor processes and engage conceptual and formal elements in the tangible ways that have long been her emphasis.

Her work suggests everyday verities: prom dresses and bedroom slippers, needlepoint and embroidery, pinpricked fingertips and patient conversation over fairy tales. Material fact is the resonant clue to this work's meaning: red silk organza, felted wool and satin ribbons. Everything is stitched together with visible needles and silken threads, the accoutrements of domestic craft, yet all is imbued with the implication of hemoglobin: bright reds, flush with oxygen; deep reds, clotted and saturated. Her circular formats suggest a map, a womb, a biopsy slide.

Humphrey's associations divide and multiply. In the age-old way of traditions that pass from mother to daughter, one can follow the evidence of Humphrey's touch. Suggestively, in *Pierced Red* needles activate the analogy, swarming like spermatozoa in a bowl of felted wool. In *Loculus #8,* a massive three-part wall hanging, silk threads follow like jet trails in the wake of organza disks the size of half dollars, each one skewered into its position—right through the felt pad into the wall—by the needles. The result resembles a strategic war map—or

bloody fingerprints on a clean white quilt. And with a resemblance to a number of Humphrey's earlier works, an embroidery hoop of silk organza, painted with curling tendrils like locks of hair, projects a silvered, ghostly image—the surface of the moon—against the gallery wall

Humphrey's visual language is based on osmosis: she simulates exchange across membranous divisions. While her *Small Worlds* pieces reflect her investigation of dying needlecraft traditions among marginalized ethnic groups in southwestern China, this work remains wholly personal, visualized from some carnal center rather than from an outside point of view. What she renders is in solidarity with a history of invisible labor; she honors that attentiveness and that touch. This is unapologetically women's work—organic, refusing the affectation of impenetrability. These sculptures bristle inward and outward with thousands of thronging pins. They bloom in roseate exuberance, as echelons of tiny buds march across proffered surfaces.

What is so interesting about Humphrey's work is the pensive intimacy of its vocabulary. History is held in a thread. Memory is a surface described in a woman's terms. In these hands, skin is not another kind of armor, but is actualized as membrane—porous and cellular, a means of connection as well as separation.

Nene Humphrey. *Small Worlds,*
at P.S. 1 / MOMA, New York City. 2003.

Iñigo Manglano-Ovalle

An Iñigo Manglano-Ovalle installation at Real Art Ways was a persuasive introduction for me to the power of installation. The experience of walking into this work was both shocking and illuminating, but also uncannily beautiful. Additionally, it was seductively visceral, even though it maintained an emotional distance (no preachy introductory wall text)— leaving me alive to my subjective and objective responses at the same time. The central strategy of installation invites viewer immersion rather than setting the perceptive experience apart by putting a crafted object on a pedestal or designating an image a work of art with a decorative frame. Instead, the artist devises an extension of the viewer's own, living spatial context, playing not only to the optical, but also to the kinesthetic, the tactile, the auditory, even the olfactory senses. There's a delicate balance that must

be achieved—beckoning the viewer into someplace strange without scaring
him/her off—and this negotiation between the compelling and the off-
putting, at its best, is one of the most indelible of stage-managing feats.

The multimedia installation *Blooms,* which I saw at Hartford's Real Art Ways
in 1997, was an exhibition of unavoidable immediacy. Iñigo Manglano-
Ovalle's installation, as simple as it seemed at first, was tautly orchestrated,
vividly real in its elements, dreamlike in its fragmented delivery. This work
was not so much something you see as something you sense involuntarily—by
sense of hearing, by sense of touch, by sense of threat. Chilling, poetic, *Blooms*
occupied its former typewriter-factory gallery space like a living thing.

Manglano-Ovalle uses sound as a sculptural element, providing physical
connection between the literal, figural, and contextual aspects of this medita-
tion on violence. From the first instant, at the doorway, you are warned off by a
dog's bark from a video monitor mounted at knee height. Then, on entering the
dimmed light of the main gallery, you are enveloped by the throbbing heartbeat
of an unborn child.

This sound, comforting and also disturbing, originates overhead, muting
all other distractions and creating a sense of interior space somehow more pal-
pable than the gallery's architectural framework. By blocking out the external
world, the sound focuses you inward, and you become aware of your own pulse
responding in tempo.

The stage is thus set for the next layer of experience in the adjacent gallery,
which is dominated by a visual situation that is beautiful yet ominous. Realiza-
tion arrives in rapid sequence. The first impression is color—four rectangular
blocks of luminous gelatin; then the recognition of position—the blocks are
set out belly-high; then the dawning implications—these jellies are laid out on
narrow slab tables, arranged like oncoming cars at a four-way intersection. It is
as you step close to study them that the elements come together: these gelatin
blocks (which the artist gave color) are forensic tools employed in police bal-
listics tests. Each one registers about the scale and heft of an adult's torso. As
you step near to study the glowing colored blocks, you finally detect bullets
streaming towards you, frozen in mid-flight, their blunt noses smashed into
mushroom blooms. Like a vapor trail, the spiraling helix of the bullets' paths
cut through the thick mucus of geometric blocks.

A viewer needs no wall text here to make the point, merely the gut's empathy
with the pulpy, bullet-riddled gel. The relation between heartbeats, raging dogs,
gang colors, cold slabs, the traveling bullets, and the intersecting trajectories

Iñigo Manglano-Ovalle, "Dirty Bomb," 2008. Painted fiberglass and aluminium, sand and steel weights, chain and hoist, and mud, 128 x 62 x 62 inches. *(Courtesy of the artist and Christopher Grimes Gallery, Santa Monica, CA.)*

need no verbal translation and, by avoiding any explanatory lecture, the artist ensures that these references claim their power. Rather than separating a viewer from the violence that spurred creation of this installation, Manglano-Ovalle invites the viewer in to examine the evidence; only once they are positioned at the center of the "intersection" do viewers discover themselves in the line of fire from all sides.

While the visual imagery is instantly apparent, the layers of significance that "bloom" in this piece continue to unfold in other parts of the installation. The green and orange of the gelatin forms, for instance, represent opposing gang colors. These colors—orange, then green, then orange, then green—are cycled in video loops that document the progressive bloom and retraction of a hibiscus blossom, in turn timed to the recording of a fetal heartbeat.

This is an exhibition of tremendous formal simplicity. In an interview with me, Manglano-Ovalle speaks of his respect for minimalism: "I cut my teeth on it," he says. But in *Blooms* his forms also defy the pretensions of that movement's other-worldly aesthetics. Minimalist sculptor Donald Judd may have worked in similarly rectangular, light-catching forms, created by machinery, and untouched by the artist's hand. This is an intentional reference: Manglano-Ovalle was inspired by Judd's hands-off artistic process, although the younger artist takes nothing of the older artist's emotional removal.

For Manglano-Ovalle, the point is not aesthetic transcendence, but documentary social commentary. These are real bullets, fired out of real guns, impacting gelatin designed to simulate the density and viscosity of human tissue, and they evidence the latest in ballistic science. *Blooms* may be an outgrowth of years the artist spent working with gang members from Chicago's West Side, but his work implicates all of us. The experience of gun violence is laid directly at our feet, as we stand in the shoes of its victims. "It is important," Manglano-

Ovalle told me, "not always to have urban youths—and urban youths of color—be the subject."

Blooms (which takes its name from the test to measure the strength of a gelatin), demonstrates that the language of fear and violence, of physical and psychic vulnerability, can be universally understood. The impact of an installation like *Bloom* testifies to the fact that for any of us, our bodies are instruments that register the damage.

Iñigo Manglano-Ovalle. *Blooms,*
at Real Art Ways, Hartford, Connecticut. 1996.

Guns

The following essay places side by side two viewpoints on the legacy of Samuel Colt. One of these was housed within the Wadsworth Atheneum Museum of Art, enshrined with all the curatorial panache that usually attends a major exhibition; the other was sidelined, outdoors, an uneasy (and not so complimentary) commentary on the implications of his "legacy" with respect to Hartford's gun magnate. The inside show was replete with evidence of Mr. Colt's material success and focused on the artifacts that he and his wife accumulated over the course of their lives together. As such, this is a time capsule of the city of Hartford in the mid-nineteenth century, a compendium of upper-class style and Victorian good taste.

Bradley McCallum's installation piece, by contrast, focused on guns themselves, invoking contemporary state strategies of firearm seizure and collection. McCallum's piece was a collaboration with current Hartford residents, whose tape-recorded stories of friends and family members lost to gun violence provided an accompanying narrative. The end product of McCallum's collaborative effort is powerful and compelling and public, although its creation poses another of the dilemmas of contemporary art thinking—this artistic concept exploited the firsthand pain of those who contributed their testimonials to its narrative.

The differences are easy to see between the Wadsworth Atheneum Museum of Art's main attraction in the winter of 1997, which was the blockbuster showcase *Sam and Elizabeth: the Legend and Legacy of Colt's Empire,* and an

austere little sideshow by collaborative artist Bradley McCallum called *The Manhole Cover Project: A Gun Legacy*. It is the similarities that prove elusive, for these two exhibits share neither temporal context, artistic vocabulary, nor equivalent institutional backing. Yet it is what *does* link the two exhibits that turns the Atheneum's commemorative showcase into such a dramatic dialogue of past and present, and makes what might seem to be a trotting-out of home-town soiled laundry a significant cultural event.

The disquieting fact at the core of each exhibit—evoked in the materials of Bradley McCallum's spartan manhole-cover installation, but intrinsic as well in the sentimental panorama of Elizabeth Colt's high-society artifacts—is death, and in retrospect, the question of how art strives, often movingly, sometimes ridiculously, to cheat mortality.

Colt's Empire is by far the showier event, given center stage, appropriately enough, inside the great gray neo-gothic Wadsworth Atheneum Museum of Art. Its panoply of Gilded Age decorative arts, including everything from nineteenth-century landscape paintings to engraved repeating rifles, sprawls into four galleries, with each object carefully documented and displayed with attention to a "breathing space" between objects that would have been unheard-of in the Victorian era. The fundamental spirit of Elizabeth Colt's collection was Romantic, typical of a time when art acted out tragedy in measured, theatrical poses—when a lock of hair or an embered, glowering sky was meant to render experience sublime.

Although Elizabeth Colt was not a victim of gun violence, she was married to the enterprise that put the revolver in the hands of Western settlers and paved the way for assembly-line industrial production. Daughter of an Episcopal minister, well connected to Rhode Island's social elite, her marriage to Samuel Colt gave her the deep pockets and social access to which this collection attests. Although privileged and protected, she was no stranger to untimely death. She outlived everyone she loved: two baby girls, her husband of six years, and the one son, Caldwell, who survived to maturity. The art she collected, the books she published, and the buildings she commissioned and oversaw with such a thorough, meddling hand, were intended as lasting monuments to her husband and their progeny. At a time when Hartford was a progressive and prosperous hive of activity, she was an active and generous sponsor of public works, including the Church of the Good Shepherd in Hartford—an edifice she envisioned as a place where all members of the Colt industrial enterprise (owners, management, and laborers) at the Colt Armory could worship together.

Wealthy, influential, and acquisitive, she left a vast repository of stylish artifacts, which constitute an effective (and curious) history of time and place.

Bradley McCallum's piles of manhole covers, stacked on the sidewalk around the corner from the main entrance of the Atheneum, also constitute a history, in this case a targeted and acquired one. Collaboratively developed with Jacqueline Tarry, McCallum's installation juxtaposes physical metaphor with personal tragedy. Minimalist in style, this installation, comprising four metal pylons and 228 manhole covers, summons the viewer to step in and acclimate. Like a Japanese garden, this is a hushed work that exists in nature, changing under different atmospheric conditions, over which the artist layers the quiet intonation of voices, each testifying to the effects of gun violence. The sewer covers, rusting into rich patinas, are piled like short stacks of poker chips. What unfolds is significance, slowly, detail by detail. These are not ordinary manhole covers, they are a "special edition," stamped with the year 1996 and the words MADE FROM 172 LBS OF YOUR CONFISCATED GUNS and HE WHO SUFFERS CONQUERS and HE WHO PERSEVERES IS VICTORIOUS.

There is an anti-aesthetic edge to the whole installation, which looks rather more like a misplaced shipment from a utility company than a work of fine art. Yet, unlike Mrs. Colt's creamy angels and gentle stone matrons, the drama in these forms is literally rather than figuratively personified. Four metal pylons rise like sentinels among the cast-iron sewer lids, defining the space and claiming it audibly by broadcasting testimonials of Hartford residents impacted by guns. In these first-person narratives, recorded by a crew of teenage summer interns, the voices of parents, siblings, friends, and health-care professionals permeate the sidewalk space. Like so many private conversation overheard anonymously, this collective chorus floats over the piles of cold, rusting metal.

These two exhibits speak the separate languages separated by a century of immense change and uncanny historical and economic inversions. The Colts lived in a time when great entrepreneurial patrons ruled the earth, lavishly supporting the work of artists and craftsmen. McCallum works in an age when artists must be entrepreneurs, securing funding where they can, persuading grant-giving agencies, private sponsors, and city councils to put down hard cash for abstract installations that might be contemplative and painful—neither quality an easy sell. Each century had its own vision of moral irresponsibility, reflecting choices made and options overlooked.

That Samuel Colt's legacy and Hartford's early prosperity are attached inseparably to the guns he manufactured is, of course, the unspoken yet not-so-secret truth of the Atheneum's central exhibition. Similarly, the testimonies of

The Manhole Cover Project acknowledge that those who use guns should know better, but misuse guns anyway—because they can. Equally haunting in both exhibitions is the specter of our whole society's moral impotence in the matter of firearms.

Mrs. Colt's personal pain was actual. However she may have leaned upon the fashion of the day (and whatever it may have lacked in terms of contemporary aesthetics), her artistic patronage was an outgrowth of legitimate feeling. That her wealth, based on the sales and marketing of guns, was the source of this expression is not the only irony, however, of this juxtaposition. McCallum's installation is current with the contemporary artistic practice; it is politically nuanced and morally positioned, but it is not an act of self-expression. In the vernacular of our day, McCallum and his collaborators speak for (or exploit) those who "have no voice," but it is just such pain that can garner public funding (if not congressional intervention). Moral irreproachability is a hard quality to come by in either instance, and the surest gauge of the costs that have always been attached to the creation of art.

> *Sam and Elizabeth: The Legend and Legacy of Colt's Empire*, at the
> Wadsworth Atheneum Museum of Art, Hartford, Connecticut.
> 1996–1997; and Bradley McCallum and Jacqueline Tarry.
> *The Manhole Cover Project: A Gun Legacy*, at the Wadsworth
> Atheneum Museum of Art, Hartford, Connecticut. 1996.

Faith in Art

One of the great shifts in thinking since the Enlightenment is the relative disappearance of religious imagery—once the centerpiece of artistic activity—among the topics taken up by artists. Once a primary source of patronage, religious art has been shouldered back by a compelling press of secular subjects and contemporary social concerns. Because of its connection, often, to organized religion and ritualized practices, sacred art tends to be traditional (conventionalized) in character—which is all the more reason that the show I write about in the following essay was so surprising.

Surely no one considers this an age of faith, certainly not if your measure is what you see in contemporary art. Spirituality may still be considered a

sweet dream, but it is far from the central premise of art in America's ever-so-secular society.

At the Aldrich Museum, however, they've gathered a group of artists who would have us take a minute and think about faith, to consider not only what it is, but also what it *isn't*. For that meditation, we are given objects that variously stir meaning or stir critique, that give us occasions for insight into where faith might dwell and where it certainly does not dwell. In this exhibit, inanimate objects wait for our identification and emotive projection, while animate objects perform strange little mystical dances for our perusal.

For the most part, there is no escaping the artist's self-conscious perspective, as if an announcement preceded each work: "I am a woman looking at art." "I am a Jew looking at ritual." "I am a Bible-thumping preacher 'witnessing' for religion." Or "I was a Catholic, but now I've got this problem with the mother church."

Take Linda Ekstrom, for instance, whose *Menstrual Blood/Liturgical Cycles* transmutes the notion of a ritual calendar in intimately personal—and primordial—terms. The elements in this work are profoundly private in their associations: squares of pristine white cloth, edged with tatting and stained with blood. Each of the small, numberless, handkerchief-size pieces is embroidered with a date; Ekstrom has kept an ongoing record of her lunar/menstrual cycle since 1994.

This is elegant, tough-minded work, knotted but clear in its principal metaphor, and, like many other feminist works, utterly self-referential and troublingly hard to stomach. This is a bodily metaphor all the more disturbing because it deals with a womanly secret that even in this age of sexual openness is loath to be aired in public. Still, if one is to speak in metaphor, how much more vividly could anyone represent the age-old, still fecund enmity between Eve and God?

Michael Tracy, in vivid parallel, goes macho neo-Baroque, constructing a chapel in a side gallery. He takes on ritual Catholicism in a theatrical, environmental way, fabricating a dark, grotto-like enclosure replete with multimedia effects and gaudy, intricate, and overblown figurative detail. One enters this grim, highly charged, candle-lit space armed with a critical historical perspective (educated by an explanatory tract on the history of Catholic colonialism in the Americas posted at the entrance) and therefore primed for a take-down. Entering, we are presented with the other-worldly nightmare of a Spanish mission, a stage set teeming with cruel and orgiastic forms. Tracy's installation is

Linda Ekstrom, from *Menstrual Blood/Liturgical Cycles,* 1994–98. Menstrual blood on silk, with text and wooden tables, 4 x 8 feet x 31 inches. *(Courtesy of the artist.)*

a sexually charged, testosterone-fueled nightmare, decorated with sprouting phalluses and twisted human features that are tortured and mutilated with daggers and needles. In an approach that is in many ways as personal as Ekstrom's, Tracy plays a sinister tune upon the Counter-Reformation's artistic instrument, ecclesiastical environments that employed art to vivify religious experience via lavishly environmental, multisensory methods.

Other works in this show embody faith as an elemental force, as water or sound. The most memorable of these have a quality of unself-conscious restraint in their substance as well as in their presentation. Nicholas Kripal, for instance, presents inverted, cast-concrete basins (modeled after four Italian cathedrals) brimming with water. Like proffered holy water, these cruciform troughs stand as mute witness to the miracle of faith: it simply *is.*

Jaume Plensa provides great brass gongs—one inscribed with the word "born," the other with "die"—and a mallet. When struck by a visitor, these great baritone voices tremble the air, the presence of sound erasing all but reverie.

Around the corner, in a tiny adjacent gallery, is Diane Samuels's *The Alphabet Project,* which builds an allegory on a folk tale: the exchange between a famous Kabala scholar and a man of simple faith, whose prayer was, "Dear

Nicholas Kripal, "Fleisher
Sanctuary Font: Cathedral of St.
Mark's, Venice," 1998. Sculpture in
Fleisher Art Memorial Sanctuary,
Philadelphia. Cast Concrete, terra
cotta, water, 25½ x 27½ x 34½ inches.
(Courtesy of the artist.)

God, I do not know how to pray. But I can recite the alphabet. Please accept my
letters and form them into prayers."

In a small space, installed simply with a table and a chair, Samuels displays a
beautiful cloth book, delicately machine embroidered and hand-assembled, its
pages featuring twenty different linguistic alphabets alternating with the prayer.
As you come close to read, you enter an environment of sound, as you become
aware of the sound of recorded voices, old and young, male and female, shuf-
fled in random overlay, all reciting the texts in their separate languages.

So it must be with God, surely, if there is a God: our voices rise, randomly
layered and beautiful, to divine ears. Here the comfort of faith is depicted by
satisfying the senses—touch, sight, hearing, all together—thereby touching the
soul with an elemental, wonderfully mystical light.

*Faith: The Impact of Judeo-Christian Religion on Art at the
Millennium,* at the Aldrich Museum of Contemporary Art,
Ridgefield, Connecticut. 2000.

Do They Still Call It Painting?

Jacqueline Gourevitch

I first encountered Jacqueline Gourevitch's work in Avery Court at the Wadsworth Atheneum Museum of Art through the medium of a vast, eleven-paneled painting entitled Notations, *which occupied two walls of that grand exhibition space and cast a pewter-colored aura over one whole corner of the space. For all its quiet, this work was persuasively present— full and lush, resonant in the way of a sustained musical tone. Although I had gone to the Atheneum in search of other exhibits, other works, this was the piece that managed to register most memorably on my eye.*

Often it is these "backdoor" presences that remain with me. I have learned to pay attention to such impressions, because they insist on persisting, really. Only later, at an opening in a small gallery, was I introduced to the way Gourevitch thought about her aims. An artist's statement is not always useful, and can sometimes be decidedly off- putting, but in this case Gourevitch's words offered a lucid affirmation of what I'd carried home from that original impression.

Jacqueline Gourevitch's paintings pronounce simple facts in abstract lan- guage. In every salient way these works are alive: there is no touch upon her surfaces that does not call up experience, no color that does not sing, no mate- rial that does not breathe. With splendid economy and tough discipline, as in traditional Chinese calligraphy, in Gourevitch's work each mark serves a double purpose: rendering observation and creating observation afresh in a sweep of paint on canvas.

Gourevitch's images are visually weightless, abstract, but also very physical, coaxed from overlaid smudges and crackled with lines that fracture a shape without actually severing its pieces from their context. Yet her subjects—the

Jacqueline Gourevitch, "in flight 2.26.98, River," 1998. From the series *Terrain / in Flight*. Graphite, 14 x 11 inches. *(Courtesy of the artist.)*

sky, the spreading landscape seen from the air—are wholly factual and easily accessible, once one accepts their lofty viewpoint. As preparation for painting, Gourevitch's practice is to take a sketchbook with her into an airplane to record what she sees.

Ultimately, hers is a truant realism, too buoyant to be pinned down, a realism that denies the conventions of perspective. The truth of the matter is that from a bird's-eye view, there can be no such thing as a vanishing point—lest it be humanity itself, invisible from that distance. At 10,000 feet, everything is reduced to a map of lines and vaguely textured shapes, and the topography of a river valley mimics the patterning of a polished geode or the veining of a leaf.

Similarly, under Gourevitch's hand, earthly particulars leap together in wonderfully graphic shorthand. This is work that conjures sense-memory via the finest adjustments of color, veiled in dusty washes, tinged with sudden heat and leaking fire under the mist.

These are works about painting itself, in short, about *seeing*. They are technically accomplished, but also directly felt and produced with instinctive cor-

respondence. Marvelously, there is no sense of editing, no sign of over-painting or second-thought adjustment. There is an ease in Gourevitch's style, a surrender to optics—to sensations of silence and distance that she captures through the manipulation of tonality and color alone, meditatively, as a Zen master concentrates the growth of a twig into the swelling variation of the single stroke of an ink-laden brush. For all its simplicity, this work has the assurance of distillation.

The pleasure of art—like the pleasure of watching a child explore a world brand-new—is in being able to borrow a hungrier eye, to slip into a more sensitive skin. The naturalism of this work is to be found in its reduction, which is to say, its abstraction: the crack of a stone is telescoped into the path of a river, the haze of a distant atmospheric event is mirrored in the dissolving slurry of a puddle. Gourevitch's panoramas signal you to step back to see, but her work couches its effects in the intimacy of its close-up revelations. The color, while muted, toggles warm neutrals against cool. The effect breathes a sense of space into a flat image. These surfaces are dry and crackled, but echo geologic history by rendering floods of pigment. Gourevitch maps desert tracts and the stony striations, blurring the distinction. Allusion as well as material richens the effects. This painting does not proffer pictures of reality so much as reality itself—pigment, canvas, surface, chromatic shimmer—each a simile for the other.

This is the character of discovery in the work of Jacqueline Gourevitch.

Jacqueline Gourevitch. *Jacqueline Gourevitch: Recent Paintings*, at Paesaggio Gallery, Canton, Connecticut. 1996.

Zbigniew Grzyb

In the early decades of the twentieth century, Wassily Kandinsky was among the first artists who gave us pictures conjured out of pure abstraction or "non-objectivity," which he likened to music rather than to the conventional products of the pictorial tradition. A musician (and the child of musicians), a seeker after universal rather than literal truths, he was a theorist who proffered fresh insights concerning the possibilities of painting. In his writing about art, notably, Kandinsky's legacy is the language of analysis that still serves to describe work that

abjures reference to the external world. He was an artistic pioneer with
regard to abstraction, but through his use of language he enabled those
who followed to visualize a new pictorial reality—something that existed
within the context of the image alone. By utilizing the vocabulary of
music—tone, pitch, rhythm, improvisation, composition—the artist
signaled the affective (rather than descriptive) qualities of pictures. In so
doing, he paved the way for conceiving of such paintings as those created
by Zbigniew Grzyb.

Zbigniew Grzyb makes abstract paintings, as simple as that: huge, vivid, grainy, elephant-hide slabs of paint that seem to come to life as much through the sense of touch as they do through sight. These are not so much "pictures" as they are crusted, color-saturated, graveled surfaces, built-up muscularly, scribbled into existence with the artist's fist using pipe-size, crayon-like sticks of oil paint. Grzyb's paintings are impenetrably closed and, at the same time, astral, unfathomably open-ended.

What they are *not* is a window on the world; rather, they are a window out of our world. Even as they proclaim their physicality, announcing their colors to the eye like a spectral "sound," they refuse to mimic the human realm. There are no "actors" represented on these canvases, not even the ring of dots that is used to anchor the scumbled, textural fields of Grzyb's images; there is no stage set, no provision for a narrative script with a beginning, middle, and end.

This is abstraction, you see; you come into the middle, without the possibility of linear time, and if you find a "history," you bring that with you, just as, if you sense closure, you bring that, too. You are the viewer, alone, surrounded by these great, sensuous screens. The pictures themselves are a kind of reverberating barrage, a room full of fraternal siblings, if you will, shoulder to shoulder. Red, blue, yellow, green, they are twins in size, approach, and proportion, yet at the same time uncannily individual, all the more succinct because they stand side by side—their affect (hot, cold, sharp, dull, lyric, prosaic) magnified by their propinquity.

"A painting is not . . . when you finish," Grzyb told me in an interview. His day job is on the security staff at the New Britain Museum of American Art, and he is a graduate of the Academy of Fine Art in Krakow, Poland, who has been painting and exhibiting since he came to the United States in 1973.

"[A painting] is what's *going on,*" the artist explained, "some spiritual quality that you materialize. I don't paint color; I paint the *spirit* of color—its highest

Zbigniew Grzyb,
Untitled, 1996. From
series *Circles*. Oil on
canvas, 7 x 7 feet.
*(Courtesy of the artist;
photo: Michael Sundra.)*

potential. I love texture not for texture's sake, but for that sense of matter, that sense of touch."

As simple as each individual work may seem, he went on to explain, it is in his paintings' relation to each other that the drama is found. In the act of painting, that "spirit of color . . . gets a physical body.

"I'd rather create a universe inside myself than focus on the outside world," said Grzyb. "When I painted from nature, I felt like I was copying, that nature was in control. I try to find a dialogue between the works, to have the whole group under control, to move back and forth. It's an exchange experience from painting to painting."

"I want people to become part of my painting," he explained. "If the painting is small, sometimes people walk right by. I want them to STOP. There's something about monumental painting [that] you can absorb, even if you don't know about art. We all have the same senses. If you bring your innocence, you can be part of the pictures. [And so] we find ourselves connected to . . . the other side of the world."

These are works of bold dichotomy: images that suggest both cosmic distances (flickering constellations in a night sky) and microscopic realities (eerily lit bacteria scrambling in a petri dish). Assembled together in a single room, these great "windows" (as big as garage doors, variously 7- and 9-foot square)

reverberate in passionate counterpoint. These are furnace windows, if you will, battling for an impression, each radiating the particular color "temperature" that is its perceptual identity.

What are they about? Red, hot, and crackling versus red, bruised, and cooled with a tincture of violet. Marks that swim in joyful, molecular arabesques; marks that are suspended tautly in brick-like echelon; marks that dance on the surface of color like beads of water on a hot griddle. Yellow scratches that crawl across a black expanse, like a giant chalkboard written upon, erased, and re-written upon, maintaining mystery as well as immediacy.

The word abstraction means "dragged away," and abstract painting is an act of removal from the world. Some theorize that the impulse to abstraction represents a human wish to withdraw, or an expression of antagonism to the world; however, abstraction is not an act of abnegation but a resting place, psychologically pristine, cleansed of association with messy realities. Abstraction was an impulse that found special resonance in a century overshadowed by the very real threat of global annihilation. In abstract art, realities can be passionately tactile, emotionally eloquent, and perceptually engaging. Abstract paintings like Grzyb's enable us to "see" beyond the smoking rubble of present events into the hopeful clarity of pure aesthetics.

Zbigniew Grzyb. *New/Now: Zbigniew Grzyb,* at the New Britain Museum of American Art, New Britain, Connecticut. 2001.

Norman Lewis

One of the operations of time is the filtering out of names. The judgment of who will reside in the history books' main chronicle, and who will be relegated to footnotes, is a matter left to the arbiters of "significance," whose biases and enthusiasms direct the ranking of names. Issues of "quality" notwithstanding, the artists whose names persist a century later are not always the same ones who reveled in the consideration of their peers.

The following piece considers the work of Norman Lewis, an African American artist whose career was spent shoulder to shoulder with the big names in the Abstract Expressionist movement in New York—a man whose picture appears in photographs of that circle of painters in the

art books, but whose work never seems to get sustained appreciation.
His invisibility may stem from his independence; as an abstractionist,
he falls outside of the prevailing style of other noted African American
artists of the time, including Romare Bearden and Jacob Lawrence; as an
expressionist, he was perhaps too much of a real-world activist, rooting
his canvases too provocatively in the political to claim a purely abstract
motivation for his forms.

The news in Hartford, now that the exhibit of works by Pieter de Hooch (a relatively little-known seventeenth-century Dutch master) has closed, is that Norman Lewis (1909–1979) is coming to the Wadsworth Atheneum Museum of Art. Like de Hooch's, Lewis's is not a household name, but that is hardly his fault, if you have a look at his work. So take a deep breath and step up, for this exhibit of forty-five paintings and works on paper is the first comprehensive exhibition to examine Lewis's contribution to the post–World War II avant-garde in New York. This represents significant—and long overdue— redress for an artist of scope and intelligence. The Lewis retrospective also reveals this artist's determined prescience in anticipating some of the most volatile contradictions of contemporary culture.

This should be an important show. A look at these paintings might help to answer why Lewis has been largely overlooked historically, and at last raise the question of why that should not be the case. He was a first-generation abstract expressionist *and* an African American of note. Maybe this forgetting has been an operation of racism, or maybe not. What is sure is that Lewis was an artist whose aesthetic battleground (whether abstraction can be "pure" in the sense of avoiding "content"; whether social consciousness intrudes on "universal" forms) will seem far timelier now than was true in his day.

Lewis's work, like his career, is doubly interesting because for a black artist working at the cutting edge, the issues of personal freedom that lie at the heart of abstract expressionism's heroic style have special importance. Lewis's commitment to social activism in his life and dedicated abstractionism in his art may have set him apart from both the white circle of the avant-garde and the black artistic community in which he was such an active participant.

Lewis was a player in the world of the so-called New York School. He showed for fifteen years with the distinguished Marian Willard Gallery, where he had eight solo exhibitions. He was a member of the roundtable Artists' Sessions at Studio 35, a series of talks organized to define abstract expressionism.

Norman Lewis, "Echoes," (1950). Ink on paper. 19 x 24 1/8 inches. Edward W. Root Bequest. 57.173. Munson-Williams-Proctor Arts Institute, Utica, NY. *(Photo: Munson-Williams-Proctor Arts Institute / Art Resource, NY.)*

He presented his work with American Abstract Artists, a group that promoted abstraction in the 1940s and '50s. He was included in the seminal exhibition *Abstract Painting and Sculpture in America* at the Museum of Modern Art in 1951, in *Nature in Abstraction* at the Whitney Museum of American Art in 1958, and in the United States Pavilion at the 1956 Venice Biennale. He won the popularity prize at the Carnegie International Exhibition of 1955.

Yet Lewis's role in supporting the African American artistic community—and the nurturing role that community played for him—was equally important. He was active in the "306" group with Jacob Lawrence and Romare Bearden, the Harlem Artists Guild, and, in 1963, along with Bearden, Hale Woodruff, Charles Alston, and others, he founded SPIRAL, a group that discussed issues of concern to African American artists. He stood with one foot uptown and the other downtown. He asked questions that nobody else in those downtown Studio 35 sessions wanted to deal with—raising issues of social responsibility, for instance, in an age when artists claimed to be seeking a "higher ground" (which in those days meant far away from social consciousness).

Most striking in this retrospective show, then, are those works that intimate what was happening in the Civil Rights Movement, even if this allusion is managed by the naming of a piece rather than the illustration of a scene. This is the crux of Lewis's abstraction—wholly personal, evocative, and only obliquely representational. Titles for visually enigmatic works, such as *Alabama, Ku Klux,* and *Orpheus*—and the fact that they are executed predominantly in black—are pregnant with the kind of double entendre familiar to us from black spirituals

and the blues. These works, in particular, bring Lewis's art to life in the context of the present day.

The ultimate dilemma is that Lewis was problematic on two fronts. His blackness cast an inescapably deeper meaning over his abstract work, while his commitment to abstraction risked taking him out of touch with an African American audience conditioned to imagery that they could read and understand. Most of the crucial African American artists (look at Bearden and Lawrence), despite the abstracting orientation of their art, took the representational route. This was a strategy that enabled them to stay connected to the public audience in ways that abstraction would not have done. Lewis chose abstraction and stands in a unique place because of this choice.

Lewis defined his aesthetic on formal, subliminal grounds, evidently feeling that a focus on social issues would be limiting, likely to result in mere illustration. He cast his lot with the avant-garde, whose proponents voiced their definition of modernist abstraction, ironically enough, in language that springs from the argot of American jazz. Lewis may not have brought an African American audience with him, but he maintained a role in the heady dialogue of big league culture, pursuing the "universal" language that abstraction was believed to be, and determined to make his mark as an artist on the merits of his work. Meanwhile, many black people (including Lewis's own father, who insisted that "art was a white man's profession") felt that abstract expressionism was inconsistent with the African American experience, where real barriers existed between black and white access to "universality." Many today—people of color, women, homosexuals, the disenfranchised—would agree.

This is precisely what is so important about Norman Lewis's example and his work. We have his paintings, which go a long way toward telling us about this artist and what he meant to his times. These paintings have an extraordinary presence, even for those very familiar with the abstract expressionist movement, and they represent a grand, heroic leap of faith in the ultimate universality of humankind. Lewis's work is personal work, but it is also a kind of historic testimonial, a look back at what such an effort meant in this country in those decades.

Norman Lewis. *Norman Lewis: Black Paintings, 1946–1977*, at the Wadsworth Atheneum Museum of Art, Hartford, Connecticut. 1999.

Edward Dugmore

Edward Dugmore was a Connecticut boy who "made good"—who made it all the way to the artistic big leagues, so to speak. He had a respected career and supported himself with his art throughout, which most of us who are artists can only aspire to do. For a viewer, a retrospective show that celebrates the work of a strong but lesser-known artist is a wonderful surprise; since the images are unfamiliar and fresh to the eye, they enable us to experience the impact that new art provided at the onset of a movement, before it settled into expectation. When we are concentrating our looking only on the credentialed "greats," we typically come to the work expecting to see what we've been told to see. With an unknown artist, you can decide entirely on your own what's going on.

If you want to understand what painting is—or a least what it became in America by the middle of the twentieth century—you should look at what a hometown Hartford, Connecticut, boy spent some sixty years doing; for this is big-hearted, fill-up-the-room painting, marked with all the swashbuckling élan and billboard-scale bravado of the movement called abstract expressionism.

Edward Dugmore's retrospective exhibition, the largest to date in a distinguished career, also tells a particularly American tale of the pursuit of high art, come hell or high water—and in the twentieth century there was plenty of both. Dugmore's education as an artist was enabled by scholarships and the G.I. Bill. He pursued his own vision of painting, which meant abstraction, even though the cultural "weather" passed, over the decades, from cold to hot and back to chill. His style stirred, gelled, blossomed, and then deepened, but it never hardened into self-parody.

Dugmore (1915–1996) was born in Hartford and educated at the Hartford Art School; he received a B.F.A. in 1938, just as the Wadsworth Atheneum Museum of Art was experiencing its Modernist heyday under J. Everett "Chick" Austin. He then studied (as had his contemporary, Jackson Pollock) with Thomas Hart Benton at the Kansas City Art Institute, after which, following a stint in the Marines during World War II, he studied with Clyfford Still and Ernest Briggs at the California School of Fine Arts (now the San Francisco Art Institute).

Although he never attained great financial success as a painter, he persisted throughout his life and achieved ample critical recognition and a respected

Edward Dugmore in his New York City studio, 1983. *(Photo by Edith Dugmore, copyright Estate of Edward Dugmore, Manny Silverman Gallery, Los Angeles, CA. Used with permission.)*

exhibition record. He was never, however, a superstar in the manner of today's artist/celebrities, a fact that lends both credibility and poignancy to the genuine beauty of the Joseloff Gallery's retrospective.

What Dugmore learned from his times is in these paintings, and so is what he had to say. This is a grand, handsome, powerful show, and also, in its scope, as eloquent a defense of poetry—and the discipline of poetry—as one could hope to find from one visual artist's hand. Abstract but also palpably physical, it celebrates visual experience rather than laying out a translatable narrative, suggesting rather than denoting meanings in the loft, the heft, and the swing of his muscular application of pigment to canvas. Dugmore's work is a testament to lifelong conviction, and to focused intensity, but also to grace under fire.

One must see this show with its times in mind. There is, in fact, no way to escape that context. Dugmore's style—his tarry, scuffed surfaces; the great, blunt shapes he interjects into the field of the canvas; and his sense of weight and monumentality—emulates the work of a number of his contemporaries, particularly Clyfford Still.

Abstract expressionism envisioned its dominion as an outpost of individual-

ism—the realm of the solitary cry, experienced heart to heart. This was macho art, mute and physical, heroic in its striving and not celebrated for easy representation. As a movement, Abstract expressionism took pride in being labor. This is key to these works, certainly, for they proclaim that a painting is something *made*, that paint is physical matter like plaster and putty, drop cloth and wall surface.

To put this point most simply, in such painting the *act* is *everything*: form and meaning, cause and effect. Viewing these works requires organic empathy. One must experience these paintings in the muscles as well as the eyes; one must step into the artist's skin and feel the stretch of the stroke and the drag of the paint; one must relive the making of the painting even while drinking it in. The work is all subjectivity and all objectivity—the body's imagination perceived through sight.

What the Dugmore retrospective demonstrates is how this artist learned to slip from the confines of that skin, how he grew past his early, brawny style—so wonderfully fresh again in a revisit—in order to tighten the humming tensions of color into an entirely new kind of physicality. Dugmore's work, at first so muscular, becomes more coloristic over time, culminating in an exquisite, hovering tenderness.

As dynamic as the early work is, the later work takes flight. In the final turn of walls in the Joseloff Gallery, a viewer comes upon gauzelike screens of color, floating with bars and bricks of luminous color—skins like suede, all touch; like the misty mirror of a pond, deep and rising simultaneously. *Ancient Evenings, 1984* and *Untitled (White on White), 1988–89,* side by side, are configured like double beds, standing upright, colored like pearl and oatmeal, respectively, their colors aglow in that veiled context, less like material than like light itself. Then, from 1994, two years before his death, Dugmore offers *Infinity,* a work like a pewter mirror—haunting, opaque yet bottomless.

Painting like this is all presence: a wonderful, enveloping caress.

Edward Dugmore. *The Passionate Eye: Paintings by Edward Dugmore,* at the Joseloff Gallery, University of Hartford, Hartford, Connecticut. 1998.

Pamela Stockamore

*The absence of "realism" is an indictment that is often hurled against the
wall of modern art. When an audience is denied the expected conventions
that signal their lived realities—the indication of a horizon line that
separates "ground" from sky; the contrivance of overlap, or diminishing
size, or the relative clarity of nearness distinguished from the blurring
haze of distance that separate a "near" from a "far"—it charges a work
with impenetrability ("What is this?") and the artist with a dearth of skills
("My three-year-old can do this!").*

*Yet modern painters would challenge that the elimination of such
representational conventions brings into focus the truer reality of what
they do: painting is an act of its own, decidedly concrete realities. Paint is
a substance fabricated out of crumbled minerals (pigment), suspended in
some liquid medium (water, oil, acrylic), and physically applied (painted,
troweled, ladled, dripped, spattered, burnished, glazed) to some kind of
ground (wood, canvas, linen, paper). Likewise, painting has a "history"
that can be inferred from the visible evidence of the marks the artist leaves
behind. Reading an abstract painting, consequently, is an act of inference
and empathy, based on following clues much as an archeologist (or a
psychologist) might do. The lovely dichotomy is that only if a viewer can
remain within the confines of an abstract painting's physical realities—by
tuning in to the metaphoric sensation (rather than the literal translation)
of a work—can they discover the "meaning" of what's in front of them.
Wassily Kandinsky's famous rhetorical question to the skeptics who
insisted on asking what a non-objective painting was about was to direct
them to the experience of a sunrise. Do we need to have a science lesson,
he scoffed, in order to know that a sunset is glorious?*

The drama of Pam Stockamore's painting is imbedded in material. Her
works resemble hunks of corroded steel dragged from the dusty wreckage
of a construction site, but these are actually pigments on paper. It is impossible
to believe, by seeing, that these lavishly encrusted surfaces are not metal but
paper; or impossible to understand, despite what you see, that their crusted
patina is actually painting, not the bloom of corrosion or the cloudy darkening
of tarnish.

Pamela Stockamore,
Untitled, 1998. Oil and
dry pigment on paper,
38 x 38 inches. *(Courtesy
of the artist.)*

This is precisely the contradiction between this artist's sensibility and that of a viewer. This work is spare and geometric in form, but lush and suggestive in handling. Stockamore's pictures are Spartan in conception, constrained by two-dimensionality: square-on-square, with no preference stated between vertical and horizontal. They abjure any suggestion of meaning per se. They operate via sense-memory, negotiating the most personal and yet universal associations.

Stockamore's work demands the sort of perceptive process with which an infant or toddler, unschooled in what things are supposed to mean, explores the world. In her paintings, history is entirely physical, embodied in the *there-ness* of the artist's colored surfaces—which is not to say they are infantile. Despite the obvious but superficial similarities of her format (and her articulate obsession with color) to the paintings of Josef Albers (an important Modernist pioneer in color theory), the contrasts are instructive: where the Bauhaus master is supremely cerebral in his dialogue of colors in context, Stockamore is resolutely tactile. The difference is like the difference between architecture and biology. Albers's abstraction is an "academic" celebration of optics, an exploration of the way the human eye constructs its comprehensions of color.

Stockamore, by contrast, is tactile. She never leaves the perceptual realities of touch, and she celebrates the most ephemeral effects of light and matter. She rejects the coldness of minimalism by eliminating the reduction of "line" (the

pure concept of axial division) as anything but a material "edge." Her squares are corporeal, not hypothetical; temporal, and substantive, rather than conceptual entities. Stockamore's exhaustive exploration of the qualities of pigment enhances her pictures' emotional kick. By confining herself to a mineral vocabulary (pigment), she finds a lyrical, living dynamic—one that enacts decomposition, which is also growth.

Color is rendered as sensation: a blush, a sudden blanching. Much as they are perceived by eye, these images are understood by the memory of touch. Stockamore's color palette is geological rather than chromatic: neutral but also glimmering and iridescent, putty warm and leaden cool, inertly flat but also freshly mottled. These pictures come alive to light, much as the world is transformed at twilight and dawning. I once had a painter describe the colors of a ripe peach as a "sunrise"; here, the rusting, cruddy surfaces of what seems to be metal come alive in ruddy, crackled, lichen-like blooming.

In every respect, Stockamore's work is about painting, with no trace of that graceful, cinematic dance of figures and perspective space that is called narrative. Narrative here must be understood in the primeval sense, as that silent place where pigment absorbs the light even as it makes light dance. The science is factual: the eye receives only those spectral wave lengths that pigment disgorges; the give-and-take of mottled colors here creates the eye's retinal dance. Within a conceptual system that is taut, regular, and geometric, the artist has found another world of experience that is anything but coldly objective. Remarkably, in defiance of an aesthetic history that is pristine and cerebral, she creates an arena that is intimate and primal and fraught with intensely felt retinal drama.

Pamela Stockamore. *Recent Works*, at
Paesaggio Gallery, Canton, Connecticut. 1997.

Benny Andrews

Once you've overcome the idea that art resides in some kind of ivory tower guarded by a pompous few who were born "in the know," what may dawn on you is how much you've been missing. Some of the most lively and engaging work being produced today comes from resources and influences outside the realm of traditional art education. For example,

*Benny Andrews, profiled here, attended the School of the Art Institute of
Chicago on the G.I. Bill after a stint in Korea, and the character of his
work—its spirit—comes not from the formal education he received at an
elite institution, but rather from the energy and imagination that spring
from his childhood as the son of a Georgia sharecropper who used to sneak
out at night and "decorate" the sides of barns with brightly colored dots.*

*Andrews, who died in 2006, modeled for me the human values that
sometimes seem undervalued in more conventional approaches to artistic
career-building—which is not to say that he did not build a successful
career in the arts, only that making art was as intrinsic to his way of
going through life as was his generosity. Benny Andrews is a humanist of
remarkable dedication, ambitiously putting his efforts where his heart lies.
When people want to tell me what shysters contemporary artists are, I am
bolstered in my response by knowing such artists as Benny Andrews.*

Benny Andrews opens the door to his new/old homestead in Litchfield. He is
a slight man of unimposing stature, freckled and fair-skinned. A wiry goa-
tee and crinkly pale hair frame his triangular face. His features and his coloring
signal a mixed-race genealogy: African American, with a little Cherokee ances-
try mixed in. Beltless, in sneakers and a knit shirt, he moves with unobtrusive,
economical gestures that are accompanied by a mild, matter-of-fact voice that
reveals the cadences of his rural Georgia heritage. The old Yankee farmhouse
he refurbished with his wife, sculptor Nene Humphrey, meanders behind him
in a series of rambling sunporches and small additions. The pathway through
the house to his studio in a shed out back is a maze with low ceilings, narrow
and well-worn staircases, and abruptly shifting floor levels.

Like the house, the studio itself is immaculately tidy, with bits and snatches
of personal and artistic memorabilia—family photographs, sketches, small
hand-made objects, quilts, antiques—tucked everywhere.

"I haven't been here long enough for the clutter to really set in," Andrews
says with a smile. Until recently, he had lived part time in New York City and in
his native Georgia. Since 1993, he has lived in Connecticut, as well.

In the studio, large and small finished canvases lean in regimental order
against the wall. Works in progress, grouped by subject matter, are propped
on easels or turned face-out in clusters. On the floor beside the largest easel,
next to a pile of battered paint tubes tumbled together like a litter of sleeping
puppies, is a carton of canvas scraps: jigsaw pieces of old paintings cut up and
ready for recycling into new works. Energetic line drawings and oil sketches are

Benny Andrews, "Revival Meeting," 1994. From the series *Revival*. Oil and collage on canvas, 50 x 72 inches. *(Copyright the Estate of Benny Andrews; licensed by VAGA, New York, NY.)*

tacked to the walls, showing details of the characters who will one day make it into larger works.

The studio tells much about Andrews the artist and Andrews the man. His imagination is restless and diverse, observant and succinct. His human subjects range widely—from the highly specific and personal to the abstract and universal, from the humorous to the tragic. In a series of works he calls collectively *A Cat Can Look at a Queen*, he renders witty glimpses of "fine folks," including portraits-from-memory of Leonard Andrews (no relation) and Kathleen Jaminson, two of Andrews's prominent New York patrons, portrayed in uptown garb as if at an opening, teetering speculatively in formal dress clothes and (in Jaminson's case) high-heeled shoes. Given his success as an artist, the world of patrons is a world with which he is quite familiar.

In another part of the room, pieces by Andrews look back with a more evangelical eye at figures from the artist's country past. The subject here is old-time religion—"revivals," in all their charismatic extremity. White-shirted preachers gesticulate broadly. "Sinners" fall passionately to their knees, clutching spindly ladder-back chairs.

Among these works, in this corner of the room, I see the stark image that

brought me to Andrews's studio for this visit. It is not a monumental-size work, but it is a commanding one. *Fruits of Genocide* presents a chilling scene. Nothing prepares an observer for this work, as the eye takes in a series of trussed corpses hanging upon a retreating line of spiked and blasted trees. Weighted, anonymous deaths recede into distant, timeless silence. An artistic belly punch, this is among the pieces included in Andrews's 1994 exhibition at the Craftery Gallery in Hartford.

Benny Andrews works in collage, a method that "assembles" pictures by combining them from a variety of sources. Parts of the pictures are painted directly on a surface, other elements are cut from other paintings and pasted in. This composite approach allows the introduction of "real-life" materials, including patterned fabrics, bits of costume jewelry, zippers, buttons, segments of ribbon or lace, as well as recycled bits scrapped from older paintings. Andrews uses a zipper, for instance, to startling effect as the emphatically closed mouth of a black woman in *Shades,* a work that is in the Wadsworth Atheneum Museum of Art's permanent collection.

A perfectionist, Andrews works an image until it feels right to him. If it doesn't, he will scrap (literally, like a quilter might) an entire picture, saving only the face or hands of one of his "people." Nothing is sacred until it "works," even if this means dismantling supposedly finished paintings after they've already been exhibited.

"I really 'build' a painting," Andrews explained. "I work as much off the canvas as I do on—and only then do I paint. I'm suspicious of any work I do that seems to come easy. I'm not comfortable with what I know exactly how to do."

Collage, in other words, is Andrews's way of challenging the facile. Painting an exact landscape or portrait would be too easy. More importantly, using a single medium would mean losing a sense of rawness that Andrews feels is essential to art. In his first collage, a piece that he credits as his starting point, *Janitors at Rest* (done in the 1950s while he was still an art student in Chicago), Andrews included paper towels and toilet tissue in the painting of the genial old black men who cleaned up after the art students. To Andrews, these plain, factual materials were more truthful, more honestly evocative of their subjects than exact portraiture would have been.

While to most of us collage is a familiar approach from arts-and-crafts programs or elementary school art projects, historically the use of collage was a rebellious assault by artists resisting traditional modes of representation, which these artists considered to be mere "illustration." Collage challenged the idea of

illusionism as an artistic principle (if I paste a piece of tablecloth into this painting of a still life, and that tablecloth is imprinted with a photographic image of chair caning, which is more "real"—the cloth or the chair caning?) and proposed the radical premise of so-called "realism" as a construct, as mutable as any other. Such challenges ended the domination of naturalistic painting, and by the 1950s in New York, no prestigious gallery was showing figurative work at all. This avoidance wouldn't change until Andy Warhol came on the scene in the mid-1960s. While pop art returned art to the use of recognizable images, it also couched its imagery in the subjects and strategies of commercial advertizing, abandoning the pretensions of heroic subjects and classical treatments. Andrews stands apart from such trends.

"My work has always had the problem of where to place it," says Andrews. "Because I was working with collage and representative imagery, the reception from the representational camp would always be, 'Why don't you forget about the collage and just work representationally?' And from the abstract camp, it would be, 'Why don't you forget about representation and work abstractly?' Even now, abstract critics talk about the 'problem' of [my] subject matter, and representational critics talk about the inclusion of collage on what I like to call the 'sacred ground' of oil paint. No matter what, it seems to pose a dilemma to everyone."

Except Andrews. Set against the work of earlier notable African American artists, like Romare Bearden (1911–1988) and Norman Lewis (1909–1979) (see page 78), whose abstract riffs on composition dominated the impression of their imagery, Andrews's is a recognizably representational structure: he employs perspective, setting up complete spatial environments rather than employing fracture.

The specifics of Andrews's style—the special character of his personal form of collage and how he came to this approach—are rooted in personal experience, in his family upbringing, and in years of activism.

"Where I come from," Andrews explained to me, "there really was no such thing as an 'artist,' except what we read about or imagined one to be. I came from a family that just made things. There are a lot of reasons why. One of the reasons was poverty. We had nothing—so everything that went beyond the bare necessities we literally had to make.

"We were removed from the public, in terms of any kind of exposure other than our immediate environment," he said. "Our idea of the 'exterior world' consisted of what we heard on the radio, saw in the movies, or read in

magazines and newspapers. Our imaginations were formed by what was outside our everyday experience. So we created, in a sense, what we 'thought' was out there. We remade it, but we also recycled it. In a way, my whole life has been a collage. From when I was a kid growing up, my whole existence has always been fragmented—it has always been 'put-together.'"

A light-skinned, mixed-race child in the black community of his youth, Andrews then struggled as a young man to find a place as a black artist in an exclusively white art world. The son of a sharecropper in the segregated South of the 1930s, he heeded his mother's educational aspirations by completing high school and then finding his way to college, a goal unheard of in the rural community where he grew up, just outside Madison, Georgia.

Yet Andrews describes himself as a youth as "barely educated." The formal education he received as a child came only when he was not needed in the fields. Nevertheless, the example of making art was in his blood. He comes from a family of creative people, among whom he was recognized early for his ability to draw. His father, George, who did not share that facility for drawing, painted anyway and was well known in his home county as the "Dot Man" for a characteristic decorative motif. In his later years, George achieved recognition as a "folk artist" in the national gallery scene.

Benny Andrews grew up watching his father paint those enlivening dots and squiggles on any kind of object that was at hand, from a pocketbook to the side of a barn. Benny's younger brother Raymond, meanwhile, was a novelist whose first book, *Appalachee Red,* won the first James Baldwin prize for fiction. Raymond's suicide was part of what spurred Andrews to tackle the *Cruelty and Sorrow* theme for his Craftery exhibition.

Like his father, Andrews was driven from his earliest days to make his mark by recording and inventing images. There was no "art education" in the small country school where he learned his letters. There, the only recognition came from being invited to draw on the blackboard. No matter. Andrews had found power in his pencil. And he set his sights on achieving a formal education, "so that no one could lord it over me that I did not have these things."

Thanks to a stint in the Air Force in Korea and the G.I. Bill, Andrews got himself to the School of the Art Institute of Chicago, where he received a degree in 1958, one of a tiny number of minority students.

Then Andrews stepped out into an art world that was expanding rapidly and was fairly contentious, as different abstractionist groups vied for exclusive rights to dominion. From the onset, Andrews was not interested in joining a

crowd. To him, art had everything to do with self-expression and little or nothing to do with being part of a group. This is one reason that he has been an outspoken voice for individual diversity in the exclusive circles of the New York City art world since the 1960s.

In 1969, Andrews cofounded the Black Emergency Cultural Coalition (BECC) to protest the Metropolitan Museum of Art's controversial exhibition of black art, *Harlem on My Mind,* which many blacks regarded as cultural tokenism. From there, BECC became a mobilizing force for minority artists protesting de facto exclusion in national museums.

By the 1970s BECC had moved into prisons, after Andrews began a program of art classes for prisoners at the Manhattan House of Detention. As a result of its success, prisons around the country permitted such projects, and Andrews was invited to help set up a federal program.

Likewise, during Andrews's tenure from 1985 to 1988 as executive director of the National Art Program at the National Endowment for the Arts, that program reached out to encourage people of diverse ages and walks of life to "give them something that would stimulate their imagination," he explained, "and also give them a sense of the adventure of doing something."

Andrea Miller-Keller, Emily Hall Tremaine Curator of Contemporary Art (and director of the MATRIX gallery) at the Wadsworth Atheneum Museum of Art, describes Andrews as "one of the most articulate and passionate critics of this society's costly deviation from its avowed principles of liberty and justice for all."

In terms of his own reputation as an artist, Andrews's success has been made by slowly building up an audience and not by jumping on any particular critical bandwagon. His idea of success is to do what you believe in, tell the story you have to tell—in your own voice and in your own way. A minority of one, intuitively inspired, classically trained yet "poorly educated," Southern and racially mixed, neither abstract nor figurative in style, Andrews sums up his choices in this way: "When you're an outsider, you either go one way or the other. You either cross over and try to be exactly like everybody else, or else you just say, *'C'est la vie,* I go with this.' Lucky for me, I decided I had to go with me—with who I am, with what I am—and see it in a positive way."

Andrews remained committed to the idea that art is a personal expression, and this position has ultimately been well received. In addition to having works in the permanent collection of the Wadsworth Atheneum Museum of Art, Andrews has works in the permanent collections of some of the world's most

prestigious museums, including the Metropolitan Museum of Art in New York, the Hirshorn Museum in Washington, D.C., and the Overhollan Museum in Amsterdam.

Andrews's long association with Hartford's CRT's Craftery Gallery began in the early 1970s, when he obliged founding director Jonathan Bruce by becoming the first minority artist—and the first major name—to open at that fledgling gallery. There have been numerous exhibitions over the years. That he chose to inaugurate the series *Cruelty and Sorrow* with a Hartford audience is a measure of his connection to this community and an acknowledgment of his faith in the energetic showmanship of curator Bruce. This is also an expression of the artist's desire to speak his conscience, to keep faith with his beginnings, and to bring "home" to a living community the opportunity to experience art firsthand.

"With each of my series," Andrews says, "I try to start them out in a community environment. This one [is] introduced in Hartford, and then it will be slowly set up for its museum tour . . . I like to show in Hartford, partly because of the size of the African American community there, but also because a lot of the people, especially the older people, have had previous experiences that are similar to those in my works and can find ways to identify . . . Also, I have worked with Jonathan so much, and he makes sure that the community outreach part of the showing is responded to. He has curated numerous exhibitions of mine. He's a very creative person in terms of curating exhibitions.

"I have always tried to have it all, as they say," Andrews said, "to achieve equal billing and response from the established institutions but equal feedback from the community as well. Artistically, these kinds of community areas tend to get fragments of things that have been done before—that is, at best, some established artist prances out something already well known as a gesture to them. What the Craftery has been so good at is bringing something exciting out to those people."

It is not surprising that the audience Andrews seeks out as he prepares a series for exhibit is not critics. He would rather begin with people who will look at the work directly, who will not be distracted by erudite concepts. He wants feedback that is based on immediate human experience rather than academic study of artistic styles and history. For Andrews the real test of his work's authenticity is with African American communities like the one he grew up in, who will be able to tell him if these images ring true.

With *Cruelty and Sorrow,* Andrews brought to Hartford perhaps the most

challenging work of his career. Its topics, which range from personal grief to transcendent suffering, are challenging to an audience that is asked to relate to them. His knack, as an artist, is distillation—he does not work from observation, but from memory, by calling up a pose, a gesture, or a character that has gelled in his mind's eye, stripping from it all extraneous clutter. Like any good storyteller, he paints with a broad brush and an instinct for the narrative. His use of collage enables him to play freely with his cut-out salvaged "people"— plucking them from the bin next to his easel and pasting them in to the picture if the story calls for it. Like a writer whose characters already live in imagination, fleshed out and pressing to enter the story, Andrew negotiates with the living energies of the memory-figures, both the ones he freshly imagines and the ones that he has already made and keeps always at hand. His "environments"— buildings, pieces of furniture, fences disappearing into the distance—are shorthand props, placed into the blank white canvas like components of a minimalist stage set.

"Sometimes when I'm working I really do get a feeling about the characters in my paintings, they take on their own life," said Andrews. "Sometimes, too, I will be sitting at a cafe with my wife and I will say, 'Nene, look, there goes one of my people!'"

In *Cruelty and Sorrow*, Andrews's pictures look back grimly at characters from his southern past. "Mother Death," for instance, is based on a woman from the artist's hometown who had a knack of knowing when someone had died and who always showed up on the mourning family's doorstep with a houseplant. At once a harbinger and a confirmation, "Mother Death" turns up in response to the first whiff of death, bearing a spiked houseplant wrapped up in a jaunty red bow.

A series of twelve canvases entitled *The Stations of the Cross* follows the transfiguration of Christ. The first picture of the series is executed in dark, earthy colors and features Christ wreathed in thorns. In successive canvases, the wreath is rendered as a golden crown, then a halo, and is eventually dissolved into a golden mist. In this progression, we are reminded of the leaden weightiness of death and the Christian transformation to glory.

He tackles war from the perspective of a Korean War veteran, who learned from the experience, he told me, that the real tragedy of war is that the people who suffer the most from it are not even soldiers, but the civilians who have no way to escape from its consequences. There is no glory for Andrews's soldiers; rather, there is the personal experience of the battlefield, as in *Locust Study*, an

oil sketch of a bayonet-rifled soldier crouched in the glare of open light, trembling in his boots.

"So long as there are old men to tell tales of the 'glory' of the battlefield, and young men—and women, we have to include the women now—who have to prove themselves, there will be war. When I think of all those stupid John Wayne movies . . ." Andrews's voice trailed off.

"As an artist," Andrews said, "you must work with a certain amount of removal. But even so, I'm trying through these pictures to experience life in a real way—not as a voyeur, but having some identification with it. These images are a medium to express that.

"What I think will be important about this show," Andrews said, "is that it declares outright that cruelty is no longer an issue that can be hidden away. Right now, faced with worldwide cruelty, we are galvanized in our indecision, in our sense of ineffectiveness about what to do.

"In retrospect," he said quietly, "I would like to feel that no matter what the conclusions were, that at least I made a statement—that I made it clear that I was aware of this, and that I employed the profession that I represent to the best of my ability to say so. I ask myself, 'If I don't do it, who will do it?' I must do it. I feel it is time.

"It is time," he said, at the door of his old house in an old New England town as we parted. The times change, and he knows this, the son of a sharecropper who was the son of a plantation owner. For Andrews it will always be time, and he has used his power to make it time for us as well, by creating pictures.

Benny Andrews. *Cruelty and Sorrow,* at the Craftery Gallery,
Hartford, Connecticut. 1994.

What Do You Mean, Conceptual?

Sol LeWitt

Perhaps like the draftsmen who are commissioned to execute Sol LeWitt's work from a set of written instructions and diagrams (but who may never actually meet the artist himself), you may be wondering, who is this guy? His ideas' impact on twentieth-century art has been both profound and controversial, even in academic circles. Yet if you approach it with the thoughtful neutrality that it demands, the paradoxical character of LeWitt's art—that it seems so clear on the one hand (i.e., in the instructions: "ten thousand lines about 10 inches long, covering the wall evenly, black pencil") and is so impossibly complex on the other (resulting impression: a silken web of silvery marks, like mohair gauze)—makes curiosity acute.

Unless, that is, you refuse to cross that barrier between what many consider the definition of art (hand-made, one-of-a-kind works in traditional genres), for LeWitt's refocusing of attention to the intellectual rather than the manual takes one step too far into an art world where they do not want to go. For those people, LeWitt's departure from treasured artistic values opened the door to the greatest ill of contemporary art, its "unrelatability." Ironically, the first step in this direction was made during the High Renaissance by none other than Leonardo da Vinci, who relentlessly sought to elevate the status of the artist by arguing that the visual arts (then considered a manual trade) were an occupation fully equal to the liberal arts of literature, poetry, music, and dance. In the words of Giorgio Vasari, that great sixteenth-century chronicler of the Italian Renaissance: [Leonardo, in answer to a patron who complained that he stood too long lost in thought when he should have been

working] . . . reasoned about art, and showed him that men of genius may
be working when they seem to be doing the least, working out inventions
in their minds, and forming those perfect ideas which afterward they
express with their hands.

Sol LeWitt: a phrase of two words and three syllables, one separated, two attached, each beginning with a capital letter. Could be a witticism—"sol" (the sun) / pregnant pause / the Wit—but it might not be. Go figure.

Born in Hartford and raised in New Britain, LeWitt lived until his death in 2007 in Chester, Connecticut. If anything is true about LeWitt, it is that his artwork is not about *him,* it is about art, which he defined as a good idea generated into physical form. He conceived of the artist more along the lines of an architect, whose blueprints direct the construction of a building, or a musical composer, whose notations direct a performance, than as someone with skillful mastery. To LeWitt, art is the idea.

Or, as he wrote in 1969, "Banal ideas cannot be rescued by beautiful execution."

Or, even more pithily: "It is difficult to bungle good ideas."

So with calm wit and steady modesty, LeWitt quietly exemplified certain revolutionary principles (that art is about ideas, not their physical embodiment), forms (that drawing should be intrinsic to a wall, rather than "hung upon it," or if structural, embodied in self-effacing, non-aesthetic materials), approaches (that an artist does not personally produce the expression of his ideas), and attitudes (that art-as-concept is physically temporary, situationally flexible, and cannot be "owned"), the concepts that have so deeply influenced successive generations of viewers. Among these "viewers" are not only many of today's most prominent artists, curators, critics, and historians, but also (and to a remarkable degree) many regular folks—people outside of elite art circles who have had direct access to LeWitt's work at colleges and junior colleges, hometown museums and galleries.

And we mustn't fail to mention the art students and tradespeople who have volunteered or been commissioned to participate on the work crews needed to execute the monumental "wall drawings" (LeWitt will not call them paintings) and "structures" (he declines to call them sculptures) for which he has become famous.

In 2000, LeWitt was the subject of an encompassing retrospective, the artist's first comprehensive survey since 1978. This forty-year recapitulation, organized

Sol LeWitt, "Open Cube," 1968. Painted aluminum. 105 x 105 x 105 centimeters. *(Nationalgalerie, Staatliche Museen, Berlin, Germany; Inv. Sammlung Marzona 0341. Copyright ARS, NY; photo: Peter Neumann, bpk, Berlin / Art Resource, NY.)*

by the San Francisco Museum of Modern Art and featuring more than 150 works that represent every phase of the artist's career, was subsequently showcased at the Whitney Museum of American Art in New York. In concert with the Whitney show, Hartford's Wadsworth Atheneum Museum of Art featured *Sol LeWitt: Incomplete Open Cubes,* the first exhibition devoted entirely to that set of seminal works. This is a particularly appropriate effort for the Atheneum, which is the museum where LeWitt took art lessons as a child and to which he remained extraordinarily generous and accessible even after he became an artist of the highest stature.

What is revealed by a survey of LeWitt's entire career is how the pursuit of answers to direct, concrete, open-ended questions can yield formal solutions that are not only groundbreaking but also reach back in history. As utterly modern as his often sparse, architectonic forms may seem to be, they are not without relation to early Renaissance concepts of visual representation—emptied, of course, of the perspective illusion that was the fundamental premise of Renaissance artists' new approach to the visual world.

If a Martian, or a child—unaccustomed to the accepted conventions of Western perspective—looked at sketches for fifteenth-century frescos by Paolo

Ucello or Piero della Francesca, they might see the structural scheme that enabled perspective: a checkerboard ground-plane setting up modular spaces for projected figures. Each hypothetical space-block on the posited horizontal and vertical grid served as a modular "measurement" in the translation of figures and structures arranged into mathematically ciphered optical recession.

Similarly, LeWitt sets up his sequential progressions of modular structures, such as *Serial Project # 1 (ABCD), 1966,* with blocks on a grid. Four separate visual systems are woven together at once (solid blocks and "open" or skeletal blocks, rising incrementally, falling incrementally), interpenetrating in reciprocal passes, side to side, top to bottom, corner to corner. Standing beside this work, which rises to waist height and inhabits the gallery space at the Whitney like a pristine white architectural model of a city block, one *senses* rather than understands the music of the artist's logic.

Visually, each motif of LeWitt's puzzle becomes comfortingly clear, like pieces on a chess board. Here's a row of solid blocks, the same height right across; here's an adjacent row of skeletal blocks, also the same height. Looking across from another side, however, the blocks step up one module at a time toward center, then step down, passing "through" the original rows. Wherever you stand, a different system makes itself known, like interwoven voices in a musical round, complicated but harmonious.

Such engaging "conceptual" richness is characteristic of even the earliest works in the San Francisco/Whitney retrospective, which are drawings executed directly on the wall (like frescos), shaped to their architectural surface like a skin. Over the decades, LeWitt's wall drawings evolved from penciled, gridded, then overlaid configurations to free-form, full-color arabesques. Remember that Muslim "arabesque" decoration was accomplished, like LeWitt's, with the simplest of drawing tools: a straight-edge and a compass. What remains consistent is their scrupulous abstraction, freed from the hand of the artist, which constitutes the intrinsic democracy of the work—nothing elitist or erudite, just plain logic, clearly demonstrated. These pieces are not bravura self-expression. They are artist-driven systems—ideas—that adapt not only to realities of the physical spaces upon which they are installed, but also adapt to an individual viewer's vantage, in the sense that each piece insists upon a completely contextual reading.

"It doesn't really matter if the viewer understands the concepts of the artist by seeing the art," LeWitt wrote. "Once [it is] out of his hand the artist has

no control over the way a viewer will perceive the work. Different people will understand the same thing in a different way."

Or, as he states this another way: "A work of art may be understood as a conductor from the artist's mind to the viewer's. But it may never reach the viewer, or it may never leave the artist's mind."

Groundedness is the generating point of LeWitt's creativity—a methodology that is all the more inclusive in refusing to illustrate the so-called real world, instead acknowledging the reality of art: that while a drawing of something in the world is not the real thing, a drawing of a line is a *real* line.

The Atheneum's more focused exhibition is not only historical, demonstrating how *Incomplete Open Cubes* plays out its conceptual basis. It also holds up a lens to a key point in the evolution of LeWitt's process—or what curator Nicholas Baume describes as a demonstration of "what this conceptual process really is and what it means and what it can produce." It speaks in a fresh voice to contemporary ideas about presentation and perception. Especially interesting is to see LeWitt's notation schemes, numerical or alphabetical, together with his related drawings, which were executed in isometric fashion (rather than in perspective), in order to represent and explain but not *illustrate* the three-dimensional structures he had built to carry out 122 possible nonrepeating permutations. As presented at the Atheneum, *Incomplete Open Cubes* is a suite of representational systems devoted to expressing each iteration of the same idea in an individual way—following its own particular rules—showing how many possible combinations of three, four, five, up to eleven drawn or constructed edges might physically imply (but not delineate) a cube.

LeWitt's drawings are, variously, thought-sketches, graphic "symbols," or a kind of runic iconography of his thought process. The physical structures themselves are the physical "test" for the theory—proving the possibilities of the hypothesis. Taken together, they sound a sort of visual chord for an idea that by this point is far too complex to hold in memory. Yet individually each one, neatly gridded and labeled, is spare, concise, and devoid of expressive (narrative) burden.

Interestingly, photographs of these works yield the image in diminishing space, but the artist's drawings correspond to an architect's mind's eye, insistently graphing increments of angle and proportion true to fact and not warped by pretensions of illusion. They also adhere tenaciously to the integrity of graphic form—interesting as shapes in their own right, irrespective of

representational bias. The Renaissance is consequently unwrapped by LeWitt's modern hands (or the hands of his hired artisans) and brought round again, and is then displayed in a traditional museum with barrel vaulting and gilt picture moldings that frame that oldest of Western conceits, the "window on the world."

For all of this artist's career-long reticence, Sol LeWitt's name managed to make art headlines at the beginning of the twenty-first century. The forty-year retrospective at the Whitney revealed his capacity to evolve, attain successive kinds of synthesis, and yet never repeat himself. Together his "Paragraphs on Conceptual Art" and "Sentences on Conceptual Art," published in *Artforum* in 1967 and 1969 respectively, remain the most coherent body of thought on their subject.

And in unforeseeable ways, LeWitt was instrumental in opening up the way art is conceived, executed, and considered in the modern world, due to his on-going dialogue with other artists across every possible genre, his dialogue with art history, his exemplary stance regarding "ownership" and "permanence" of art objects, and the generous distribution that continues to be made of his personal collection of contemporary art, which includes more than 45,000 objects, 1,700 of these made by more than 250 other artists),

Early in the 1970s, critic Donald Kuspit assessed LeWitt's work as absolutely rational, as "the Look of Thought"; critic Barbara Krauss, looking at the same work, disagreed, calling LeWitt's achievement a paradox of rationality.

Ultimately, LeWitt's work makes sense but also demonstrates the limitations of sense. Its logic is implicit, its execution a negotiation, its potential both inchoate and concrete. Its logic is made *transparent,* in the dual sense of that word—visible and invisible at the same time. LeWitt's conceptualism takes a stance midway between the artist's intent and the viewer's perception, and defines both viewer and artist with respect to their physical relation to the work, giving no hierarchical preference to one or the other when interpreting objects generated from the artist's impulse. LeWitt's art is a matter of ideas, but it is also matter-of-fact, centrally concerned with the inherent shortfall in our perception of ideas.

Lewitt's works inhabit a space, much as his ideas inhabit their physical embodiment; in special ways his works are *of* the space, *of* the form, but they are bound to neither—which is why these works can be carried away with the viewer or reconstructed in another place, can even take on new form in that new place, and why LeWitt's works cannot precisely be bought, why their life survives mere expertise, or finesse, or interpretation.

All ideas are latent until they find form, perhaps, which is to say ideas *are*—present tense—art.

Of course, as LeWitt would say, they've got to be *good* ideas.

> Sol LeWitt. *Sol LeWitt: Incomplete Open Cubes*, at the Wadsworth
> Atheneum Museum of Art, Hartford, Connecticut;
> and *Sol LeWitt: A Retrospective*, at the Whitney Museum of
> American Art, New York, New York. 2000.

Ellen Carey

No matter what their grievances with modern art may be, almost everyone is comfortable with photography, which constitutes the last bastion of popular assumptions about what is commonly termed realism. Here is a medium that is necessarily "real": technologically reproduced from reality itself, without any of the offending manipulation and abstraction that modern drawing and painting so often attach. That photography is the epitome of realism is implicit in my students' compliments about artists they admire: "Van Eyck's painting is so amazingly realistic—like a photograph!"

What most people don't realize is that photography, too, is open to abstraction, and even its earliest practitioners created forms on photosensitive paper that were adventurous experiments with light and shadow, not merely recordings of visual data.

What is remarkable about Ellen Carey is, first of all, that her work is entirely abstract, and secondly that her abstraction is for the most part joyously accessible—large-scale, glossy, and gorgeously colored. Simply put, it is a pleasure to stand in front of this work and just look. If you stop there, however, you've missed essential parts of the potential experience— the complexity of the artist's conceptual foundation, the surprisingly personal genesis of her imagery—which is the wacky, irreverent, and well-informed character of her experimentation. For all the polish of Carey's finished works, they are the result of an ecstatic, fly-by-the-seat-of-your-pants, crazy-assed instinct.

In Gaelic, the name Ellen means "light," and light is the very engine of her chosen medium as an artist. Where most photographers use a

camera as a kind of recording device, Carey takes the mechanism apart, conceptually, letting its processes alone become her subject. They are real objects, all right, but their subject matter is metaphorical, not directly illustrative. Unique among her peers in the world of large-format Polaroid 20 x 24 photography—notably including Chuck Close and William Wegman—Ellen Carey does not "take" pictures; she makes them.

Ellen Carey's artistic intent might seem to be an oxymoron: she makes abstract photography. Hers is not the product of filmed imagery manipulated in a darkroom through an enlarger. Carey's works are the result of a process far more direct: the transcription of the *event* of light—its recorded absence or presence, its movements, and what happens when light is filtered with colored gels, double exposed, refracted through transparent matter, or masked by opaque presences laid directly onto the surface of the print. Like an alchemist, Carey traps light's fingerprint without the intervention of outside references. For her, and for us, that fingerprint is the material manifestation of metaphor.

In Greek myth (as related by Pliny the Elder), the origins of art were simple: a woman traces her lover's shadow as he prepares to go to war. Implicit in the act is the impulse that spawned it—the desire to fix a shadow as a spiritual hedge against loss. If we fast-forward to the early nineteenth century, the English inventor William Henry Fox Talbot pioneered the "art" of photography by laying a fern leaf upon a paper made chemically sensitive to light. To fix a shadow was the point, enabled by a newfangled chemistry of silver and salt.

This poetic truth—a dance with legend and history, light and shadow—lies at the heart of Carey's approach; for as radical as her work might seem, it cannot be separated from history: not from the history of photography, nor from her personal history, nor from the history of art. Carey's exploration of photography follows a thematic trajectory that early on embraced the figure, then incorporated abstraction, and in more recent years has embraced minimalism and conceptualism.

An exhibit at Real Art Ways in Hartford in 2000 showcased three major series of Carey's work, which would tour the country before and following the 9/11 tragedy. Titled *No Voice Is Wholly Lost* (a phrase derived from a book on grieving by Dr. Louise Kaplan), this fugue of works included *Family Portrait* (1996 and 1999), *Birthday Portrait* (1997), and *Mourning Wall* (2000). These works are the artist's responses not only to the dying of the millennium but also to the deaths of three immediate family members. In what she calls "grief

Ellen Carey, "Mourning Wall,"
2000–2002. B/W Polaroid 20 X 24 ER
Negative Prints. Individual images:
34 x 22 inches; composite: 10 by 36
feet. Installation view (left) and detail
(lower left). *(Courtesy of the artist.)*

work," Carey transmutes the pain of loss into a conceptual dialogue with light, manipulating the process of Polaroid photography into an elegiac form.

Carey's father and mother and her brother John each died within days of their birthdays, lending a double edge to the remembrance. The artist's abstract memorials are at once celebratory and pensive, monumental-scale "photographs" that are whimsical and transcendent, resembling melted Crayola crayons, or puddling birthday candles (rose-pink and blue), and also Japanese scrolls. They are produced by the signature processes that Carey has pioneered in her more than two decades of large-format Polaroid work. That she calls them "pulls" is a descriptive reference to their process, which should be familiar to anyone who has used a hand-held Polaroid camera. Each of these monumental-scaled pictures is the product of successive exposures of Polaroid film to colored light— colors derived from her parents' and her brother's birthstones, as well as tones of pink and blue, the conventional assignations of gender.

As mutely abstract as Carey's Polaroid images may be, their double meaning (birth/death) is made evident in the fact that she displays them side by side with their "negatives," the chemically coated facing paper that has been peeled away from the mirroring positive. In the *Birthday Portrait* pulls, further, in a kind of conceptual denial of death, instead of cutting the Polaroid prints off

at the conventional twenty-four inches as they scroll out of the camera, Carey continues to pull them out into six-, eight-, ten-foot runs—whatever length is required for the developing inks in the camera to expend themselves. After each exposure to colored light, the film's pods of colored dye are squeezed empty between the camera's internal rollers, laying down glassy pools of ink in great, looping ellipses. After a first exposure, the Polaroid's "sandwich" is pulled apart (the negative's facing is peeled away from the print), the ink allowed to dry, and then the glossy, jewel-like positive is spooled back into the camera, where it receives a new "negative" for each of its second, third, and even fourth exposures. Like raku pottery, the combinations are unpredictable productions, intuitively managed relations of chemistry and timing.

The *Family Portrait* suite (1996) is another "memento mori" to Carey's family, its form even more austere. Entering the room, the viewer encounters on the center wall seven color Polaroid positives tacked to the white drywall. They are arranged in a disrupted rhythm of pairs, left to right: two glossy black rectangles, then two ivory white, a single black pane, then two more in white. These are exquisitely clean objects, like polished onyx, "framed" top and bottom with smeary dark edges of golden brown. These are the positives that represent Carey's immediate family, living and dead, her father and mother, her four siblings, and herself.

The black images are created by the lack of exposure: no light reached the film. The white images are their converse, produced by exposing the film to a brightly lit white rectangle.

Thus we are presented with death, death, life, life, death, life, life—like musical scales, like keys on a piano, mirroring the spectator in the glossy sheen of their surface, blocking entry into the picture plane, which is not a picture at all but merely the registered evidence of the presence or absence of light. Each flanking wall presents an echoing series of images, told "in the negative." Those on the left are velvety black upon a brown paper. These are the color negatives, peeled away from the exposed Polaroid film displayed on the center wall. All are identically black—whether exposed to light or not, the negatives present the same. These record a physical history instead of a picture: Silvery streaks at the edges record the squeegee swipes that removed the dripping emulsion from each image's margins. In the silence of these images, this subtle visual indication of the artist's hands has an effect equivalent to sound—something homey and routine, as if someone, invisibly, was washing down the kitchen counter after the noisy turmoil of a funeral wake.

Mourning Wall (2000) is the newest of these series and Carey's most monumental work, her millennial crossover. A composite image 13 feet high and 38 feet wide, this is certainly one of the largest photographic works in contemporary art. Here she offers an austere, spiritualized lament. It is a composition whose immediate impression is physical—a wall of slate-like rectangles face-on to the viewer, with a grid of one hundred unique photographic "windows," one for each year of the century, rendering meaning like a silvered mirror-back, opaquely. Each image is executed in black-and-white Polaroid film, confronting us with the contrasting effect of a *non-color* "black": not black at all, but whitish-gray and leaching silvered salts.

Each image is a large-format (20-by-24-inch) Polaroid negative, created by exposing the black-and-white film to a white surface illuminated by white light. Peeled away from the positive—which looks white—these negatives assert themselves as black, which is to say, the physical and conceptual opposite of light. The stark beauty of the piece is metaphoric, not narrative; as in all minimalist work, the aim is presentation, not *re*-presentation. Graveyards present grids like this one, as do barrier walls. The Wailing Wall's weathered stone face, constructed like ashlar building stones, comes to the mind's eye, an allusion underscored by the delicate fringe—like a prayer shawl's—that is created in the dripping margins of each print where the chemical emulsion "weeps" with gravity.

These surfaces reveal the stew of chemical salts that are the material truth of her photographic method. This is no pretty Kodachrome moment, but a profoundly quiet one, as we are brought close to living surfaces that respond to temperature and moisture as they cure, a crystallization that continues as they hang. Speckled, salty, lichen-like, Carey's "pictures" are immensely rich and utterly mundane—more connected to frayed duct tape or crumbling mortar than with picturesque vistas. But they also stand as emotional equivalents, in a sense-specific way, to the numbing effects of a chemical burn or the visual "sound" of a hundred television screens gone suddenly blank—switched on, but vacant. Carey's imagery has none of the stupefying vacancy of television, and everything of direct visceral experience. Unalleviated by any hint of documentation, of "friendly" figural and spatial references, this testament to mourning demands a viewer's embracing empathy.

Ellen Carey. *Family Portrait, Birthday Portrait,* and *Mourning Wall,*
at Real Art Ways, Hartford, Connecticut. 2000.

Chris Doyle

*Like most digital media, videography, the younger sibling of filmmaking, is
a medium that has not yet had time to settle into convention, in large part
because the ubiquity—and user-friendliness—of digital editing capabilities
has opened the door for anyone to tackle an art form that used to require
massive corporate structures. The result is an explosion of creativity
and an anything-goes spirit of the frontier. YouTube enables anyone and
everyone to get something out in cyberspace, where, remarkably, somebody
is bound to discover it.*

*The essay that follows deals with the concept of an enterprising young
artist who, by writing a successful grant proposal, was able to bring
together forty-five artists whose sole connection was the use of film or
digital mediums in the consideration of a single, open-ended topic: the
hotel room.*

It's hard not to miss the bare-bones simplicity of Sol LeWitt, who died in 2007,
leaving in his wake a whole new way of considering what constitutes a work
of art. His pithy outlook, articulated in a list of sentences in 1969, included the
assertion that "It is difficult to bungle good ideas."

If ever there was a test of that declaration, it is the ambitious curatorial ex-
periment mounted by three prominent Connecticut contemporary art spaces—
Hartford's Real Art Ways, Artspace New Haven, and the Aldrich Contempo-
rary Art Museum in Ridgefield.

"I've been thinking a lot about Sol LeWitt," says artist Chris Doyle, the direc-
tor of the enterprise, whose own work dealing with hotel rooms (inspired from
his peripatetic experience as an artist) was the germ for the idea that ultimately
involved three institutions and forty-five artists in a collaborative video project
titled *50,000 Beds*.

Doyle's concept, commissioned by its three venues from a shortlist of solic-
ited proposals, was open-ended: "What would happen if people went into
[hotel] rooms with [film] crews and made pieces behind closed doors?"

His project orchestrates forty-five takes on the "hospitality" industry, framed
with an artistic freedom that is the metaphorical heart—and liability—of the
entire enterprise. This was an experiment of quite stunning liberality: an

assemblage of videographers (including documentary and narrative filmmakers as well as media artists) were set loose in hotel rooms across the state of Connecticut. Each was allotted twenty-four hours to film *in situ*, from which each produced a video work. Only after the forty-five works were created did Doyle finalize the three exhibitions that knit them together.

These videos run the gamut, riffing on the notion of the hotel room as a workplace and as a dreamland, as settings of both desperate loneliness and fetishist obsession, and from viewpoints as disparate as surveillance cameras and marketing fantasies. They range from the self-consciously fictional ("Let's pretend we just discovered a camera lens") to surreal and cartoon landscapes.

As a viewing experience, *50,000 Beds* is hard to consolidate. At each venue, the viewer serially encounters fifteen strikingly unrelated videos, and you move from program to program without any sense of where you are going, or why—an experience in some ways equivalent to watching television programming except that your route controls the remote control.

At each of the venues, there were rapt viewers tucked into chairs or leaning against railings, some connected by earphones, and everyone seemed mesmerized by the lit-aquarium specter of the proffered screens. The "audience" is eerily solitary, comprising viewers who move past each other in silence, waiting patiently outside of each other's private "spaces" for a turn in front of each viewing station.

We may experience these compound works as complex wholes, in a seemingly unmediated way . . . until it dawns on us that we are passing along anonymous corridors separating individual worlds that have little or nothing to do with one another except through some accident of architectural alignment.

Yet this is no accident. Doyle's shaping intelligence can be felt in the sometimes subtle visual affinities between adjacent works. His "architecture" involves the cunning interplay of peripheral vision and carefully gauged audio-sound leaks. Even the stage-set installation strategy (a viewer must climb stairs to a succession of landings, or move down maze-like corridors to encounter the video placements—some on monitors, some projected directly on the wall, some over neatly made beds) becomes the metaphorical projection of hostelry.

50,000 Beds is most successful in its overall concept, or in independent moments. There is no satisfyingly unifying means to perceive the work in its entirety except conceptually. As a cumulative "event," *50,000 Beds* insists on contemporary rather than modernist tactics, employing juxtaposition rather

Coordinated by Chris Doyle, forty-five artists made short films or videos in hotel rooms in just twenty-four hours, and the result was *50,000 Beds*, exhibited in 2007 in three Connecticut venues: Real Art Ways (Hartford), Artspace (New Haven), and the Aldrich Contemporary Art Museum (Ridgefield). Still images shown here are from (clockwise, from top left): Paul McGuirk, *My Secret Smile;* Tim Rutili, *Key to the Highway;* Chris Wilcha, *Cart Raid;* and Erika Van Natta, *By The Hour. (Courtesy of the artists and Chris Doyle Studio.)*

than unity, duality rather than integration, parallel universes rather than universality. A viewer needs buckets of time (not to mention transportation) and considerable willingness to see all forty-five of the videos.

The key to Doyle's strategy is its emphasis on the virtual. As viewers, we must enter and act upon the stage set that the curator and the participating artists have provided. It is necessary to become self-conscious, as, for the moment, we are pressed into vacation. Strangers to these spaces, we are made to occupy the place between one individual's perception and another's. What is "real" (documentary moments recorded from hotel workers, for instance) are salted among specious videographers' fictions, a largely incompatible relation. What is "false" (animations overlaid onto real-time footage) is likewise shocking.

The whole is a fugue of democratic proportions, whose real power is offering a vantage point somewhere in-between the microcosm and the macrocosm.

There is a generational disconnect, perhaps, intrinsic to the forms employed—to the umbilicus of earphones, the ubiquity of monitors and television screens.

Even so, we encounter moments from the "old-time religion"; and certain images (although they were conceived and executed separately) echo and dance with one another from adjacent walls. There are transcendent works like Melissa Dubbin and Aaron Davidson's *Thank You For Not Smoking* and the genuine poignancy of Liz Cohen's *Housekeeping* (in which a hotel housekeeper tells of suicides in the rooms she cleans).

First and last, however, something as banal as the idea of a hotel room galvanizes the whole—and in the end, it is a concept that gathers the forces of this uneven convention of filmmakers.

50,000 Beds, a collaborative project coordinated by Chris Doyle,
exhibited at Artspace, New Haven, Connecticut;
Real Art Ways, Hartford, Connecticut; and The Aldrich
Contemporary Art Museum, Ridgefield, Connecticut. 2007.

Kandinsky Called It Inner Need

Wassily Kandinsky (1866–1944) is a special kind of hero for me—catalytic to my evolution as a painter. An early professor, seeing an affinity of style, told me to look him up; Pat Lipsky, my graduate school professor, made me read his book Concerning the Spiritual in Art. *Kandinsky was able to give to the analysis of abstraction a language that struck a chord with my own perceptions. Emphatic and effusive, his views were passionate and sometimes florid, but his unapologetic embrace of the new was infectious and bracing. Like many of the avant-garde artists at the beginning of the twentieth century, Kandinsky was a Utopian spirit. He was a purist and a proselytizer who defined the role of an artist in epic terms (on the cutting edge of the great pyramidal blade of cultural progress), and he described the creative impulse in terms of spiritual (abstract) values in search of material form. He wrote about the yearning—which he called inner need—that he considered to be the genesis for the physical materialization we call art.*

To Kandinsky, the "creative spirit" is an irrepressible force. "Matter" (form) he likened to a storeroom from which the spirit chooses what is necessary to reveal itself. In this way, he not only characterized the process of discovery that is abstraction, but also provided a defense for imagery that derived from other starting places than the illustration of the visible world. His analogy to music composition was crucially instructive, since music is per force "abstract," and his description of his own paintings as "improvisations" and "compositions" goes far in constructing a new paradigm.

Kandinsky's evocation of the artist as a solitary force, brimming with need and relying on expressive instinct alone, was a sentiment that defined its cultural moment, in art (abstraction), in music (jazz), and in poetry and prose, where such writers as T. S. Eliot and James Joyce

were transforming the way literature was being written and read. In Kandinsky's view, experience is the means and the measure of truth, and intuitive understanding is closer to the full reality than careful scrutiny and rendering of surface appearances. Such thinking suited the collective psyche in the first half of a bellicose century, responding to the sense that somehow by starting over again we might circumvent the prejudices of received cultural expectations. It was an era when artists hoped that by looking away from the real world, which had become such an impossible snarl of political, technological, and spiritual trauma, somehow we might find the Utopia for which we longed. To borrow a term from psychology, a realm of knowledge entirely new to the twentieth century, today's "gestalt" may have changed, but the idea of an artist's driving inner need is still viable. In the essays that follow, I discuss artists whose pressing motivations have resulted in highly personal expressions.

Joe Coleman

As an art critic, you run into some pretty remarkable people, some of whom give pause just because they're still out there slugging. The art world is vast and difficult to maneuver, and whether survival is a matter of the "fittest" or some other superlative can be impossibly hard to ascertain. Culture makes itself up as it goes along, and the experiments are often utterly freewheeling. For every Titian (successful and worldly master of his trade) there is a Van Gogh (outrageous misfit, half-mad and self-destructive). History makes much of such personalities after the fact, but being a determined character counts for a lot—whether that determination is rational or irrational, visionary or radical.

Among those artists who persist, as Van Gogh did and as Joe Coleman (whose story follows) is doing, what is interesting is not that some people might consider them deranged but that their work—their art—may have been the one aspect of their experience that kept them sane, that gave them a place in the culture, and that gave them a productive focus and a dynamic point of entry into the goings-on of a larger world.

Joe Coleman's wisdom, he would have you believe, is the wisdom of lunatics and saints, of madmen, serial killers, porno queens, and sideshow freaks. He

is an artist engaged in laying bare our primordial fascination with sordid and repugnant archetypes. Disquietingly, Coleman accepts no artificial distinction between "them" and "us." As an artist, he stands outside the self-protective niceties of polite society, with a vantage point all the more disturbing because he is neither mad nor possessed, isolated nor out of touch, but merely—and deliberately—heretical.

After more than two decades on the fringes of the New York art scene, in 1999 the Connecticut-born Coleman took his first "legitimate" stage at the Wadsworth Atheneum Museum of Art's MATRIX gallery. Although he was already an underground cult figure, one known as much for his comic book art and violent performance persona (he blows himself up with explosives), this was his first museum show, which served to acknowledge the changing focus in his work as well as to test his capability to reach a broader audience.

Setting aside the performance aspect that first gained him attention, at MATRIX this fearsomely sinister showman let his paintings speak for themselves and for a sensibility painstakingly constructed in a life that many would consider to be a maelstrom.

Coleman was the child of violence and frustration, with a sensibility given to the ceremonial. His mother—an obsessively devout Catholic—had been excommunicated for divorcing her first husband to marry Coleman's father, an abusive and alcoholic ne'er-do-well. Coleman's early childhood playground was the graveyard across the street, and his imagination was formed by the Bible and the strange pictorial world of Hieronymus Bosch.

Diminutive and shy, convinced by his mother that he was special but tormented at school, at age fifteen he first took up arms against his rage by taping a collection of fireworks to his chest, crashing a neighborhood party, and detonating the explosives.

From this point on, outrage became his ticket out. That he survived his own life is something of a miracle. That he turned the powerlessness and vulnerability of his early life into a grand and cathartic vision is certainly his salvation.

When you meet him, he's not such a scary guy, really. Lucid, mild, and wry, he seems amused by his audience, and is equally amused by the specter of himself as mythological guide—a savvy little Dante Alighieri taking the tourists on a sight-seeing drive through hell. His modest living quarters and workspace in Brooklyn Heights are dispersed to the perimeters of the central feature of the place, a showcase of objects that he grinningly calls the "Odditorium." He has

Joe Coleman, "Coal Man," 1997. Acrylic on panel, 38 x 34 inches. *(Courtesy of the artist and Dickinson Roundell, New York, NY.)*

been accumulating since childhood this collection of curiosities, religious relics, medicine-show props, scientific specimens, and wax museum figures.

The Odditorium is a shrine-like space, with heavy velvet drapes and Persian rugs, and is crammed with every variety of creepy relic. In Coleman's archive of the bizarre we are presented with a freakish compendium of objects: nature's aberrations (pictures of two-headed calves, anatomical illustrations of the Elephant Man, a deformed fetus preserved in formaldehyde); society's psychotics (documents by and about serial killers Ed Gein and Carl Panzram, as well as cannibal and pedophilic killer Albert Fish); scientific documentation of twisted medical experiments; evidence of medieval superstition (Catholic reliquaries and chronicles of the lives of the saints); Inquisitional torture devices; and brightly colored sideshow banners, all reverently displayed in the Victorian parlor at the center of Joe Coleman's home and studio.

What's so shocking here, of course, is the equivalence Coleman posits be-

tween what most people would consider to be opposite poles of the moral spectrum. Yet this repository is a shrine to his personal, professional, and artistic cosmology.

"I consider the collection my family," says Coleman quite simply, explaining, "family is also the people I let into that family."

"Say you look at a piece of Jesus Christ in a reliquary," Coleman continues, "and a baby in a medical museum, and the hand of a murderer in a crime museum—they're interchangeable. Each one creates a kind of awe—just like lap-dance places and sideshows. In Christian culture they have disdained the dark gods—the dark side of people's souls. I see just as much in Eastern religions as [in] Christianity—also voodoo and Satanism."

Heresy, if you wish, but eloquent, as well. Joe Coleman is more of a showman than a shaman, although he respects the dark arts. To him, spirituality itself is at stake, and the great gap at the heart of modernity in its embrace of rationality—and an aesthetic that would allow no place for work like Coleman's—is a crisis of spirituality. If he has a mission, it is to prevent us as a culture from backing away from our demons. Instead, he holds up a mirror to our dark side; he screams to get our attention and makes us look.

Coleman's art addresses the worlds where "inhumanity" dwells—worlds he knows well, and with which he identifies. He views sainthood, dementia, medical research, sadism, and Satanism as aspects of the same human impulse. His may not be a pretty world, nor is it a safe one, but according to Coleman, here is where the truth resides.

"I deal in gallows humor," he says. "Someone who's in a really shitty place—who has cancer, say, makes a joke; the whole room recoils. Gallows humor is . . . above the snake pit."

He refuses to buy into the so-cool irony that is the stuff and substance of high art these days, just as he disdains to look away from what most people find unpleasant and weird. In this respect Coleman is a medieval soul, engaged in an epic struggle for contact with the indefinable, poised on the cusp of heaven and hell, and crazed by the touch of the infinite mystery, which is his definition of art. But he is never so far gone that he loses touch with the corporeal world.

"Nature is about one thing—culling the herd—culling the children who don't procreate," says Coleman. "We try to make it that everything is about us. Nature can think of something way better."

The "problem" is that the artist Joe Coleman has been denounced by the ASPCA for biting off the heads of rats, and was famously arrested in 1989 by the

Venice Beach, California, police as a "fish-fucking Satanist," and arrested again that same year in Boston for being "a breach of the peace (disorderly person)" after he detonated an incendiary device strapped to his chest in the offices of the Boston Film and Video Foundation. Coleman was the first person since the 1800s to be arrested in Boston for being in possession of an "infernal machine."

But another way to look at art, says Coleman, is to consider the way Romanesque artists thought of gargoyles: as a way of embodying fears in order to contain them. In many cultures, he explains, "tribes will make a fetish object to control a fear."

Like them, he sees this as functional—the prime element of an artist's social responsibility—and he takes that function deadly seriously. He cares not one whit if others find his reasoning archaic. Coleman's is an imagination habituated since youth to thinking in terms of the cosmos—even if that requires constructing a cosmos completely from scratch. He has devoted a lifetime of serious study to the task, which seems to have been more than a means of addressing his own troubled life.

Well-known art collector Micky Cartin, who has known Coleman for years, sees compassion at the core of Coleman's sensibility, a perspective Cartin has gained from knowing the artist mainly as a painter rather than only from the wild array of personas that Coleman quicksilvers between in his performances.

Cartin says that Coleman "championed the 'geek' as a horrible epitome of the underclass, [one] who would do anything for five dollars." In Cartin's view, Coleman became the geek—the guy who bites the heads off living animals in a carnival sideshow. "He is quite a gifted showman. A quiet, private kind of guy, but he likes that kind of attention. He's by no means inauthentic, and is not afraid to say exactly what he thinks. He's holding us responsible for all this ugliness. There's an inescapable Catholicism to him. It had this horrifying influence. He finds it so fascinating that we live in this wonderful world, and we are drawn to ugliness.

"There's also this bad-boy element," Cartin continues. "Originally, his motivation was to shock, anger, offend, ridicule. But he's come full circle on that—unlike Ashley Bickerton, who makes fun of the rich assholes that buy his work." By contrast, Cartin says, Coleman "now plays a distant, secondary role to his art."

"Joe is uncompromising in his work—doesn't bend in any way," says Cartin. "He could have made a lot more money, doing pretty paintings that would sell by the dozens. But he puts too much of his soul into them. He won't take on a

project until he's convinced that it's worthy. He does five or six paintings a year, and has a waiting list of twenty to thirty people who want them."

Coleman's buyers now include Leonardo DiCaprio and Johnny Depp.

"He works each day, nine to one, takes lunch, then works from two to six," says Cartin, praising Coleman's discipline. "He takes a vacation. He's decent, loyal, honorable. He doesn't want to become wealthy from [his paintings], just wants the freedom to make them. He's doing great now, is able to work full time . . . and doesn't have to answer to anybody. I feel lucky I know people like him—not that there's anyone like him."

Once you look beyond the almost adolescent obsession with taboo that is the dominant first impression of Coleman's style—a mixture of Dante, Edgar Allen Poe, and P. T. Barnum, filtered through the *Book of Kells,* Bosch, R. Crumb, and Ivan Albright—what is remarkable is how Coleman taps an otherwise untouched aquifer of the collective twentieth-century psyche. By going back to the Dark Ages, he manages to pick up a thread we would like to think we had dropped but that Coleman insists is in our DNA.

In one sense, his approach to art plays out—seriously, intently, the way a child plays—the most compelling neuroses of the modern era. In an age of ceaseless self-consciousness, Joe Coleman conjures a pantheon of larger-than-life alter egos. In an age of cynicism, he espouses profound, active passion. In an age of commercialism and rationalization, he seeks—without a vestige of apology—the mystical essence of art making. In a faithless age that pretends to be otherwise, he is one of our most devastatingly perceptive moral critics.

He abrogates the very notion of modern "civilization," turning his back on contemporary systems, reconstructing a mythology, a history, an artistic process, a belief system, an ethical structure from a distant, imagined historical past. He believes his own mythology, but he knows that faith has nothing to do with the truth, just as authenticity has little to do with political correctness.

He won't let us throw out the baby with the bath water but instead puts the baby in a jar on the shelf—complete with amniotic fluid, fecal matter, and scraps of the umbilical cord—to remind us of what we would otherwise throw away in a spirit of cultural housecleaning. His art percolates up through subterranean strata, from the corpulent flesh of Gaia, rather than springing from the brow of Zeus.

Coleman began by blowing himself up to get our attention—playing the social game on his own terms, although that game would have excluded him—and he brought his ideas to us against our will, against our aesthetic, against our

better judgment. His first offspring was chaos: fire and brimstone, panic and confusion. And he found this satisfying.

"Outsider art has value because it says *I truly believe*," explains Coleman (who is anything but the uneducated naïf usually implied by "outsider"). "If you want to label me an outsider, that's okay."

He acknowledges that art school kicked him out. "But I'm not illiterate," he says. "It's because I don't think 'right'. A lot of modern art is built up on irony, which is the disdain of logic. The outsider has a logic that I understand and respect. My law is a personal law that has nothing to do with irony."

"Art critics think I'm a nut, but how can you say I'm a nut?" Coleman is aware that [viewers] may not "understand" what he is doing, "but they're engaged," he says. "All's it matters is what it means to *you*. Everybody can be an art critic."

"If you look at my paintings," he continues, "I reject . . . the things that are part of so-called civilization—invented by people trying to form tribes . . . saying, in effect, if you want to live under this flag you have to deal under these precepts. Why I like Charles Manson is that he had a code: *relation to family* . . . I like criminals—like Joe Black, who essentially said *in the criminal class, there is a code of honor,* which has nothing to do with what society tells you is right or wrong."

"I'm not going to defend your law. I can deal with the penalty," Coleman says.

"The art game today is about commodity. If that's art, that's not me."

"I don't deal with galleries. I've got a waiting list. I think of it as a patronage system—the buyer has the ultimate relation to me."

"I'm pre–Industrial Revolution; the only invention I ever thought worth its salt is dynamite."

Joe Coleman. *Joe Coleman / MATRIX 139*, at the Wadsworth Atheneum Museum of Art, Hartford, Connecticut. 1999.

Lee Lozano

Lee Lozano (1930–1999) is another artist, like Vincent Van Gogh, whose mental stability is an issue. An important figure in the early days of conceptual art, her scrupulous adherence to the "projects" she devised, which dictated the performance of specific activities (financial decisions,

sexual practices, drug use) on predetermined schedules, ultimately led to the breakdown of the dividing line between her art and her life. For most artists, even though their energies are generated from personal passions and enthusiasms, the work is nevertheless something separate. For Lozano, one whole component of her work was the way she "performed" her day-to-day living. The seeds of her breakdown are evident in the bifurcated character of an early production: On the one hand, Lozano was making paintings—a physical act. On the other, she was restlessly chronicling directives for action (life-as-art), which she would carry out precisely as written. The purest conceptual logic applied to real-world actions led inexorably to a disconnect, as the consequences of her decisions (to take LSD daily for a period of many days, for instance) impacted directly on her health and well-being.

Most famous of these self-directives, her 1971 resolve to boycott all interaction with other women began as a one-month experiment, but remained operative until her death from cervical cancer in 1999.

Lozano was a pioneer and a role model, if not a salutary one. Her importance as a conceptual artist relates to her scrupulous performance of the ideas she penned. Even her paintings, beyond their physical impression, are direct reflections of a thoroughgoing rational intention. Her unrelenting discipline carried out such directives to their logical conclusion, even if that conclusion was career-canceling or self-destructive.

Whatever its consequences, there is a purity of process at the root of her productions, and, considered in the context of feminism, a prescient focus on her life as an artistic medium. The major female figure in conceptual art in the 1970s, Lozano boldly anticipated contemporary concerns (identity, subjectivity) through performance. Her self-determination was more powerful than self-preservation—an object lesson, perhaps, but also a unique instance of following ideas to their ultimate conclusions. There is a crystalline clarity to be found in the ideas and the images that she left behind. Considering the arc of her life and career, one has to wonder at the power of human determination, which can press a soul beyond the boundaries of survival.

In 1996, the Wadsworth Atheneum Museum of Art's MATRIX gallery featured Janine Antoni, an artist whose principal work was to paint her audience, using her own waist-length hair as a mop, right out of the exhibition space. In 1998, in the same space, the audience was asked to confront the fierce

products of a pioneering conceptual artist whose signature act at the peak of a burgeoning career was to remove herself from the art world.

Lee Lozano / MATRIX 135 is an exhibit at once stern and irreverent, icy and heated, lavish and spare. It is a show wholly personal—scarily so—and steely in its demonstration of will over response. Its drama is passionate but Spartan; its character surprisingly withdrawn, for her work's arena is not to be found either in its products (these paintings), nor in its groundwork (her notebooks).

In keeping with the nature of the works gathered here, the gallery is divided into two chambers, which showcases the evidence of the working of her mind in a purposeful, though uneasily wedded kind of parallel play: word and image, idea and vehicle.

On one side, Lozano's paintings are powerfully subtle, as tightly wrought as wire cable yet as delicately differentiated as the brushed nap of suede. In the other half of the space, in the form of written "projects," is a running dialogue of Lee Lozano's exploration of ideas that range from works as petulant as instructions to throw all the latest issues of a noted art magazine up in the air *(Throwing Up Piece)*, to work as poignant as her *General Strike Piece,* which she describes as a "withdrawal from humans and the outside world."

Like much of the art of its period, Lozano's seeks an intersection between art and everyday life. Distinctly, however, her scripted "performances" were directions to herself, not to anonymous others, directions such as her decision to boycott women beginning in 1971, which once committed to, she never reversed. What this meant, in real-world terms, was that if she encountered a female teller at a bank, she would withdraw from the transaction. If a city bus had a female driver, she would not ride. She would not speak to or acknowledge a female dealer, curator, sales clerk, or physician. Her withdrawal from her own gender was absolute and nonnegotiable.

In many ways, this exhibition is resurrectional, although Lozano, sixty-seven at the time, would not attend the opening. She had no hand in its installation and no direct contact with its curators, James Rondeau and Andrea Miller-Keller. *General Strike Piece* was no mere pose for some camera or the scribes of art-historical notation.

In art history, as a consequence, her name is essentially unknown. Unlike Sol LeWitt, Lawrence Weiner, and Dan Graham, who were part of her immediate circle in the early days of the conceptual art movement—and whose works help to compose a companion exhibit in neighboring galleries—Lozano, of her own accord, has remained resolutely out of the picture for nearly thirty years.

In fact, since the early 1970s when she began her systematic withdrawal from

Lee Lozano, Untitled
("General Strike"),
handwritten version,
February 8, 1969.
Graphite and ink on
paper, 11 x 8½ inches.
Alexander A. Goldfarb
Contemporary Art
Acquisition Fund.
1998.6.9, Wadsworth
Atheneum Museum
of Art, Hartford, CT.
*(photo: Wadsworth
Atheneum / Art Resource,
NY; copyright courtesy of
the Estate of Lee Lozano,
Hauser & Wirth, Zurich.)*

the events and people of the New York art world, Lozano has effectively been erased from a scene where in the 1960s she achieved unprecedented cachet for a woman. At the time of her 1998 Hartford show, she was living in Dallas and in contact only with her dealers, Barry Rosen and Jap van Liere. Until the late 1990s, her work was mostly gathering dust in storage, and her life had been lived out of sight, protected and apparently marked by periods of mental instability.

Lee Lozano / MATRIX 135 is historically and culturally significant, a gesture of curatorial redress and an example of groundbreaking scholarship. The show highlights never-before-exhibited works that were already part of the Atheneum's permanent collection, emphatically underscoring the richness of those holdings. But her MATRIX show also brings to critical light for the first time Lozano's working notebooks, one of the most important firsthand archives of early conceptual art, according to exhibit curator Rondeau, who is also Associate Curator of Contemporary Art at the Wadsworth Atheneum Museum of Art.

Perhaps surprisingly, in an exhibition of works by one of the pioneers of language-based art, the tone is set by Lozano's powerful *Wave Series*—a body of eleven paintings that explore the mathematics of wave phenomena, paintings executed during the same period as the accompanying language-based conceptual pieces. These diverse works from 1967 to 1970 (three of which belong to the Atheneum) are reunited for the first time since 1972.

It was early work—small, figurative paintings—that led curator Rondeau to Lozano. In 1995, Sol and Carol LeWitt, who contributed one of the *Wave Series* paintings to this show, had encouraged Rondeau to see a group of small paintings by Lozano in a private viewing at Rosen and van Liere Modern and Contemporary Art in New York City.

"The paintings were extraordinary," said Rondeau, "and the paintings brought us to the working notebooks. We knew instantly that this was an important show—a virtually untapped resource. It was from [her companion] writings," he explained, "that we first began to realize what we had in our own basement."

Anticipation of the MATRIX show in Hartford renewed interest in Lozano's work in New York. The major art publications took notice and, after a hiatus of twenty-seven years, Lozano was given three one-person New York exhibitions in 1998 alone.

"It takes a nudge to get things going," said Lozano's dealer, Barry Rosen. "People don't do anything unless there's a significant spur. Lee made extraordinary and really influential work in the 1960s—and then she disappeared. It's hard to do anything with an artist who is not making work but is not dead. Everyone says, 'Oh yes, I remember her,' and then they don't do anything."

But Lucy Lippard, the legendary critic and art historian who first chronicled the conceptual art movement, has credited Lozano's pioneering role in the earliest days of that movement. In her introduction to the exhibition catalogue for *Reconsidering the Object of Art: 1965–1975,* a 1995 retrospective of conceptual art at the Los Angeles Museum of Contemporary Art, Lippard observed that "in terms of conceptual art, the major female figure in New York in the 1960s was Lee Lozano."

Even so, that large-scale retrospective did not include a single work by Lozano.

Seeing the MATRIX installation, it is not hard to be moved. While Lozano's life may have been a disappearing act, this exhibition uncovers the crystalline surface through which one can seek this artist's mind. Here was a bitch in high

heels, so to speak, yet like one of the boys—most everyone said—in dealing with life and art on her own terms: hard, uncompromising, sensuous, surgically logical, relentless. Lozano not only brought up hitherto untouchable underground topics, such as sexuality, drugs, and radical economics, but she took them on directly in her work, making them not only her topic, but her *medium*: performing them, yes, but at the same time developing rational systems to examine and delineate them, chart them, and objectify them, and putting all of this down neatly on paper.

From an objective point of view, of course, the turning point for Lozano is a work that she once fleetingly referred to as the *Dropout Piece*. She simply walked away. She removed herself from the art world with such quirky and deliberate finality that this act suggests a kind of dementia, at least for those of us who look upon life and success as a rising embrace of power and recognition. But that is a notion the MATRIX curator repudiates with some heat.

"In clear ways she was a pioneer," explained Rondeau. "Her involvement with sexual politics, for instance, or body politics, the issues of money (investment and financial machinations); in all of these areas—which became wildly important in subsequent decades—she was clearly prescient.

". . . the whole context of conceptual activity provided a forum in which there was nothing really crazy about doing this. Look at her contemporaries. Donald Judd was writing down measurements for plywood boxes and someone in New Jersey was building them. Tony Smith was writing down measurements for black metal boxes and somebody else in New Jersey was probably building them.

"We're quick to put her life under this wacky rubric: masturbation, sex, drugs, money—she pushes all the hot buttons," Rondeau said. "The thing is, in her work, she's de-wackifying it, de-weirding it, because she's so clear and so focused about [her aims]. Lozano wants to dissect, understand, and analyze. She's not basing her practices on a psychedelic drug culture or crazy numerologies or strange new religions—she aspires to math and science. She objectifies living. I'd like to see her not made the crazy person.

"When you get this work in one room," he added, "there's nothing crazy about it."

Lee Lozano. *Lee Lozano / MATRIX 135,* at the Wadsworth
Atheneum Museum of Art, Hartford, Connecticut. 1998.

Prison Art

I first gave a serious look to prison art because an artist I respected called me and told me that I should. "This is real art," he said. I took him at his word. What I discovered, on fuller investigation, is a situation as compelling as any I had experienced.

By definition, prison art constitutes "outsider art," a designation with which Joe Coleman, too, identifies. While it's clear from looking at Coleman's work that his art is more skillful and substantial than most of the work that comes out of the prison system, the story of art being done in prisons is a powerful one, in part because of the heartfelt determination of those who are struggling to keep such programs alive and in part because of the extremity of conditions under which art is produced within these institutions.

If I wanted proof of how intrinsic the need to make art can be, there were no more potent examples than the work of the individuals described in the article that follows.

Benny Andrews (see page 87, in chapter 5) initiated a prison arts program at the Manhattan House of Detention in New York City in early 1970, and because of its success, he was invited to help set up a similar program on the federal level. This sort of humane outreach, another worthy product of the 1970s, would become a point of dispute in the culture wars of the 1980s.

The signature is as blunt as the drawing: *E. MARSTEN—#70494, Osborn Correctional Institution.* The drawing itself is as clean and bare of illusion or interpretation as the thoughts that accompany it in a firm, round, schoolboy-like handwriting:

After drawing my self-portrait, I took some time to look at the picture I saw:

I see a man with a hidden past. Secrets never to be revealed, tormented by the years of isolation and neglect. In the eyes, I see the loneliness that has captivated the host, leaving him with no emotion of his own. I see the emptiness in his eyes. The masks worn throughout the years have taken toll.

But yet, I see a man that has hidden hopes for his future. He still hopes and dreams for a better future with all its possibilities. I see a man that will only put

on a new mask to raise to any occasion. I see a man with so many masks—he don't know himself.

I see a man with inner light and yet refuses to let it shine. I see a man that keeps to himself from fear of further prejudice, further isolation and one that dreads loneliness.

Not perhaps what some people might expect from a convict—insight, introspection.

But then again, neither might you expect the beautiful little frogs that Robert Michael "Lefty" Garabedian carved out of Styrofoam trays, "welded" together with liquid floor wax, for each of his two children, who were sent to live with relatives when both of their parents went to prison. Lefty is a passionate naturalist whose love of amphibians shines in these beautiful and realistic creatures (he wants you to know that this is *exactly* what they look like), which he made as gifts for his kids to replace the pets they lost when the family was separated.

Marsten's pencil portrait and accompanying text and Garabedian's frogs are part of the exhibition *Prison Arts Program Annual Show 2001* at Real Art Ways, which offers an eye-opening experience. Installed in the huge main gallery space, this show gives a broad and insightful view into a world that most people shudder to consider.

Will K. Wilkins, director of Real Art Ways, which helped sponsor this exhibition, says that prison art "is not a 'feel-good' experience. It reflects some deeply troubled personalities, but also some incredibly sweet ones, full of longing. Some are bitter, some are surprisingly joyful. Some [are] better than others. But I think this program is valuable for us as society to have that window into the world of incarceration."

Prison Art 2001 represents the hopeful flowering of a new-century answer to conflicting American attitudes about correction, proffering an alternative to brutal, dehumanizing punishment with a brave, thoroughly unapologetic demonstration of what fostering creativity and self-respect can accomplish for long-term inmates. The point, said Prison Art coordinator Jeffrey Greene in an interview, is not to condescend to this work but instead, as he tells his inmate-students, to take a good long look. This aim of the program comes through clearly in the exhibited work, and the value of the experience can be read in the prisoners' words that accompany the visual art. The program's value is also evident in the stories the instructors tell of their students' remarkable courage and their persistence beyond all expectation.

The achievement of the Real Art Ways show is its comprehensiveness—

E. Marsten, self-portrait, c. 2001.
Pencil on paper. *(Courtesy of the
artist and Jeffrey Greene, Prison Arts
Program/Community Partners in
Action.)*

indigenous prison folk art forms are presented side by side with tattoo-like
"biker" styles or highly personal creations. For viewers unfamiliar with art
made by prisoners, the variety (and the ingeniousness of materials) may be
surprising. Who would expect a Ferris wheel crafted out of 11,472 carefully
interwoven pieces of potato chip bags, or the dozens and dozens of colorful
baby booties fashioned with a clever paper-folding technique and festooned
with little white pom-poms made from the threads of unraveled cotton socks?

Paper weaving is a prison folk art form that recycles materials available to
the incarcerated: candy wrappers and other colorful packaging, folded carefully
to display a particular color in just the right place. This is a craft passed down
from prisoner to prisoner, in prison after prison, a means to fashion gifts for
family on the outside, mementos that can be hung on rearview mirrors as a
reminder that someone cares, that someone still exists.

Maybe more to be expected are the biker/tattoo drawings that crawl fiercely
over letter-size paper, detailing grimly intense characters, symbols, and may-
hem: knife-mangled, blood-dripping, muscle-flexing action-hero violence.
The vernacular of prison art can be as lockstep as that of adolescents, adher-
ing to a repertoire of standard images: cell bars, gargoyles and other fantastical

medieval creatures, comic book characters, graffiti forms, sexy women in pro-vocative poses, spider webs, bleeding hearts, eyeballs, teardrops, and the like.

The genre identified as outsider art, which has a ready market among deep-pocket collectors, also makes an appearance in the Real Art Ways show. For aficionados, this art is distinguished from more derivative, folk-art forms by a degree of introspection and a disregard for stylistic "norms," either conven-tional or typical of the incarcerated. That an investment in art making might also provide a form of therapy may be reflected in a tendency toward compul-sive patterning, rife with autobiographical reference.

What the works in this show have in common is a direct result of the condi-tions under which they are made: they show a marvelously cunning resource-fulness regarding material. The work in the exhibit is for the most part small in scale, in many instances executed in ballpoint pen, pencil, or colored pencil, or improvised in "sculptural" materials of the most mundane sort; for example, a carefully executed model of a house built with colored papers and held together with toothpaste.

And although most prisoner-artists are self-taught, in the social context of the institution—in stark contrast to the usual value system of the outside world—their art can be highly sought after. There's evidently an eager mar-ket for art behind bars, and a convict-artist who can turn out popular motifs can barter or work on commission, providing to block-mates and corrections officers everything from portraits to picture frames, religious icons to hand-decorated envelopes.

"Artists are heroes in prison," Phyllis Kornfeld said in an interview con-ducted in conjunction with this show, and she ought to know. For thirty years, in eighteen institutions and six states, she has served as a prison arts instructor. She is also a well-traveled lecturer whose 1997 book *Cellblock Visions* details the struggle for self-expression against all odds that is the nature of art-making in prison (see the website *http://cellblockvisions.com/*).

To understand the accomplishment of these artists, Kornfeld emphasizes in her book, one must understand the context in which these works of art are made—which is to say, an environment deprived of any comfort, dignity, or visual stimulation: small, crowded cells; a colorless environment of cinder-blocks, drab-painted brick, and concrete; steel bars and razor-wire fencing; and constant surveillance. Prison artists experience sudden and arbitrary transfers to distant states; unbending limitations on time, materials, and working space; restrictions even as to choice of imagery, since drawings of the prison itself

are not permitted, for security reasons. And all work and supplies (even if an inmate purchased them) can be confiscated at any time and for any reason.

In her book, Kornfeld cites Hans Prinzhorn (1886–1933), a German psychiatrist and aesthetician who made the first recorded account of prison art as a genre category.

"The inescapable fact about imprisonment," wrote Prinzhorn, "is that it is imposed rather than chosen, so that prisoners feel trapped in a system whose aim largely seems to be to make them vegetate, lose all initiative, and become the submissive creatures of institutional power . . ."

What happens in an art program, according to Kornfeld, "is incredible, because positivity permeates this negative environment. Even if somebody is a hack just doing it for soda or potato chips, [making art] is something positive and productive that doesn't hurt anybody. Guys in maximum security situations [especially] need it. It's so intense there and it's the only experience of humanity they have . . ."

Kornfield characterizes what happens when you put materials in the hands of inmates and then try "to get out of their way" as "an explosion of creativity," but in her book she credits outreaches like the Prison Arts Program with an important role in the process: "Inventive, expressive paintings rarely surface in prison without the presence of a program and someone from the outside to recognize it, protect its creation, nurture it, and advocate for the artist.

"There was no doubt I was seeing the inmates at their best," Kornfield says in her book, "in a peaceful, pleasant circumstance, and it may be that I met the best of them, interested in positive, productive behavior. I met many people who had stolen and they were honest, people who had killed and were kind, and even some who had raped and were lovable," she wrote.

Following up this statement in an interview, Kornfield added another, and unexpected, perspective: "The message you can't escape," she said, "is how many innocent people are in prison, and that even people who are guilty have a capacity to do good."

Self-Portraits

In the culture of the criminal justice system, opportunities to create art hold a tenuous place under the umbrella of "recreational" programs, and they are at the mercy of an institution's budgetary and space limitations, not to mention outside political pressure and public sentiment. They have continued to exist,

for example in Connecticut, where they have gained the support of prison personnel from top to bottom, from individual wardens to officers and rank-and-file guards.

Acceptance rises when people see what can happen, according to Jeffrey Greene, coordinator of Connecticut's Prison Arts Program, an arm of Community Partners in Action, a nonprofit agency dedicated to building community by providing services that promote accountability, dignity, and restoration for people affected by the penal system.

I interviewed Greene as he was installing the 2001 Prison Arts Program exhibit at Real Art Ways. For Greene, the job he has held for sixteen years goes well beyond the work he has done directly with the participants in his prison-based art classes. This 2001 exhibition, and the ten that preceded it, and the annual full-color *Journal of the Community Partners in Action Prison Arts Program,* are also important parts of his larger mission to generate genuine respect for prisoners' art and to give us a glimpse into the world of prisons. Without increasing understanding on the part of those of us on the outside, Greene emphasizes, nothing can change inside.

"I send these journals and posters to correctional institutions all over the country," he said, explaining that the quality of the artwork in the publication and the poster is persuasive. "The posters make it *real,*" Greene told me, validating not only the work generated, but also the values of the program. "Those posters go up on walls in correctional offices and give evidence that it's absolutely normal to make art in prison."

If you dignify prison-based arts programs—for instance, with a glossy photograph—the work will carry further. Even in states that have prison art programs, said Greene, where people are allowed and encouraged to do art, there's often little value placed on the work produced. "The expectation," he said, "is that you shouldn't be critical or demanding of this work—that whatever they make is fine, and that any old materials will do. Yet art is one way you can teach people to be self-critical . . ."

This tall, lanky, and tousled youth became more emphatic as he led me to a group of self-portraits. ". . . to look back at their lives and to self-assess."

The self-portrait by E. Marsten mentioned at the beginning of this essay was done as part of a project Greene established in one of his classes. He gave each of the inmates a plastic mirror (glass would be contraband, of course, as would any polished metal surface), somewhat warped but nevertheless reflective. He

instructed the inmates to "take a long, hard look at yourself" and draw a self-portrait. Not from a photo, from life. Later they were asked to write a statement to go with the drawing.

The drawings by Marsten and his fellows are remarkably powerful—not because of flourish and individual style (these are not the admired qualities of prisoner art, which respects exactitude and hyper-precision, clarity and firm delineation), but because of the utter frankness of viewpoint. Neither self-pity, nor self-aggrandizement, nor bluster enter in—just a clean, hard, objective stare.

The accompanying statements were equally forthright. Consider that of Dennis Coleman, who was convicted of killing Joyce Aparo, the mother of his then-girlfriend Karin, as a teenager in 1987. Currently serving a thirty-four-year sentence for the murder, Coleman participates in the art program at Osborn Correctional Institution in Somers, Connecticut.

"As a kid," writes Coleman in his statement, "I remember feeling that something great, something big would happen to me . . .

So strong were these impressions, I held it as second nature, as a given, that it was truth. All that was left for me was to sit back and wait . . . Most often I associated it with a sense of security, like when we were driving home at night, me huddled in the back seat trying to avoid the stream of cool air rushing in through the cracked open window up front. I watched the stars flicker by above the overhanging trees, feeling at peace and at one with everything from tree to star. Of course, as a child, I didn't think it out so much. Instead it lived in me as this amazing swell of potential.

Twenty years later (twelve of them now in prison) I am drawing this self-portrait (something I dislike). It strikes me again, the irony of circumstance. Indeed, something big did happen to me, and it was something that found me, as I'd expected. It landed me in prison, in a book, in a movie, on the nightly news, in I don't know how many newspaper articles and so on. I am infamous, notorious, misunderstood and sadly resentful. And I wonder now if this is it; if this is my presentiment fulfilled. I wonder if this childhood foundation of peace and security was pointing at a despicable murder which I'd never intended. It makes me cynical and at the same time optimistic.

Certainly the worst is behind me. My life really can only get better, no matter what happens. And I will see things from a perspective most people never will. I am redeeming myself in my own eyes. I am trying to make it up to that little kid in the back seat. There are discouraging times, lonely times, but they mean less to

me as it goes. In another ten years or so I will get out to see if there is still some of that potential yet to be realized. I hope that it hasn't been spent so poorly. Who knows, maybe you'll hear from me some day.

Vincent Nardone, Lester Allen, Jesus Rios, and Robert Michael Garabedian

One of the stars of the *Prison Arts Program Annual Show 2001* at Real Art Ways is Vincent Nardone, a prisoner who had served thirty years by the time Jeffrey Greene met him in 1991. Prior to their meeting, Nardone was already considered an artist, a specialist in making drawings of clipper ships, extremely detailed and exact.

"Why do you do clipper ships?" asked Greene, expecting to learn about a seaport childhood or a family history tied to sailing ships. The answer was revealing in quite another sense.

"Because that's what people want," answered Nardone.

Greene asked if there was anything in his own life experience that Nardone could picture clearly in his mind. Nardone mentioned an amusement park in Revere Beach, Massachusetts, near his childhood home.

"If you can flesh out that world in your mind . . ." Greene suggested, "then you might really have something."

Now Nardone says he never stops drawing, never stops working, because he has an inexhaustible store of memories to work from. He's creating from memory a remarkable series of pen-and-ink drawings. The images are crowded with details and figures; for instance, in a vista spanning two pages, a vast wooden roller coaster with every beam and cross-brace articulated exactly, or an avid look into a remembered bumper-car arena, attention focused on every aspect, including the tracks, and cranks against the ceiling, and rousing encounters of the child-crowded cars on the ground. Other drawings show views into his family's kitchen; pictures of and with his father; chronicles of family, of connection, of a gentler, happier, more vivid time than the decades of his incarceration.

"[Prisoners] have huge bodies of experience to draw from," Greene told me, "and they go about their work with complete concentration. In a way, this is an ideal teaching situation. These artists have no distractions to deter them from this work—some of them work upwards of ten hours a day at their art."

As an example, he showed me a pile of three hundred watercolors by Lester Allen, completed in just one year, along with another pile of pages, with song

Vincent Nardone, "Blast from the Past in Black and White, I," c. 1990s. Pen and ink on paper. *(Courtesy of the artist and Jeffrey Greene, Prison Arts Program/Community Partners in Action.)*

lyrics that "THE Lester Allen" (as he signs his self-portrait) says "just keep popping into my head."

Prison is not a place that offers a "window on the world," to use the old Renaissance phrase. Its purpose is to isolate convicted felons from the world, to lock them away where they can do no further harm to society. In the meantime—while convicts are pent up for years or decades or lifetimes in tiny, crowded cells and rigid schedules—correctional institutions are engaged in a wavering moral dialectic. There are those who view a prison simply as a "penitentiary"—a place of punishment, of penance. And yet, rising from a nineteenth-century attitude of enlightenment (albeit with a resolve that varies greatly from time to time, place to place, political campaign to political campaign) there is the notion that one of the functions of prison is to "rehabilitate" prisoners.

That's where art comes in, not as occupational therapy or hands-on busywork, but as an engaged and challenging investigation of feelings and ideas. Under the most limiting conditions imaginable, art programs were offered and flourish stubbornly in prisons in some thirteen states in 2001, at the pleasure and whim of state governors and Departments of Correction. According to the

Jesus Rios, "God's Houses,"
c. 2001. Recycled cardboard,
stitched with raveled thread.
*(Courtesy of the artist
and Jeffrey Greene, Prison
Arts Program/Community
Partners in Action.)*

Prison Arts Coalition *(http://theprisonartscoalition.com/programs/)*, in 2012 there are art programs in more than forty-three states. These art programs exist not only because there is a deeply felt need for self-expression, but also because there are teachers who care passionately about their inmate-students, and because there are correctional officers who have come to see the positive impact such programs have on the lives of their charges.

Take the officer who called Jeffrey Greene when he discovered that Jesus Rios—deaf, mute, illiterate, and an internee at a maximum-security mental health unit—had constructed a life-size cellmate out of Saltine cracker boxes. Greene told me that although Rios is one of the most isolated members of our society, he had found a way to make art, employing the raveled thread of his socks to stitch together three-dimensional constructions in cardboard. What he makes now are "God's houses"—freestanding, three-story cardboard buildings, some shaped like crucifixes with windows and doors.

"There are rules, and then there are people," Greene told me. His program "wouldn't have happened without the help of the correctional staff—they assist and encourage the staff in order to encourage inmates. It's one of the reasons the prison art program works so well" in Connecticut, he said.

Consider Greene's student Robert Michael "Lefty" Garabedian, mentioned at the beginning of this essay, the one-armed sculptor who fashions beautifully

colored amphibians out of disposable food trays. In a statement for the 2001 show, Garabedian writes that these works are "made of recycled materials like Styrofoam food trays, scraps of cardboard, paper, and whatever I see that might be useful. It's difficult to do sculptures in prison because we are not allowed any tools to sculpt with, so I use pens, pencils, plastic pen caps, and whatever I find that works. In some of these works I made my own paint using chalk pastels and floor-wax sealer, similar to clear acrylic. Once painted, each piece is covered with up to fifty coats of this sealer to bring out a fine gloss and durable finish."

Garabedian writes that he became an "artist at age eleven when I made my first metal sculpture and realized I could express myself better with sculpture than with drawing or painting. I was encouraged further after winning in art shows. Then at age sixteen, I lost my right arm because of a motorcycle accident . . . I refused to let it be a disability. I look at missing my arm as only an inconvenience. These works express my feelings for art, animals, and my amazement for the finest artist of all . . . Mother Nature, which is a constant source of inspiration.

"Working on these pieces in prison helps me in several ways. As I focus on each piece, I'm able to block out this environment. Also after I finish each project another few weeks or a month have passed by, plus I have something nice to show for my time. It took me about a year to complete these eighteen pieces. By creating and showing these reflections of nature I hope to call attention to the need for preserving our ecosystems for future generations of all animals.

Robert "Lefty" Garabedian, "Tortoise." c. 2001. Recycled food trays and cardboard, handmade paint, floor-wax sealer. *(Courtesy of the artist and Jeffrey Greene, Prison Arts Program/Community Partners in Action.)*

"[There are] rules in all prisons about contraband materials," Greene told me. In many prisons, bendable ballpoint pens are the only acceptable art medium; an extravagant supply list might include pencils, colored pencils, water colors (in plastic containers), and art-quality paper.

"Then again," Greene said, "there is a guy who works ten hours a day on his art. Those are ten hours when he is not making trouble."

The alternative? Phyllis Kornfeld tells of a prisoner she had worked with for many years, a model prisoner, without a mark on his disciplinary record, a wonderful painter active in the art program, who was sent across the country to one of the new for-profit prisons. There was no art program in that facility, no access to art supplies of any kind. The prisoner was confined twenty-three hours per day to his cell.

"I can't believe how cruel . . . " he wrote her, but he enclosed with the letter a faintly colored painting on letter paper. "I'm learning how to draw with M&M's and Skittles," he explained.

What does this tell you, Kornfeld asks, when a person is reduced to such a degree and still finds a way to make art—by soaking candies overnight in water in order to get a tint of green?

Prison Arts Program Annual Show 2001, at Real Art Ways,
Hartford, Connecticut. 2001.

*Claude Monet (1840–1926)
retrained our eyes, and his
work continues to excite and
inspire experimental innova-
tors.* "Water Lilies," 1906. Oil
on canvas, 34½ x 36½ inches.
(Mr. and Mrs. Martin A. Ryer-
son Collection, 1933.1157, The
Art Institute of Chicago.)

*Over decades, the works
of John Walker (1939–)
have made a personal and
documentary chronicle of the
catastrophe of World War I.*
"Passchendaele 1," 1996. Oil
on canvas, 108 x 192 inches.
(Yale Center for British Art,
Paul Mellon Fund, Accession
Number B1998.16.)

*Art is translation. While from a
distance the paintings of Chuck
Close (1940–) look "realistic,"
near their surfaces these works
appear to be just dabs of color.*
From the exhibition "Chuck
Close," The Museum of Mod-
ern Art, New York, February
25–May 26, 1998. (Photo:
copyright MOMA, licensed by
SCALA / Art Resource; copy-
right Chuck Close, courtesy of
Pace Gallery.)

*The assemblages of **Joseph Cornell** (1903–1972) are shrine-like, as the remnant objects he rescued from oblivion are imbued with reverence.* "Towards the Blue Peninsula (for Emily Dickinson)," 1953. Box construction. 14½ x 10¼ x 5½ inches. (Photo: Edward Owen / Art Resource; copyright The Edward and Robert Cornell Memorial Foundation; licensed by VAGA, NY.)

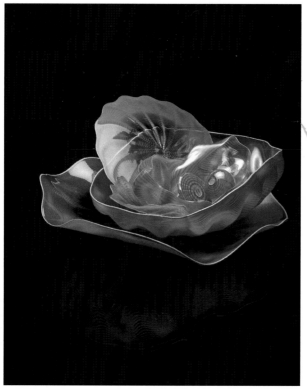

*Abstraction is a reflection of a spiritualizing ethos. The works of **Dale Chihuly** (1941–) resemble bowls and vases, but these marvelous forms seem pure as molten color.* "Honeysuckle Blue Seaform Set with Yellow Lip Wraps," 1993. Glass, 15 x 27 x 24 inches. (Copyright Chihuly Studio; courtesy of the artist.)

Bryan Nash Gill (1961–) has a visceral relationship with the land, and in his sculptures natural things are presented without being deformed. "Woods," site-specific installation at the New Britain Museum of American Art, 1996. Paint, tarpaper, and wood, 10 x 25 x 19 feet. (Courtesy of the artist and copyright 2012 Artists Rights Society (ARS), NY.)

The materials used by Nene Humphrey (1947–) are commonplace, but her sculptures evoke the mysteries of cosmic and cellular complexity. "Pierced Red," 2003, from the series *Small Worlds.* Corsage pins, felt, silk, 9 x 8 x 9 inches. (Collection of Barbara Sahlman; courtesy of the artist.)

The artistic process of Linda Ekstrom (1951–) has its sources in feminist values, spirituality, and traditional women's crafts. "The Visitation," 1998. Cotton gauze, rolled Bible text, 8 x 22 x 60 inches. (Courtesy of the artist.)

*In paintings by **Jacqueline Gourevitch** (1933–), based on sketches made from 10,000 feet up, the topography of a river valley resembles a geode's patterns or a leaf's veins. "Terrain #24," 1996. Oil, 68 x 54 inches. (Courtesy of the artist.)*

*The huge, vivid, and grainy painted surfaces of **Zbigniew Grzyb** (1943–) come alive through the sense of touch as much as sight.* Untitled, 1997 (detail). Oil on canvas, full dimensions 7 x 7 feet. (Courtesy of the artist. Photo by Michael Sundra.)

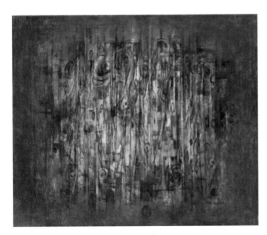

*The invisibility of **Norman Lewis** (1909–1979) may stem from his independence; as an abstractionist, he falls outside of the prevailing style of Black artists, and as an activist he rooted his canvases provocatively in the political. Untitled, 1949. Oil on canvas, 26⅞ x 31⅞ inches. (Digital image copyright The Museum of Modern Art, New York; licensed by SCALA / Art Resource, NY.)*

Edward Dugmore (1915–1996) approached "meaning" by suggestion, in the heft and swing of his muscular application of pigment. "1961 – D," 1961. Oil on canvas; 110 ¼ by 149 ¼ inches. (Private collection. Copyright the Estate of Edward Dugmore, Manny Silverman Gallery, Los Angeles.)

In the art of *Pamela Stockamore* (1952–), surfaces look ancient. Her work demands the kind of perceptive process with which an infant explores the world. "Sabiru Redux," 2010. Oil and dry pigment on paper, 38 x 38 inches. (Courtesy of the artist.)

Benny Andrews (1930–2006) often used collage, painting directly and also pasting in patterned fabrics, zippers, buttons, ribbon or lace, and recycled scraps from older paintings. "War Clouds," 1990. Oil and collage on paper, 74½ x 55½ inches. (Copyright the Estate of Benny Andrews; licensed by VAGA, NY.)

Sol LeWitt *(1928–1907)*
systematically sought every
possible combination of ele-
ments in serial arrangements
of graphic and architectural
forms. "Two Modular Cubes
/ Half-Off," 1972. Enameled
aluminum, 63 x 120½ x 91⅞
inches. (Copyright Artists
Rights Society (ARS),
NY; photo: Tate Gallery,
London, Great Britain / Art
Resource, NY.)

Lee Lozano *(1930–1999) created her works as*
extensions of ideas she composed in writing. Even
her paintings are direct enactments of a thoroughly
rational process. "24 Wave," c. 1968–1970. Oil on
cotton duck, 96 x 42 inches. (Copyright the Estate
of Lee Lozano; photo: Wadsworth Atheneum
Museum of Art / Art Resource, NY.)

Photography can be abstract, rather than directly representational. Where most photographers use a camera as a recording device, **Ellen Carey** *(1952–) takes the process apart, and the results are her subject. "Multichrome Pulls," 2007. Polaroid 20 x 24 Dye-Diffusion Transfer Prints from* Photography Degree Zero, *1996–2012; each print 77 x 24 inches, 77 x 88 inches overall. (Courtesy of the artist.)*

In the collaborative creation 50,000 Beds, forty-five artists coordinated by filmmaker **Chris Doyle** *were given twenty-four hours to make short films in hotel rooms, and in 2007 showings took place in three Connecticut venues: Real Art Ways (Hartford), Artspace (New Haven), and the Aldrich Contemporary Art Museum (Ridgefield). Stills shown here are from (clockwise, from top left): Pawel Wojtasik and Terry Berkowitz's* Three Chimneys; *Jorge Colombo's* Scott; *Karina Aguilera Skvirsky's* Giocanda; *and Tyler Coburn's* HOTEL HOTEL HOTEL. *(Copyright the artists; courtesy of Chris Doyle Studio.)*

For the installation "Hay House" (2004), **David Brown** *(1953–) recreated the interior and exterior of his actual home using oil-painted panels mounted on hay bales. He surrounded this recreation on adjacent gallery walls with 365 small painted landscapes.* Installation at New Britain Museum of American Art and at the Discovery Museum, Bridgeport, Connecticut. Exterior walls: oil on luan, 7½ x 12 x 20 feet; interior walls: oil/mixed media on MDO board, 7½ x 9 x 17 feet; landscapes: oil on MDO board; morning series 24 x 20 inches, afternoon series 24 x 18 inches. (Courtesy of the artist.)

The installations of **Iñigo Manglano-Ovalle** *(1961–) compel immersion; for instance, this full-scale reproduction of the type of trailer alleged by U.S. Secretary of State Colin Powell to be a mobile biological weapons lab, justifying the invasion of Iraq (but later conceded to be illusory).* "Phantom Truck," 2007. Aluminum and epoxy paint. Installation at Documenta 12 in Kassels, Germany. (Courtesy of the artist and Christopher Grimes Gallery, Santa Monica, California; photo: Barbara Sax/AFP/Getty Images, copyright 2007 AFP.)

*Embracing industrial materials and trashy colors, and defying a two-dimensional picture plane, the huge installations of **William DeLottie** are spatial contraptions, disobedient to the laws of physics (and art).* "The Imaginary Lover," 1999–2000. White acrylic paint, fabric attached to metal plates, aluminum poles, metal stanchions, black felt, with special halogen lamps for illumination, 10 x 17 x 4 feet. (Courtesy of the artist.)

*During World War II, 120,000 Japanese Americans were called "enemy aliens" and interned in camps, with a military exclusion zone along the entire west coast of the U.S. **Mona Higuchi's** installation used a section of fence that borders the former demarcation line.* "Line of Exclusion 1942–45, Verde Park, Phoenix, Arizona," 2006. Archival photographs printed on an adhesive-backed outdoor vinyl, affixed to ¼-inch sintra. Single photo panels were 5 x 49 inches, double panels were 11 x 49 inches, and triple panels were 17 x 49 inches, mounted along a fence 120 feet long and 6 feet tall. (Courtesy of the artist.)

*Many of the multi-part works by **Spencer Finch** (1962–) might be called paintings, but in their varied scale, materials, and sensory range they're akin to sculptures, with titles invoking historical, scientific, and poetic contexts.* "Abecedary (Nabokov's Theory Of A Colored Alphabet Applied To Heisenberg's Uncertainty Principle)," 2004. Ink and watercolor on paper, 9 x 30 feet. (Courtesy of Spencer Finch Studio, Brooklyn.)

*The paintings of **Mary Kenealy** (1953–), anchored in religious symbolism, are built from successive applications of color into strict formal geometries.* "Golgotha, Seven" (1995). Watercolor on paper; diptych: each 10 x 7 inches. (Courtesy of the artist.)

Joe Coleman (1955–) has a medieval sensibility, his style a mixture of Dante, Poe, and P. T. Barnum refracted through the Book of Kells, Hieronymus Bosch, Ivan Albright, and R. Crumb. "I Am Joe's Fear of Disease," 2001. Acrylic on panel, hospital gown, medical paraphernalia, 30 x 40 inches, including frame. (Courtesy of the artist and Dickinson Roundell, NY.)

Pioneering performance artist **Lorraine O'Grady** *(1934–) incorporates into her serial works the improvisatory process of photo-making, often in the midst of crowds.* "Art Is … (Woman with Man and Cop Watching)," 1983/2009. C-print, limited edition, 16 x 20 inches. (Courtesy of the artist and Alexander Gray Associates, NY.)

Yukinori Yanagi (1959–) collaborates with living ants to explore nationalism and community in "wall works" that are made with flat containers of colored sand, fashioned to look like national flags and interconnected with tunnels. "The World Flag Ant Farm," 1990. Red harvester ants, colored sand, plastic box, plastic tubing, and plastic pipe. 180 boxes, each 240 × 300 centimeters. (Collection: Benesse Art Site Naoshima, Japan. Photo: Norihiro Ueno; copyright Yanagi Studio.)

Jenny Holzer (1950–) asserts her critiques of society by having these pop up in print or illumination like advertisements. Having begun with hand-typed handbills, she now works on a vaster scale. "Xenon for BALTIC," 2000, from *Inflammatory Essays, 1979–82.* Light projection on Castle Keep, Newcastle, United Kingdom. (Copyright Artists Rights Society (ARS), NY; photo: Attilio Maranzano / Art Resource, NY.)

Janine Antoni (1964–) combines a conceptual artist's purist ideas and a "pop" playfulness with commercial products, meanwhile guided by a feminist eye that's hyper-aware of power dynamics. "Inhabit," 2009. Digital C-print, image: 116½ x 72 inches; frame: 119¹¹/₁₆ x 75⅛ x 3 inches. (Courtesy of the artist and Luhring Augustine Gallery, NY.)

It's a Dialogue

Mary Kenealy

To "see" Mary Kenealy's work, one must give her products a great deal more than a passing glance. She does not engage in free association, but true abstraction, drawing from life in a logically figurative manner. Kenealy's work is the careful product of long consideration and excruciatingly patient process. Rather than noisy commotion, her paintings offer meditative, Zen-like calm; they are tonally and psychologically dark, and are anchored in religious symbolism. Yet they are also very clear and legible, built from successive applications of rich color poured into stringent geometries of form. These are work in both meanings of the word: objects (which represent ancient symbol systems) and labor (evidence of the procedural sequences that brought them to life).

As is true of the most severe geometric abstraction, Mary Kenealy's water-colors require a considerable degree of receptivity from a viewer. Her images glower like embers, and they are spare—demanding a disciplined, patient reading. The approach they demand is well suited to the dark theme of passion suggested by the title of Kenealy's 1995 show at Paesaggio Gallery, *Golgotha*—etymologically, the skull: the site of Christ's crucifixion. These are works that suggest deliberately inflicted pain and yet also transcendent hope; pain and hope rendered at once sensuous and cerebral.

The dominant first impression of *Golgotha* is a result of these works' restrictive similarity and their lack of descriptive "event." A second impression, which emerges more slowly, is bedded in the seductiveness of their colors, which overcome the austerely repetitive format.

Long a printmaker, Kenealy's gift as a painter is her capacity for transubstantiation: she molds cold form and dead symbol into living surface by a system-

Mary Kenealy,
"Golgotha, Seven," 1995.
Watercolor on paper;
diptych: each 10 x 7
inches. *(Courtesy of the
artist.)*

atic and laborious working and reworking of impression. Her Paesaggio pieces
are small works, intimate in scale, yet their clarion colors resonate across the
muted spaces of this small gallery. It is this contradiction—a play of introverted
against extroverted—that gives *Golgotha* its credibility and depth.

The central image of *Golgotha* is a simple cross-in-square, glowing dimly
against a dark ground. This series of pictures presents like bare, four-paned
windows, all in a row. Aligned at eye level, they evoke a haunting cityscape—as
much the Holocaust as the Crucifixion, as much blind innocence as tragedy—
orchestrated by ever-deepening washes of crimson applied over a bright, taut,
opaque grid.

In final form, a Kenealy work may incorporate as many as twenty or thirty
layers of transparent red over yellow, yellow-green, blue-green, and turquoise.
In the over-painting there is a tinge of Prussian blue, added early, subsequently
buried in veils of red. This blue cools the red, drinking the light and subduing
its color "hit." What makes these pictures work is the sensual flex of modulated
color striving against the confines of a grid. The hard-edge format pits color
against color as if determined to dissolve the boundaries, and this provides the
pivotal tension of the show.

A medievalist might find multiple references in Kenealy's geometric con-
figurations, certainly, but so might a modernist. The foursquare format of each
small painting is face-sized and hung at eye level. In this consideration, *Gol-
gotha* takes on anthropomorphic resonance (the skull), as we regard the empty
sockets of an image that looks right back at us. The seventeenth century called
such a confrontation *memento mori,* a reminder of death.

Although mystical geometry may simplify the work (the cross signifies the

intersection of horizontal and vertical, temporal and spiritual), a kind of contemporary algebra elaborates and complicates the effect. A subtext is established in the bilateral division of the images within each frame. The pictures are paired, in diptychs, but as each twin multiplies its partner, it also divides the attention of a viewer, who will probably find it impossible to consider one piece outside the context of its counterpart, which compounds the visual complexity.

What is most striking about *Golgotha* is the way Kenealy controverts tradition. It takes nerve to render a subject as emotionally evocative as the *Fourteen Stations of the Cross* from a seemingly mechanical and objective point of view. Expression arises not from the story told, however, but from the way Kenealy frames the story. Her defiance of conventional piety is not forgetful but coolly considered, although her strategy is bedded in propinquity, not distance. Because they are so much alike, these dark images are all the more startling in their difference. Nuance is vivid in such context. One must look past surface impressions, peer through color strata through which "warmth" percolates, as brighter pigment seeks its way up through veiled and bloody shadows, a Byzantine journey of denial and delay orchestrated by the artist's determined optical procrastination. This is color that projects heat but not flame.

Kenealy's passion play is profoundly abstract. Although she has always been drawn to symbol, she has always sought to make symbols personal. In this series, her embrace of an old iconography is an appropriation that casts off tradition. Kenealy invokes meaning in a sequence of signs and touches. One must follow these signs directly with the senses, retracing the artist's steps, excavating them layer by imaginative layer. One reads in these paintings the character of Kenealy's process—purposeful and intensely felt, painstaking and layered.

Mary Kenealy. *Golgotha,* at Paesaggio Gallery,
Canton, Connecticut. 1995.

William DeLottie, Five Years Later

From the way I begin this second essay on his work, you can tell I am still flummoxed by DeLottie's irreverent approach to "painting," but I've now had the opportunity to interview him, which gives me a fuller picture of both his motivation and his intentions in the work.

As a rule, I'd rather not talk to an artist in advance of meeting his

or her work—it's almost impossible to approach an exhibition freely
when you've got someone's explanations answering your questions in
advance. I figure I'm not much use to an artist if I come to the work with
preconceptions in place, since what kind of barometer can I be if I'm set up
to understand before I get there?

On the other hand, with truly unconventional approaches it can be
very hard to grasp the full character of an artist's impulses without some
firsthand exposure to the logic that's behind them. After five years, there
had been a considerable shift in DeLottie's approach from the previous
exhibit I'd seen, and the new work demanded a more conceptually based
perspective.

When I met with him to talk, DeLottie had recently been accepted
to the 2000 Whitney Biennial, quite an honor for an artist who works
out of his rural Connecticut studio and rarely makes the rounds of hip
establishments in New York. As I prepared to meet him, I was interested
not only in how his work had changed since I'd first seen it, but also in how
he managed to keep working in relative obscurity. Some people seem to
believe—and like to complain—that art is some kind of a hoax, whereby
artists do ridiculous things and get outrageous amounts of money to do
so. But Bill DeLottie is closer to the model I encounter more frequently:
an artist who does work because he must, because it's fascinating to him,
because even off in the green belt of northeastern Connecticut in his "spare
time," he is determined to enter the conversation with culture that is the
entire point of being an artist.

My personal opinion, with such an artist, is that we should pay
attention.

As I acknowledged in a previous essay (see page 41, in chapter 3), you really can't call what artist William DeLottie does "painting," but this is what gained him entrance into the Whitney Biennial, that always-controversial Big Apple hothouse for contemporary art.

In an interview at his studio in Putnam, Connecticut, the tall, lean, and laconic artist remarked that he was pleased and happy to be part of the event and that he has felt for some time that his work belongs to the kind of discussion the Biennial generates.

He stated this as simple fact, and it is; for here is an artist who since the 1970s has been systematically pulling apart painting conventions, putting a magnifying glass to them, notion by notion, and putting them back together again.

William DeLottie, "The Imaginary Lover," from *Love Letters Straight from Your Heart, I and II*, 1999/2000. Installation: white acrylic paint; fabric attached to metal plates, aluminum poles, and metal stanchions; black felt; and special halogen lamps for illumination; 10 x 17 x 4 feet. *(Courtesy of the artist.)*

There is something very pure about DeLottie's work, and something extraordinarily disciplined. For all of his bizarre avoidance of the traditional formalities of aesthetics (his embrace of industrial materials, his love of really trashy colors and patterns, his defiance of the illusionistic restrictions of a two-dimensional picture plane), he has an eye as finely tuned to the balance of line, shape, spatial relation, and color as any modernist painter I can name.

For many years his workplace has been one variety or another of a second-story walk-up in Putnam, Connecticut, an old mill town now experiencing a second incarnation as a center for buying and selling antiques. By the late 1990s, his studio was a kind of gypsy playroom/fish tank/bulletin board, with carefully placed chairs for viewers of his work. In one corner of the room a huge pile of his working materials climbs toward the ceiling: bolts of upholstery fabric and Day-Glo yard goods, hunks of foam rubber, sheets of colored paper, photocopied enlargements of magazine photographs, crumpled wads of tin foil, duct tape, and fuzzy chenille balls.

As for the work itself, *Love Letters Straight from Your Heart* (I and II), which when I visited occupied two walls of the space, is *not* panel painting, that's for

sure. There is almost nothing that hangs on the wall—although huge slices of the wall itself, vividly bordered in a fat black outline, are part of these pieces. Instead, we are offered a variety of fabric-draped rectangles that sprout laterally on poles, in crazy echelon, like weirded-out jousting shields craning, front-on, to the viewer.

These great installations (some twenty feet wide, stretching floor to ceiling) are not "pictures," per se, but spatial contraptions that project out at you like a city block of skyscrapers tipped on its side. The effect is a sight as disobedient to the laws of physics (and art) as that film clip in which Fred Astaire taps his way around the walls of the room—floor, wall, ceiling, all shifting places to accommodate his play. As on a film set, in DeLottie's installations light stands are placed strategically; however, unlike on such a set, which is designed to hide its means from the eye of the camera, these lights are a considered part of the whole optical experience.

You've got to recalibrate your way of looking to take all of this in; the effects are both blatant and wonderfully subtle. Bright rectangles of color—blinding chartreuse, black-and-white polka dot, red, silver lamé—are suspended separately in space, interspersed with an occasional black-and-white photocopy.

All the elements are arranged in parallel vertical planes, variously stepped forward from the wall, and the carefully directed light sources splash their echoing shadows across the wall, projecting a shadow-drawing into the space. Each of three lamps directs its light into the field, tripling the play of transparent shadows on the backdrop—two or three pale shadows per shield—causing them to lap and overlap as deliberately as any painter might illustrate them in an illusion. Only in the viewer's eye do they merge into a "picture"—which is the rationale for the vantage point proffered by his chair. It is an image that DeLottie sketches into by moving the light stands rather than by pushing pigment around with a brush. The resulting effect may be painterly, but illusion this is not—not the lights, the white wall, nor the gaudy fabric-costumed "props."

But a static viewpoint is not the object of all this business: DeLottie's three-dimensional construction invites you inside the picture, where, by moving around the installation, you encounter otherwise-invisible elements of social commentary (enriching "background" information) posted on the back side of some of the pictorial "shields." One such posting features photocopied images (1990s-variety and 1950s-variety "glamour girls," body piercing, bodybuilders, and so on). In another, DeLottie features seemingly random photos taken from his inexhaustible file of interesting characters: one is a decidedly Teutonic male (Eichmann at his trial in Israel), another is a young Isaiah Berlin (who resem-

bles DeLottie at the same age), and a third is an Arab youth. There's an image of American trains leaving Berlin, loaded with Nazi loot. These pictures just hang there, not highlighted in any way, skeletons in a backstage closet, yet as intentionally present as the song that lends this work its title, *Love Letters Straight from Your Heart,* in a thumping 1950s rendition by Ketty Lester. For the Whitney show, artists were asked to provide spoken commentary for the recorded audio-guides; DeLottie considered just playing Lester's song. Although issues of licensing squelched this intent, it would have been entirely in keeping with the oblique character of the artist's deconstructivist raveling.

"On the back . . ." DeLottie told me, "I always have this kind of commentary. I think of the back as another side that coexists with the front.

"I wanted to have things in real time and space—in the moment," he explained. "When you look at a painting, no matter what, it's never here . . . What I like is when [art] becomes experience."

"Twenty years ago I gave up painting," he said, and referred to his "black weavings," which were constructed of heavy strips of canvas permeated with dry pigment. "As much as I love painting and love to look at painting, I didn't feel I could bring anything to painting."

DeLottie put away paint and brushes, then even pigment, the timeless tools of artistic creation, limiting himself instead to what he can find in shopping malls and strip plazas, Home Depot and the local hardware store. Discovery trumps planning in this approach, which he describes as a kind of animism: his elements identify themselves, he says, from that pile of stuff in the corner. He responds by moving them into place when they catch his eye. "They find themselves," he says. "They come together on their own."

In contrast to his feelings for traditional artistic media like pigment, DeLottie told me that "fabric is far more personal to me." Compared with mixing a color, he said, "Finding a fabric someone has designed is definitely far more involved . . . Material is so universal—we use it, we wear it, we sleep with it. I felt more people could relate to material more than to paint."

He explained that he wants his work to be "beautiful and trashy at the same moment—like teenagers. I like to relate this work back to adolescence. There's something about coming out in adolescence that will never happen again—that sense of identity, need for peer approval and companionship—that's just wonderful. Teenagers take chances, take risks, ninety-nine percent of which they get away with."

Although he can sound easygoing, even casual, he agonizes over the coordination of every optical impulse that he presents—where it sits in space, how it

plays in the context of other elements, both optical and narrative. Most noticeable in his process is DeLottie's embrace of free-wheeling risk: a willingness to cut loose from all the trappings that for most people signal art as art, yet an ability to discipline himself to the age-old task of putting everything together.

He intends that the results will have a kind of universality unavailable to conventional ways of making art. In effect, he has turned the central conceit of Western painting—the idea that a picture is a window on the world—inside out, because in DeLottie's conception of how things work, it is the *viewer* who is put in the box.

The Renaissance conceit of perspective is based on the construction (in two dimensions) of a hypothetical box of space. The front plane (the viewer's "window") is a rectangle that corresponds to the shape of the painting's frame; the illusion is a sense of floor, ceiling, and side walls all visible through that frame but diminishing in size as they "go back" in space. Carefully calibrated geometry determines the scale and position of each object within that illusionistic "space." In *Love Letters Straight from Your Heart,* which acts (visually) like a painting, the box is an actual room, which the viewer can physically navigate. DeLottie allows the viewer to step through the fictive construct of the picture plane and experience this work in actual time and space, giving access to its backstory *not* from museum wall text, but within the context of the work itself. Indeed, his challenge has been to make the viewer consciously aware that there are two systems operating at the same time.

"I always have chairs as a prompt," he explains. "I expect people to sit down and look at the piece."

DeLottie's strategy is very much at odds with the Renaissance's scientific methodology. He is an artist who works intuitively, not geometrically, to construct a "picture" (if one can call these contraptions pictures). His process is a matter of creative trial and error. "Ideas don't always work," he says. "You have to do it first; you have to see it. When I'm in my studio, I don't want to know anything—if it's raining or snowing, day or night. I don't even play the radio. For me, the relationship between parts is everything. I try to cover all the bases, so when [a work] is installed, it's all worked out.

"*Love Letters Straight from Your Heart* is a perfect thing to me."

<div style="text-align: right">

Interview done by Patricia Rosoff during a studio visit with William
DeLottie as he was looking ahead to the Whitney Biennial. 1999.

</div>

Spencer Finch

*When I first encountered artist Spencer Finch, who was installing work
at the Wadsworth Atheneum Museum of Art's MATRIX gallery in 1997, I
found the whole place in turmoil. Finch was attempting to recreate a work
called* Self-Portrait as Crazy Horse. *He had been standing on a footstool
for many hours, with flood lamps focused on him in an attempt to fix his
shadow on a wall that had been treated with light-sensitive chemicals. The
process wasn't working, however, and the museum installer was sending
assistants scrambling to get another type of flood lamp.*

*This was an absurd calamity, of course, technology stomping its
ubiquitous foot and foiling the best-laid plans of artist and curator, but
absurdity was highly appropriate for such an artist as Finch, whose
playground is the never-never land in-between conventional and
conceptual art. This was an exhibit of widely varied work. Each object was
the result of careful consideration as to both form and medium, and those
considerations, ultimately, were more important than the product that
culminated from them.*

*At first take, Finch's work is overridingly bland; he deliberately
underplays its effect. His strategy begins not with the visual impression,
but with the dawning conflict between the visual impression and the wall
title.*

*In the interview that follows, Finch remembers his first one-person
gallery show at the Tomoko Liguori Gallery in New York City in 1992 as "a
bit of a disaster."*

"I came with huge expectations," Spencer Finch recalled, "and, straight out of
art school, lots of text. At the opening I had all these Xeroxed sheets, which,
when I walked out of the gallery, I was dismayed to find filling the garbage can
right outside on the street corner.

"I learned a lot about the gallery system in that show," Finch said, "and
about viewers. The show was dull—photographic work based on Freud and on
Renaissance perspective devices, set in Dallas on the site of the Book Deposi-
tory building. Very minimal, but not visually engaging."

This was a misjudgment, he said, that set him back on his conceptual heels
and forced him to reconsider his job in relation to the viewer and his affection

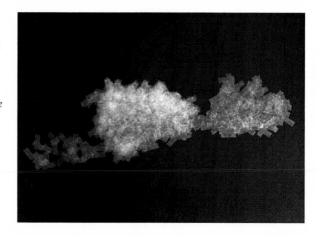

Spencer Finch, "Cloud Study, Cumulus Humilis," 2010. Scotch tape on paper, 21 x 29 inches. *(Courtesy of the artist.)*

for the beautifully made object. He was not shaken, however, from the determination to grapple with ideas as art.

That experience so early in his career has borne remarkable fruit. His work is wry and but also straightforward and convincingly earnest, and the combination situates him at a crossroads between two of the most contentious currents of modernism: between aesthetic and conceptual concerns, between so-called elitist and so-called democratic processes. He dodges back and forth between two opposing perspectives: the first is painter Frank Stella's argument that "what you see is what you see." The second is at the crux of conceptual art, that what you see is *not* what you see—it is only the physical spin-off of a concept, which is the true art.

Finch believes that both are true, and neither.

"I see the whole pursuit as incredibly serious," he says, "but also absurd—too absurd to take seriously. Sometimes I get this sinking feeling—what the hell am I doing?"

What his MATRIX show revealed, in forms strikingly unpretentious and brimming with humor, is his affirmation of art that "in its very failure points to a possibility that is beyond the realm, say, of representation."

Spencer Finch's MATRIX exhibit comprised a mix of objects that might loosely be called paintings, if their titles didn't jarringly abut their visual realities, providing sensory as well as physical locales for largely uneventful visual experiences. One of the pieces (part of a series) is an oval of frescoed plaster entitled *Ceiling (above Freud's couch, morning effect, 19 Berggasse, Vienna, Austria, February 19, 1994)*. The abstract vagaries of a series of ink-stained *mutsu*

(mulberry) papers are given a location, a framework, and a sensation by the title of *Grand Canyon (from Valhalla plateau with my eyes closed, morning, late morning, noon, evening effects, October 16/17, 1995)*.

There might be nothing more to these works than the material fact of them and the incisive poetry suggested by their titular explications—except that there is a whole world of meaning implied in the gap between the two declarative realities that he presents: one visual, one verbal.

At face value, there is nothing ambiguous or poetic about either, alone.

"My intentions are generally obvious," says Finch, pointing out that of course a painting of a ceiling would have to be a fresco. "My work is almost always literal—pictures of something, as accurate as I can make them. The medium is chosen for conceptual reasons. Some people will look at the work as abstraction, and then learn it is representation. I am interested in both pure visual and conceptual and how it all unfolds. Especially if it unfolds interestingly."

Self-Portrait as Crazy Horse was the central image of the 1997 MATRIX exhibit. It is a historically logical nod to the Oglala Sioux chieftain most often remembered for crushing General George Custer's Seventh Cavalry at the Battle of Little Big Horn in 1876. The title points up the contradiction of the minimalist image (which is a portrait not of the chieftain's presence, but of his absence). No image comes down to us of Crazy Horse (allegedly due to his aversion to photography), so Finch's strategy is to monumentalize this antipathy by performance. He "sits in" for Crazy Horse on-site in MATRIX, employing the vintage photographic methods (an improvised version of the "photogenic drawings" pioneered by Henry Fox Talbot), standing for eight hours in front of studio lights in order to capture a shadow on the gallery wall.

The implicit irony is that Crazy Horse may have refused to be photographed because he believed that having his shadow "taken" would steal his essence. Finch effectively agrees, although his grievance with the photography is not its power to capture life, but rather its incapacity to do so. By parallel, Finch's process also meditates upon the efforts of American artist/ethnographers during the great period of western expansion after the Civil War, who sought to "document" the images of Native Americans even as Manifest Destiny spelled their cultural extinction. The physical manifestation of Finch's artistic process was a vague white silhouette on a blue wall, created by the glacier-slow-motion reaction of photographic chemistry, taken out of a closed black box and projected directly, life-size onto the white walls of the gallery.

Finch's strategy is to quietly confront the simplistic notion that photography

might have captured Crazy Horse—or anything else, for that matter—at all. That critical skepticism about the capacity of art to render experience informs all of Finch's work in this show. That is the heart of his raging debate with culture. For those of us who have waded so often through the esoteric linguistic gymnastics that seem to go hand in hand with contemporary art, Finch states his case with sensible economy and grace.

Scrupulous authenticity is his modus operandus. He travels to specific locations, carefully documents everything he finds there, and literally translates his experiences into meaning-appropriate media (wax encaustic for a series of works on Icarus; fresco for Freud's ceiling; pin-hole photography for renditions of Civil War battle sites). Such choices are conceptually necessary contingencies, and the balancing tension of his approach, which pivots on the contrast and the contradiction. In each case, however, the choice of medium is spelled out within the formal context of gallery convention (titles on wall tags) but without other fanfare—if not without philosophical ambivalence.

These titles are sometimes problematic for Finch. He admitted that he struggles with "when to add information that is necessary and how to present it. You can't exactly write it on the edge of the canvas or pipe it in over the PA system. I haven't found a way to get it in besides the title."

Finch's central strategy is to ground things in lived experience, in art history and world history—and then launch them somewhere out of grasp. His intent is to find a sentient balance between the two polarities, between the concrete and the abstract, and reaching for this seeming impossibility he achieves his most poignant success.

"There is always more complexity to be discovered," Finch has written. "It's like a struggle to attain what is ordinary."

In his work Finch asserts that the things we call experiences are really memories, and ultimately subjective. Color, an attribute that most people think they understand, is frequently his starting point. What is the color of blue in the patch of sky where the space shuttle Challenger exploded in January 1986? What is the color of pink of the pillbox hat that Jackie Kennedy wore when JFK was assassinated? Is it this, or this, or this? What is the "color" we see behind closed eyelids (when "looking" at the Grand Canyon) at morning, late morning, noon, and evening? Look, Finch suggests, because look we must, but we must be aware of our puny capacities in the face of genuine wonder.

Can any of these colors even be recalled exactly, let alone simulated in art? And if experience can be firmly attached to visual perception, have we not di-

minished the experience? These are the questions a young Spencer Finch has raised, his theories mimicking those of Monet, that stubborn, insistent old observer. Finch is nodding to the Master, and, ever so gently, mocking him—and us . . . but, at the same time, holding a door open to where we might go from here.

Spencer Finch. *Spencer Finch / MATRIX 133*, at the Wadsworth Atheneum Museum of Art, Hartford, Connecticut. 1997.

Lorraine O'Grady

Lorraine O'Grady made her name in the art world initially by pitching a cultural fit. Young, attractive, full of irritation and audacity, in the early 1980s she crashed the party in New York, barging in and yelling her head off. What's so interesting about O'Grady's form of so-called performance art is how obnoxiously she refuses to play by the rules. Neither theater nor gallery art, stand-up comedy nor self-immolating social protest, her art defies constraint and makes its own rules.

I find O'Grady's performance work especially difficult to deal with, partly because the confrontation she seeks makes me squirm, partly because I like good old traditional painting and sculpture, and partly because like all racial fury, her pieces leave me bewildered about what I am supposed to do.

Nevertheless, there's a sassy humor to O'Grady's onslaught that's hard to discount and an inescapable satisfaction in her metaphorical choices. Certainly, it's hard to shake the image she creates by sashaying into galleries where she hasn't been invited and delivering her challenging proclamations.

L orraine O'Grady, transfigured into a tiara-crowned beauty queen and identified by her sash as "Mlle Bourgeoise Noire 1955," barged her way onto the New York art scene in the early 1980s. Quite ceremoniously, though completely unannounced, she stormed onto the uptown art scene as a cultural critic, crashing hoity-toity art openings and demanding straight out that black artists "take off the white gloves" and "invade" the art world.

English professor, *Rolling Stone* rock critic, former State Department econo-

Lorraine O'Grady, "Mademoiselle Bourgeoise
Noire Leaves the Safety of Home," 1980.
Photograph of performance. *(Courtesy the artist
and Alexander Gray Associates.)*

mist, and self-taught Egyptologist, O'Grady brought together a variety of dispa-
rate threads in her life—patchwork personal background, intellectual strivings,
eclectic interests, I-refuse-to-be-conventionalized outlook—and found herself
at mid-career a persona that denied none of these roots and expressed them
all. Under the commodious umbrella of performance art, O'Grady became an
artist.

As the scope of her work widened, leaving behind the ephemeral theatri-
cality of performance art and reaching for a more contemplative visual arena,
O'Grady was featured in her first one-person museum exposure, *Lorraine
O'Grady: The Spaces Between,* at the Wadsworth Atheneum. This was a show
intended to acknowledge O'Grady's emerging status "as an important national
figure in contemporary art," according to Andrea Miller-Keller, Emily Hall Tre-
maine Curator of Contemporary Art at the Wadsworth Atheneum.

O'Grady is a black woman whose work subjectively addresses her own expe-
riences, yet she refuses to be characterized in any way as a spokesperson for the
black experience. This is a big point with her, an issue of self-determination
and of fundamental respect for the complexity of blackness. Her work targets
just this kind of oversimplification, which she feels comes from the hierarchical
Western notion that things must be either all white or all black, all good or all
evil, all male or all female, all culture or all nature.

Instead, O'Grady's fascination is with "hybrid" culture. In her images she
seeks to establish the connections between what society chooses to call oppo-

sites. She tries to demonstrate that culture is not a matter of racial stratification but of complex and ongoing negotiation, sometimes white or black but more often both white and black at the same time.

This concentration on ties rather than rifts is the core of her radicalism and gives her work a distinctly shaded character. With a determined focus on the richness of a blended culture, she revisits the old WASP idea of the melting pot from an entirely new angle.

"I was drawn to O'Grady's work," said Miller-Keller, "because it challenged a variety of accepted cultural paradigms: the binarism that holds our Western thinking in a vice, the concept of race (which is not in fact a scientifically verifiable concept), and the notions of elegance and where it can be located. Above all," Miller-Keller adds, "the work is so beautiful and so damned smart."

The exhibit at MATRIX demonstrated what O'Grady means when she calls visual art "a heightened form of writing."

The gallery is divided in two. Each half presents a different body of works, each of which began as performances and have been developed into less transitory documentary form. The relation between the two parts is neither direct nor directed in the exhibition, which is unusually explication-free for MATRIX, a space that prides itself on making ideas accessible to the uninitiated public.

The point of this curatorial restraint is revealed in the show, which is animated by what the artist calls its "spatial" rather than "linear" relatedness; that is, by the fact that the arrangement of parts makes sense overall but somewhat mysteriously, and not in neat little logical steps. This is precisely the point.

The Spaces Between is the title on the wall that greets the viewer. At every turn, it is spaces we meet; juxtapositions, rather than entities, are the salient experience. In one room a gown, made out of white gloves (once worn by Mlle Bourgeoise Noire), is laid out under plexiglas like an Egyptian mummy. Above this case, a shrill poem on the wall reads:

<div align="center">

WAIT

wait in your alternate/alternate spaces

spitted on fish hooks of hope

be polite

wait to be discovered

be proud

be independent

</div>

tongues cauterized at openings no one attends
stay in your place
after all, art is only for art's sake
THAT'S ENOUGH!
don't you know
sleeping beauty needs more than a kiss to awake
now is the time for an INVASION!

On one side of the exhibit space, a series of thirteen photographs wrapping two walls records O'Grady's 1981 intrusion (as Mlle Bourgeoise Noire) into an exhibition of nine white performance artists at the New Museum of Contemporary Art, New York. Documented here as an intermingling of words, images, and physical memorabilia, there is little of the immediacy and shock that O'Grady must have generated when she swept into the gallery. At the time, she distributed flowers, threw aside her cloak and lashed herself with a cat-o'-nine-tails, and then, after pronouncing her poetic challenge, swept just as suddenly out of the room. Yet, as O'Grady explains, what the shift from the event of performance to the quiet permanence of installation may have lost in confrontational dynamism, it has gained from the chance to "sit still" and let the ideas come together for the viewer.

Likewise, *Miscegenated Family Album,* the installation in the other half of the MATRIX space, is an evolution from slide presentation to black-and-white photographs that allows a more patient savoring of imagistic irony. This presentation pairs ceremonial images of Egyptian Queen Nefertiti with family photographs of O'Grady's sister, Devonia Evangeline. The linking is incongruous, accomplished by noticeable parallels in feature, pose, or gesture but involving as well all manner of connections developed through O'Grady's intimate knowledge of both subjects.

Some of these links can be deduced from the diptych titles; for example, "Worldly Princesses"—on the left we see Nefertiti's daughter, Merytaten; on the right we see Devonia's daughter Kimberly.

Many of the connections, however, can only be sensed. The enlarging aspect of the artist's musings gives this room its lingering powers. The very familiar image of female family members gussied up at a reception, distributing smiles, beverages, and pieces of cake is placed next to a ritualized relief carving of Nefertiti, arms raised, beverages in hand, making an offering to the sun disk Aten, represented with many rays of light, each terminating in a hand that reaches back toward the Queen in kind.

The bizarre mix of elements—hands, plates, arms, offering, formality of dress—bridge the two images with a visual empathy that overcomes puzzling gaps of iconographic meaning and make tedious any questions of "why." The truth of the figures' positioning is a subjective matter, dependent neither on art history nor on sermons on social posturing, and the strength of this work, while unverifiable in any specific proof, is in its fascination.

Significantly for O'Grady, however, the paired figures' hybridity is essential and positive.

O'Grady traces the mixed threads of her upbringing along racial (black and Irish), regional (West Indian), social (upper-middle-class, British colonial), educational (private, classical), and inspirational (I am what I am, not what you want me to be) divides. Long ago, she decided to refuse to be one thing or the other. Looking back later, she could see that her personal experience, "however arduous," was far from unique, but instead is increasingly typical in a world where, she says, "we will all have to become bi- or tri-cultural."

O'Grady's attempts first to rebel against and then to reconcile confining and conflicting categories in a society split along racial, sexual, and cultural hierarchies have led her to confront a world that refuses to acknowledge its hybrid nature. The opportunity of this MATRIX installation came to her, said O'Grady, at a turning point in her realization of mission.

"I have always acted on how I felt," she told me, "but I am just beginning to arrive at a clearer sense of what that might be.

"Mobilization of emotion is necessary for the sharpening of intellect," O'Grady said, going on to describe how something as subjective as anger can seek its form as art. The persona of Mlle Bourgeoise Noire was born out of O'Grady's anger about black artists internalizing white condescension.

She insisted, however, that while "anger is enabling of thought . . . a shout that's not aesthetically and conceptually layered is going to drop to the floor five inches in front of your face."

Only a shout that has been framed is going to project, and projection has been her intent. Through her art, O'Grady has made a career of speaking up—walking into situations controlled by others and making a calculated scene, or taking images that people accept without a second thought and inserting things-that-don't-belong right alongside them.

O'Grady's work is intrinsically defiant in its insistence on subjectivity, and evokes her conception of a black woman as an agent rather than an object of history. This is the central principle of all her forms, and was certainly the genesis of her original metaphor, Mlle Bourgeoise Noire. That persona, smiling on

the arm of her tuxedoed male escort, arrived where she had not been invited, wrapped in a cloak and dress made entirely of white gloves—180 pairs of muted empty palms and 900 pairs of muffled fingers stirring to her graceful swagger, clapping soundlessly as she moved, delivering her shout to the world:

<div align="center">

THAT'S ENOUGH!

No more boot-licking . . .

No more ass-kicking . . .

No more buttering-up . . .

No more posturing

of super-ass . . . imilates . . .

BLACK ART MUST TAKE MORE RISKS!

</div>

Lorraine O'Grady. *MATRIX 127: The Spaces Between,*
at the Wadsworth Atheneum Museum of Art,
Hartford, Connecticut. 1995.

Museums and My Continuing Education

For people, like me, who grew up outside the excitement and stimulation of the "art scene," museums have offered exactly what the Enlightenment thinkers had envisioned—doorways to far-reaching histories and ideas; repositories for priceless archeological and cultural treasures and timelines of stylistic and intellectual change. The product of democratic thinking, like libraries, these modern palaces certainly showcase artifacts that no commoner in any other time period would have the privilege to experience firsthand.

Beyond such cultural treasures, however, there is the eternally unsettled matter of what's going on today, a vast, unevaluated tumult of strivings of every sort. Art schools are pumping out graduates by the thousands every year; less credentialed entrepreneurial types are elbowing their way onto the scene, as well. Hidden away in musty garage-studios, there are also individuals who may not be "discovered" until after they die. There is no official clearinghouse, no central committee to judge (other than grant-giving commissions, but that's another story); not even, in this diverse, global, free-market age, a common set of standards by which such things might be judged.

Ground-breaking art, by definition, is unorthodox and experimental. The logic of the terminology is instructive: avant-garde (vanguard, or front lines) is a military reference. Taken as an impulse, this work—since it is still in-the-making, is a living thing, sprouting up wherever its makers can find a toehold—is not generally the charge of the traditional museum; in fact, the traditional museum is often the target of new art's critique. One has to give credit, then, to the move in the twentieth century, as the gap between art making and its popular audience has widened, to carve out some space for "experimental" forms: gallery spaces like the

*Wadsworth Atheneum Museum of Art's MATRIX, for instance, that
pioneered the concept of a gallery for contemporary art within the context
of the traditional museum.*

*Contemporary art curators have a particular mission—part staging,
part education, part critical articulation—and their role is to make new
ideas accessible to folks that might not be expected to consider them. It is
from such work that I came to understand art (and museums) not in terms
of static inventories of magnificent objects, but as a forum for the ongoing
dialogue between the present and the past carried out in physical form.*

Yukinori Yanagi

*This review probably speaks for itself, really, highlighting an artist whose
work was extremely interesting not only on a conceptual level, but also
visually. It was a challenge to interview Yukinori Yanagi, partly because
he is by nature reticent, and also because his command of English was
limited. What was amazing to me was to discover just how much room for
commentary one might find if you just slowed down, got on your knees,
and paid attention to the fierce little insects in his paintings.*

A shy child, growing up in the Japanese countryside, Yukinori Yanagi was
fascinated by ants.

"Ants are one of [my] best friends," he said to me in an interview at the Wadsworth Atheneum.

As a child, he made an "ants' map," showing the world from the point of view
of ants. As an adult artist, Yanagi's gift has been to reverse the lens of his critical
investigation outward, focusing instead on human society but as if from the
position of his friends, the ants.

It is this dispassionately alien perspective, reinforced by Yanagi's experiences as an outsider in Japan and in the United States where he now chiefly
resides, that gives his work its crucial sting. That he chooses to find empathy
with another species gives his work an element of parody, which makes it both
immediately accessible and lingeringly resonant.

An installation at the Atheneum's MATRIX gallery combined a naturalistic
objectivity, a child's naïveté, and a social critic's relentless edge in a wry juxtapo-

sition of elements that, while utterly Japanese, rang like a Kafkaesque *Gulliver's Travels*.

Ants, like humans, are one of the most successful species on earth. It is calculated that they exist in equal mass, pound for pound (said to be something like a million ants per person), with humans and they populate their respective ecological niches with equivalent dominance and comparably organized ferocity. Like their human counterparts although more so, ants are warlike, territorial, and relentlessly aggressive. Socially sophisticated, omnivorous, and essentially fascist, ants practice genocidal annihilation with an absolutism that is appallingly familiar to people—a bipedal vertebrate group legendary for our "inhumanity."

That ants are regarded as harmless by people is a mere happenstance of scale. These small creatures overmatch us in strength, organization, and cooperative determination, attributes that we blithely overlook, maybe because while they may outnumber us, we outweigh them. As for the ants, if they are aware of us at all, we are too gigantic to be perceived except perhaps as an unpredictable feature of the landscape.

Neither species has an eye gauged to give significance to the other. This is the irony in perception that provides the central humor as well as pathos in the work of Yukinori Yanagi.

Seen against the backdrop of Japanese culture, in which the sacrifice of individualism to unquestioned nationalism is a deeply embedded societal value, Yanagi's work offers a blasphemously skeptical examination of such assumptions. From a wider geographic vantage point, such critique is also timely, viewed in light of the Japanese economic miracle since World War II—a success story to which the contemporary American business establishment often compares itself with both competitive apprehension and diagnostic emulation.

To this conflicting mix of perspectives, Yanagi offers an allegory built of ants.

The power of his work is maintained by the almost clinically neutral—and resolutely biological—examination of such issues as fixed boundaries and containment. The key to Yanagi's artistic effectiveness is a certain self-effacement coupled with probity in the limitations he imposes on the "free will" of ants. As an artist, Yanagi appeals to our fascinations with other forms of life in a directly engaging manner that raises, almost incidentally, discomfiting questions about humanity.

What Yanagi presents to us is the "world" of living ants—carefully contained,

mounted, and displayed in a context of human scale and human symbolic concerns to which the insects are naturally oblivious. Design decisions, in Yanagi's practice, might be more properly characterized as biological imperatives than as aesthetic options.

There are two related works, *America* and *Wandering Position,* in Yanagi's 1995 MATRIX exhibit.

America is a "wall work" made up of thirty-six separate national flags, representing the countries of North and South America and mounted on the wall in a regular grid. Each flag, fashioned from a panel-like container of colored sand, is an actual ant-farm, and is connected to the rest by clear plastic tubing that serves as conduits between the farms/countries for the tunneling ants. These tiny creatures, red harvester ants from southern California, enter the complex from visible feeding stations on the other side of the mounting wall. The ants dismantle and deform the national banners in utter disregard of human intellectual constructions.

With surprising poignancy, Yanagi has set up a demonstration of parallel blindness as a kind of lens. There is something inescapably compelling about the small, living drama of these efficient drones, which appear to be identically bedecked in narrow-waisted business attire, as they follow some inexorable program to which we in our majestic distance see no logic. Queen-less and consequently sterile, this ant society nevertheless presses on with urgency, piling up the bodies of those who die in the traces, making neat cemeteries, and acting out the mercantile imperative. Order is imperative: One more or less doesn't matter! Get back to work!

Both the approach and the focus are different in Yanagi's second MATRIX work, *Wandering Position,* which is the "floor work" in the other half of the gallery. Like its companion piece, this one carries forward the theme of containment. Yet here the ant is present only in the form of a record of former presence.

Except for its position on the ground and the loosely framing placement of four dark metal railings—serving as walls of a rectangular containment area for the ant-participants in this performance piece—*Wandering Position* might be taken for an abstract drawing.

Upon a wide, beeswax-coated surface of paper, scuffed and blackened, a neat rectangle is outlined in red and filled with meandering crayon paths that "travel" across this demarcated terrain, densest at the edges and largely vacant at the center, as if the travelers who left these paths were hesitant to cross the vast middle plain. This large work, 168 by 180 inches, is the record of a perfor-

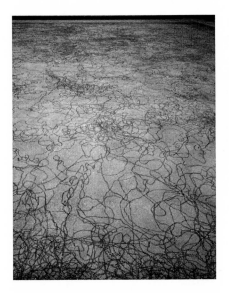

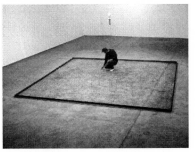

Yukinori Yanagi, "Wandering Position," 1997. Ant, steel angle, wax-crayon, 520 x 520 centimeters. Artist at work with ant (above) and detail (left). *(Courtesy of the artist and copyright Yanagi Studio.)*

mance piece carried out by Yanagi on his hands and knees as he knelt to follow the movements of a series of individual ants with a red crayon. For several hours each day over a period of weeks, the artist gave himself over to the directive of the insects. While the drawing's passage is confined to the bounded rectangle, each of the ants was free to move within that frame. Yanagi did not "drive" the ant but followed it, tracing its movements with his crayon, as patient as he had been when as a small boy he viewed ants as "best friends."

"Each kind of ant has its own character," he said to me, going on to explain that the black ants who were part of this piece (gathered from Washington Square Park in New York) left a more circuitous trail than the edgier red ants from California, who had left a more angular pattern of marks in an earlier drawing.

A drawing like this takes many crayons, he said shyly, noticeably animated whenever our conversation involved the ants. "They wear down quickly."

To a large degree, the effectiveness of these two works derives from Yanagi's very evident empathy for ants. And yet . . . ants are mere insects.

But the impact of these works originates in an intricately layered reading of social systems of a "lower order" of creatures that just happen to magnify our own. These pieces are presented to us using a child's vocabulary of presentation by a man who will find insight where it presents itself, even if that means lying upon the floor to look even more closely.

The ironies of Yanagi's juxtapositions are underscored by his naturalistic insight, and by the truthful humor implicit in his observations. Of his earliest days as a Yale graduate art student, Yanagi says, "I really felt like an ant. The language problem, the culture shock. I see one ant, running around like me."

Everything comes back to ants, in being able to look at them and consider the implications of their existence.

The art in these works is not "ant art" nor "anti-art," by which I mean anti-aesthetic. The beauty of Yanagi's rambling marks rises from a natural system carefully examined and recognized as "part of the plan."

The restrictive containment Yanagi has devised in these pieces is not new to conceptual art, although politically speaking this representation of restriction has a particular incisiveness when considered alongside a restrained culture such as Japan's. Yet what is psychologically gripping—and what gives weight to the implicit political meanings here—is that close attentiveness to nature evokes enlarging insight, as in haiku poetry.

Yanagi resists any distracting comparisons of his work to what he calls allegory, and in this articulation is the source of his art.

"The ants don't know how they are being framed," Yanagi explains, suddenly serious. "Ants have their own mission. This is a *human* system."

Yukinori Yanagi. *MATRIX 128: America* and *Wandering Position,*
at the Wadsworth Atheneum Museum of Art,
Hartford, Connecticut. 1995.

Jenny Holzer

If you're looking for a handle on what artist Jenny Holzer does, you might say that she is a kind of cultural "hacker"—inserting her assault (and critique) into contemporary culture by having these pop up in the everyday locations usually reserved for advertising and more recently in cyberspace (for instance, see http://adaweb.walkerart.org/project/holzer/cgi/pcb.cgi).

Holzer started out in 1977 with the rather more mundane medium of anonymous, hand-typed handbills, which she posted around New York City. These now-famous fliers, part of a series she called Truisms, *presented trenchant but often impenetrable maxims (gleaned from her*

*post-graduate readings in philosophy, aesthetics, and critical theory) as
incisive one-liners. These sentences were nothing if not catchy:* A LOT OF
PROFESSIONALS ARE CRACKPOTS; PRIVATE PROPERTY CREATED
CRIME; ACTION CAUSES MORE TROUBLE THAN THOUGHT; ABUSE
OF POWER COMES AS NO SURPRISE.

*Holzer's earliest forays into an all-text format exemplify the profound
shift in art thinking that was taking place in the 1960s and '70s under the
extended influence of minimalism and conceptualism. Those modest-
looking handbills were an auspicious beginning to an illustrious career
that has made a woman born in 1950 in Gallipolis, Ohio, a presence at
the forefront of contemporary art—if one defines the "forefront" as a seat
behind the scenes and "presence" as a form of insinuation rather than
celebrity.*

*In addition to scores of solo and group shows in galleries and museums,
Holzer has created many important public installation projects—for
example, in 1982, a display of* Truisms *on the famous Spectacolor
board in Times Square.* Truisms *also made an appearance as a series
of "commercials" on cable and network television in California and
Connecticut (called* Art Breaks*), and on the previously mentioned
Internet site. In 1990, Holzer was chosen to represent the United States in
the Venice Biennale, for which she won the Leone d'Oro award for best
pavilion.*

*I*nterface: Jenny Holzer and Media Art, on display at the Housatonic Museum
of Art in Bridgeport, Connecticut, provides an intriguing sample of how
Jenny Holzer has continued to probe the intersections between language, its
formats, and its contexts. What is so interesting, of course, is the way this art-
ist triggers responses in a viewer—plugging her activism into the most famil-
iar scenarios, the most disarming layouts, the most innocuous of our habits of
viewing—and getting us to take notice.

Anywhere that an advertiser might apply a product logo, Holzer has slipped
in her lines of text, like data bytes. These have been commercially printed on
golf balls, coffee mugs, drinking glasses, and pencils; they have been carved
into benches and picnic tables, published in magazines and in poster forms,
and encoded into electronic LEDs (light-emitting diodes). She utilizes the fonts
and formats to which we are inured. She calls up the authority of the familiar to
clothe the stunning idiosyncrasy of her phrases, which are seemingly random,

Jenny Holzer, "Oh Lord when you are alone . . . ," from *Inflammatory Essays*, 1979–82. Lithograph on paper, image: 431 x 431 millimeters. Tate Gallery, London, Great Britain. *(Copyright 2012 Jenny Holzer, member Artists Rights Society (ARS), New York; photo: Tate, London / Art Resource, NY.)*

OH LORD WHEN YOU ARE ALONE AND DO NOT WANT TO BE, YOU LIE IN BED WITH YOUR OWN SHOULDER WRAPPED AROUND AND BENEATH YOURSELF SO THAT THE SURGES OF PAIN KEEP YOU COMPANY. THIS IS HURTFUL BUT IT IS SO MUCH BETTER THAN NO NERVES FIRING AT ALL. THE WORST IS WHEN THERE'S NO ONE NEAR TO PRESS ON YOU AND MAKE DENTS IN YOUR SKIN WITH THEIR FINGER NAILS. YOU ARE LEFT RUNNING YOUR HANDS ALL OVER YOURSELF, BITING TRYING AND EXPERIMENTING TO CREATE SENSATIONS. THE ENORMOUS FEELINGS YOU MAKE PROVE TO YOURSELF THAT YOU CREATE GREAT EXCITEMENT.

often contradictory, following one another in non sequitur fashion, all aimed at making us actually pay attention to what we are reading.

Holzer has made a career of inserting potent phrases into the sidebars and advertisement spaces of our everyday lives. In the process, she has insisted that we become aware that these venues are portals. And she insists that we recognize the degree of passivity with which we accept a continual stream of "messages."

Hers is a remarkable energy—targeting an audience beyond the art world and employing the methodology of those who buy and sell public opinion to clue in those assumed to be "suckers" to what is going on.

In the Housatonic Museum show, right at the front door, a viewer is greeted with LED signage (the words, rendered in a pattern of electronically illuminated dots, appear in successive echelons, one "page" at a time). This text-generator's monitor busily runs through notices about deadlines for student registration and dates for FAFSA student financial aid workshops, then occasionally comes up with a page of quite another timbre:

I AM CRYING HARD/THERE WAS BLOOD/NO ONE TOLD ME/NO ONE KNEW/MY MOTHER KNOWS . . .

One goes from reading, as one of my students once told me, to *hearing* what is being written. Here in this rupture of expectation and attention Holzer works her magic. What is important, to borrow a phrase from Marshall McLuhan

(which provides a central thread in curator Robin Zella's insightful catalogue essay on Holzer) is the way in which *the medium is the message*.

Throughout this show, Holzer achieves a certain snap-to-attention.

In a piece called *Inflammatory Essays,* she cites Hitler, Mao, Trotsky, and others, taming the way their words look by casting them in an ordinary Times New Roman typeface, printing them on same-size sheets of colored paper, wall-papering the entire display space ceiling to floor, and leaving to the viewer the challenge of paying attention to what is being said, without an explicit editorial other than the title of the series posted in the gallery, and without overt instructions from our invisible stage manager.

Likewise, a safe-enough-looking plaque on the gallery wall presents burnished letters against a blackened background. One assumes that this will name the sponsor of the exhibit or the honorific name of the gallery. Instead, we read:

SILLY HOLES IN PEOPLE

ARE FOR BREEDING

OR ARE FROM SHOOTING

Since the 1980s, Holzer's use of LED technology has lent a dynamic elaboration to the way her messages are delivered—a means to set us on our heads, perceptually speaking. Phrases float by in space, animated, marching briskly and importantly up and down a wall, or slipping by on a too-small monitor, leaking out their catchphrases letter by letter, changing colors with each new phrase, till your head is thrumming with words and the blinking of lights that come at you as vividly and dizzyingly as headlights and taillights moving through traffic under the blinking neon marquees of Broadway or Las Vegas.

In the formal environment of a gallery or museum, the competition for attention by the traveling words and phrases can compound our inundation, sucking such concepts as time and sequence, or form and space, or beginning, middle, and end, right out of the air. In such an environment, there will be no survival of the fittest, no orchestration of effect that is directive, meaning coherent and comprehensible. A viewer must grasp for meaning, pay attention, reading and seeking to understand not only what is being said, but what to think of it.

Jenny Holzer. *Interface: Jenny Holzer and Media Art*, at the
Housatonic Museum of Art, Bridgeport, Connecticut. 2004.

Janine Antoni

Speaking in shorthand, Janine Antoni is the artist known for Loving Care, *a performance piece in which she dipped her hair in a bucket of hair dye and mopped the gallery floor.*

My encounter with Antoni and her art—facilitated by an interview, and her wary negotiation over how she would be quoted (originally, the phone interview was granted as background-only)—opened a window for me into the world of the chancy avant-garde. Although at that time Antoni was already an artist of international stature, with a long resume of important exhibitions and credible big-name reviews, she was gun-shy about the press, well aware of how reporters and critics can call down ridicule on art such as hers.

Antoni's work, however, is savvy in the extreme, full of references to the canon of art history and continually reflective of her position relative to that history. She has been the victim (as well as the darling) of the press, but she manages her career with skill and ambition. Her work satisfies on many levels at once, and she works hard to ensure that it does.

Antoni's performances and their aftereffects are very different from the confrontational style of Lorraine O'Grady. Although Antoni performed Loving Care *at the feet of her audience, she maintained strict isolation from the viewers, as if asserting firm boundaries of artistic territoriality. Even while concentrating on making references to key historical movements and figures (for instance, Yves Klein and Jackson Pollock), she also managed an adept commentary on caustic "beauty" products. Her performance, for all its physical effort and sensory impact, was remarkably clear and composed. Its layered commentary constituted a surprisingly comprehensive embrace of issues and forms, which means that each time a witness takes the memory of the event out for perusal, you find some other way of looking at the piece. This poses a still more contemporary question: If performance art is intrinsically ephemeral, experiential, and personal, what strategies exist to "keep it"? And, speaking conceptually, is it not heretical to do so?*

Artist Janine Antoni dips her long hair into a bucket of jet-black hair color and mops the gallery floor. Absurd as this might seem, the 1995 United

States debut of *Loving Care* at the Wadsworth Atheneum Museum of Art was considered by its curators an event of the first order.

In this internationally known performance piece, Antoni sweeps out the old history of art and redefines art on her own terms. By this act she knowingly cleans the slate and stains the ground with a mundane, elemental gesture, one that she must have learned (mythically speaking, at any rate) from her mother.

Antoni was a hot property in the art world in 1995, having come to the Atheneum directly from her first one-person museum show, which was at Scotland's Glasgow Centre for Contemporary Art. In 1995 alone, she had exhibited in four prominent New York galleries as well as in Los Angeles, Boston, and Barcelona, where she was featured in an important group exhibition funded by the Fundacio Antoni Tapies. She was included that year, too, in the Johannesburg Biennale, her third prestigious international showcase in two years.

Still challenging and acknowledged today (she was awarded a prestigious Guggenheim fellowship in 2011), in 1995 she was definitely hot. Antoni's work sparked the fires of critical debate on four continents and was written about in virtually every important arts publication in this country and abroad—from *Flash Art* to *Art in America,* from the *New York Times* to *Le Monde.* Antoni was being treated by many as one of the most important emerging voices of her artistic generation.

So how did this young woman, only a few years out of graduate school at the Rhode Island School of Design, come to stir such a fuss? Perhaps her work has this degree of impact not only because she reclaims the once-hot genre of conceptual art and the ever-irritating topic of feminism—both of which were generally considered to have been played out over the previous thirty years—but also because she reinvigorates them. She has done so in the age-old manner of all groundbreakers, by going back to the premise, stripping away layers of convention and assumption, and speaking for herself.

The central heresy of this artist's work, in terms of entrenched art-world antagonisms, stems from the way she has embraced what other contemporary artists might consider antithetical movements. Although she turns them inside out, Antoni nevertheless includes the minimalists and abstract expressionists (the heroic/fat cat/white males so often a target of the mid-century pop/conceptual/feminist revolt) in her artistic genesis—an independent position in an intensely argumentative era.

Her process derives its energy from its peculiar hybrid of purist ideals

concerning truth-to-materials combined with a pop enthusiasm for commercial products, all accomplished under a feminist eye that is hypersensitive to manipulated agendas. Yet even here Antoni defines the issues in her own generational terms.

"People want to paint me into a militant feminist," she objected when we spoke, even while giving credit where credit is due. "The generation before me was angry. They had to be to claim this ground. Because of that anger, I have the privilege of humor."

What is interesting about Antoni, both in terms of her approach and her subject matter, is her stringent insistence on the seminal importance of physical form.

"As a sculptor, I work with the physical nature of things." she explained. "I am involved in the knowledge that is gained from the direct experience of an object."

That is certainly an understatement, when you consider the way she brings subjectivity to a startling level of consciousness.

Humor and obsession, diffusion and directness drive Antoni's work. Her rhetorical points, most often taking the form of assaults on narrow cultural stereotypes concerning beauty and ugliness, are delivered in a way that begins with simplistic positions and then goes to ridiculous extremes to open these up.

"My work makes use of feminine clichés and stereotypes: chocolate, hair dye, lipstick, and mascara—materials that have a specific relationship to women," she told me. "My hope is that as the piece unfolds these widely held assumptions about women and beauty will be called into question."

Characteristic of her work in general, both works on display at MATRIX arise from intimate physical acts couched in a kind of enlarging, brand-name burlesque.

Loving Care (the monumental floor painting done in hair dye with the artist's hair) and *Butterfly Kisses* (a drawing executed by batting her eyelashes, wet with mascara, onto paper) each reexamine the "art" of painting: After all, what is dye but paint; what is a brush but a device made out of hair?

Yet her suggestive critique was not finished there, but at every turn—from the direct contradiction she poses between "loving care" and the olfactory punishment delivered by a bucket of chemical dyes; from the sweet childhood association of "butterfly kisses" to the physical realities of creating such a "drawing" (twenty flutters at a time, three times a day for weeks). The slowly unfolding delivery of these works is a product of a perspective at once absurd and businesslike.

Janine Antoni, *Gnaw,* 1992. Installation photograph: 600 pounds of chocolate gnawed by the artist, 24 x 24 x 24 inches; 600 pounds of lard, gnawed by the artist 24 x 24 x 24 inches; heart-shaped packages for chocolate made from chewed chocolate removed from the chocolate cube; and lipsticks made with pigment, beeswax, and chewed lard removed from the lard cube. *(Courtesy of the artist and Luhring Augustine, New York.)*

Similarly, Antoni takes on sculpture at its most elemental level.

In *Gnaw* and *Lick and Lather,* she begins with material: in *Gnaw,* two pure blocks, one of chocolate, one of lard; in *Lick and Lather,* fourteen self-portraits, seven cast in chocolate, seven cast in soap. Antoni then uses simple bodily acts—gnawing, chewing and spitting out, licking, washing—to transform the material. Her commentary, making a circular equation between the pleasure represented by chocolate and the repulsion embodied in fat touch upon contemporary issues far more expansive than the direct rendition of an image.

Antoni's juxtapositions play with our expectations and give her work its critical edge. At its most fundamental level, this work challenges the definitions of such terms as art, work, beauty, and even paint. She structures her pieces within the constraints of an everyday commodity or an unspectacularly common act, and she depends upon viewer empathy with the physical immediacy of her work to hook her audience and then, as she says, she "flips their expectations."

It takes conceptual cheek to reference Jackson Pollock ("action" painting,

executed on the floor), Andy Warhol (the grinning use of commercial brand name), and Yves Klein (who did a well-known, mid-1950s performance using a nude woman as a paintbrush), and to do so with such concentrated physicality. Her work is physical fact, not only in terms of the objects/images she creates, but also in regard to the way in which she manufactures them. Antoni's mundane factuality cuts in every direction—high art, pop art, elitism, commercialism—but from a fresh and very physical perspective.

Antoni is essentially a formalist; that is, she disciplines herself to the logic of form as a starting point. She also puts her faith in a kind of universal "body knowledge" to connect her work with her audience. She trusts that the senses will find meaning without being sidelined by prior associations.

"I do extreme acts because I want the viewer to empathize with my process," Antoni says. "Oftentimes my work is interpreted as masochistic, but it is much less brutal on the body than a commonly accepted activity like sports. I want to bring my body to its physical limit, but I do not take it over the edge."

And so it is that in *Loving Care* Antoni patiently creates art by rhythmically mopping the floor with her color-saturated hair. For an audience of observers, which she resolutely ignores, the initial novelty of her actions wears off and self-consciousness sets in.

This is a performance that only gradually reveals its true character, as the usual relationship between artist and audience is inverted. The artist, self-absorbed, claims first a foothold, then ultimately the whole floor. The audience, all dressed up and gathered in attendance, is slowly, deliberately, backed out of the gallery. Even forewarned, viewers instinctively react with confusion as they slowly yield the space. The artist, by contrast, is dispassionate.

"Once I've mopped across the floor one time, the viewer can predict what I am going to do for the duration of the performance," says Antoni. "It is amazing to me that people stay to watch the whole thing."

If past performances are any measure, audience reactions will be mixed; for Antoni's art is not so much about itself as it is about us. In this subjective, intimate truth, her work finds its disturbing power.

Interview done by Patricia Rosoff with Janine Antoni prior to the
show *Janine Antoni / MATRIX 129,* at the Wadsworth Atheneum
Museum of Art, Hartford, Connecticut. 1996.

Janine Antoni, Postscript

The preceding piece on Janine Antoni was a preview—written in
advance of my seeing her MATRIX show based on my interview with
the artist and with the curators along with what I had gathered from
the press materials they had provided to me. The following is a response
to actually being there and experiencing the work-in-progress. I tried
to achieve a perspective as attentive and receptive as that of one of my
students, who came to see the show and crouched down to look the
artist in the face as she "painted" the floor. The context of the museum
becomes an inescapable element of the whole, as does the assembled work
in an adjacent gallery and my own relationships with the curators who
mounted both shows.

The performance went as planned and as described: Janine Antoni got down
on her hands and knees and, using her own long hair, covered the floor
with dye. Unfortunately the MATRIX gallery was so crammed that only the
front rows of viewers could see. The situation was no better in front of two side-
by-side television monitors in the atrium at nearby Avery Court, since these
were mounted at eye level, so again the front rows of viewers blocked the sight
lines of those behind them.

Consequently, the crowd's dynamic made the strongest first impression—as
hunger to see the event stirred a kind of frenzy for a good vantage point. There
was a snowstorm brewing outside the glass doors of the museum, which added
intensity to this test of survival. As might have occurred during a closeout sale
in a department store, the crowd took heat from adrenaline and tempers rose.
There were voices calling, "If everyone would just step back, we could all see,"
to which, of course, no one paid any attention.

The press got the front-row stations, which meant that a mini-cam and a
dozen or so cameras were blocking the view.

Meanwhile a teenage girl crouched down on the floor to look through the
feet of the bystanders, and she was startled by the glazed concentration of the
artist's eyes. And there it was, the real event of this demonstration—the kid and
the artist, eye to eye.

Here was an absurd scene—of course, intentionally so—but I found it oddly
touching to see all those people struggling to get a look at the woman who was

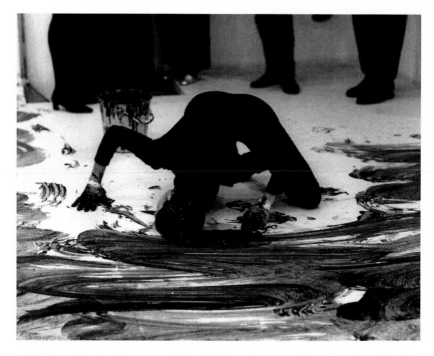

Janine Antoni, *Loving Care,* 1992–96. Site specific performance with "Loving Care Natural Black" hair dye, dimensions variable. Photograph of 1993 performance at Anthony d'Offay Gallery, London, by Prudence Cumming Associates. *(Courtesy of the artist and Luhring Augustine, New York.)*

working so hard to paint the floor with her body. Antoni's act, whatever may be said about its representations of women's work and feminist art and deconstruction and all that, was tender. Further, her act embodied that comforting, repetitious, and private monotone of rhythmic sound and touch that is deeply buried in our sensual memories and still has the power to move us.

The attending crowd, seeking diversion, got something else. Antoni's self-isolation in the midst of such display brought her closer than had she confronted us and fought for our attention. It was her withdrawal—which was an assertion of control—that gave authenticity to whatever it is about caretakers and artists that actually does have meaning.

The chief awkwardness, from this viewer's perspective, is that the curators failed the audience with the misplaced monitors. The fact is that everyone came to witness a "live" performance that for the most part they couldn't see. Yet

what might seem to be a petty oversight, by its glaring rarity, is an issue unto itself; for the art of curation can be seen as a kind of woman's work, too.

In most people's minds, the show is the event, and not how it got there, just as the art object is the occurrence and not the ideas and labor that brought it to be. Yet how remarkable it is to present art to a viewing public—especially in the setting of a traditional museum that wishes to present work that challenges the expectations of a general audience that will likely be indifferent and at worst hostile to the work. Too much teaching can kill an experience; too little reinforces prejudice. The curator's talent must be to intrigue, not to preach.

In the companion gallery a short distance from Antoni's grandiose conceptual floor washing, there was another "event" going on. While Antoni was painting the floor next door, a quirky array of contemporary works on loan from the estate of collector Julian Pretto hung on the white walls in the age-old way. The juxtaposition was instructive, presenting the "how" and the "what" and letting the audience sense the connection.

A word about Julian Pretto: Pretto was well regarded in the contemporary art scene in SoHo, TriBeCa, and the West Village from the early 1970s through the early '90s. An art dealer known for his dedication to young artists, during that time he opened a number of tiny gallery spaces that he operated on a shoestring, sometimes keeping afloat by living in his gallery spaces. He died in 1995 at age fifty, but not before amassing a deep collection of works, many by the artists he encouraged. Pretto specialized in emerging artists, giving many of them their first solo shows. The images on display range in style from playful to beautiful, from "found" to fabricated, and many viewers would find this work inaccessibly spare, and in that sense they represent a style of presentation with which Antoni, in full irony, spars.

These are works that a naive viewer might find "difficult." They were not "events," like Antoni's, but products of artists without an established track record. There was tiny, Spartan, abstract painting by Cary Smith that resembled little more than a bit of brightly colored geometric braid cut from the breast of a khaki uniform. There was Carl Ostendarp's painting, enamel on paper, that presented as a solid, vaguely modulated square of color. Melissa Kretschmer was represented in a work made of tar and latex on wood, dark and gloppy.

Even though these works are wall hung and framed or stand on pedestals, though they can be analyzed on formal terms and connect to artistic trends that arose in the late nineteenth century, they invite the disapprobation of tradition-

loving audiences. Such art brings the too-familiar judgment that art has gone off the deep end and charges that modern artists are the perpetrators of cynical flimflam—foisting things "a kindergartner could have done better" (for millions of dollars, mind you) on the public in the name of art. The gap between modern art and the general public is often huge.

So I say hooray for Janine Antoni and for a museum staff who insists on bridging that gap—because alongside her own intelligent and piercing agenda, as demonstrated in *Loving Care*, Antoni's dance at museum-goers' feet made visible the one fact that makes art real for those who love it—she opened the closet door and let us see how *intently* these things are made, not only in her show, but in the other quiet rooms off the atrium. This is what art has always been—animal sensation, fine tuned, utterly alive, and directed by the exuberant, expressive nonsense that is the human spirit.

<div style="text-align: right">

Janine Antoni. *Janine Antoni / MATRIX 129,* at the Wadsworth Atheneum Museum of Art, Hartford, Connecticut. 1996.

</div>

Afterword

Patricia Rosoff: From There to Here

I was born in the heroic shadows of abstract expressionism, went to art school at a time when talk itself was suspect, and started writing just about the time someone announced that painting was dead and that everything I had finally learned about it was consequently irrelevant.

A relatively verbal type, I stumbled through my undergraduate days at the Rhode Island School of Design largely in the dark about what was going on—damned if I tried to steer a good-student's course; damned if I tried to work instinctively, since I didn't know how. What art was, how it worked, what we were trying to accomplish—all were deep secrets, I could only suppose, given to few and obscured by impenetrable mists of genius.

One lesson was clear: you were not supposed to talk about art; art was something that should explain itself—or go without saying. But that's only art school.

I've since learned that the regular world, too, packs a valise—and the message is pretty much the same, although for distinctly different reasons. Artists want art to stay a mystery; "civilians" are sure that mysterious art is a hoax. Many in the audience want their art to take the form of pictures and sculptures of the regular sort, meaning representational: simple, declarative, and directly illustrative of the world they received from a largely conservative tradition of painting and sculpture as well as from photography and motion pictures.

A picture, most folks assert, is (or should be) worth a thousand words . . . and, of course, nobody wants to *hear* those thousand words.

Beyond this matter of representation, there's also the general hostility toward "modern art," roughly translated as anything abstract or otherwise execrable. "Modern," or any of its more recent permutations like "contemporary" or "conceptual," is a dirty word, implying a scam perpetrated by shysters who want

to make a lot of money by selling utter nonsense to complete idiots. (Where anyone got the idea that art was so easy to sell, I have no idea.)

My struggle as an artist has been to shut up and pay attention to what is happening under my hands, physically and visually.

My struggle as a writer and as an educator has been to step out from behind the shield of preconceptions to form my own opinions.

It has been through writing about art that I found a way to understand it, which in turn transformed the way I paint. It is by writing—that is, bringing a viewer with me to look where I look and see what I see—that I hope to make today's art understandable to others.

The Stanislaus Valley

I grew up on a dairy farm in California's great Central Valley, a geography that was arid and table-flat, but coherently ordered—the valley ran north–south and was hemmed in by two mountain ranges that demarcated east and west. The great elevations of the Sierra Nevada chewed off the eastern rim of the sky. Upon those hoary, wrinkled faces nested the snows that were the lifeblood of the valley, runoff delivered by a one-way circulatory system through dams, irrigation canals, and ditches to farms divided systematically by larger and smaller levees into the farmers' patchwork of rectangular "checks."

The Central Valley has fertile soil but a desert climate. For the fields, thirst-slaking water arrived by telephone call: "You've got the water" meant that my father, brother, and the field hand would wake, dress, and work seventy-two hours straight, opening the sluices one after the other, irrigating the corn, alfalfa, and the pasturage one check at a time.

The water is a memory as tactile as my mother's touch. Under a violet sky, in the hushed hours of early morning in that desert country, the water would glide, silent and molten, between the plants. In the wavering heat of summer afternoons we would "swim" in the concrete irrigation ditches—slip into the tugging current that came to our waists, fold up to avoid the abrasion of the rough concrete of the ditch bottom, and let ourselves be carried with that steady surging power down the length of the farm, drifting between the grapevines and the tall yellow grasses that would float their "beards" on the fringes of our stream.

It was a largely unchanging landscape, with two seasons only. A New Englander now, I remember those childhood seasons in terms of neutral colors, gray

and buff—the impression dominated by dense gray winter fogs and bleached-out summer grass.

Where I grew up, the landscape provided an unbroken orientation: mountains, foothills, flatland between; north, south, east, west. And I always knew just where I stood.

Adam and Eve in the *Encyclopedia Americana*

My first exposure to art—other than in grade school activities—was in books. I drew in my spare time, horses mostly (never cows, God forbid, or the farm, or people). If my mother thought to place anything against the walls, it would be a mirror or a bookcase, and in the interminable, boring days of summer—hot days, lonely days, since the nearest schoolmate lived several miles away—books were a godsend.

I used to haunt the empty school grounds in July and August, riding circles in the parking lot on my bicycle, hoping a teacher would show up. The periodic arrival of a shiny silver bookmobile at the Grange Hall down the road from our farm was the highlight of the week. I'd strip the shelves of horse stories, or, if those came up short, of dog stories, bringing home twelve or thirteen books at a time. My mother kept trying to broaden my interests, but I would have no part of it. Walter Farley, and Albert Payson Terhune—these were my faithful companions.

Among the bookcases at home, however, with their random collection of titles sorted by size and thickness, I played my own version of literary Russian roulette, pulling out a volume with no idea of what was there. I got started on *Animal Farm* because I thought it was another Freddie the Pig book—talking animals, after all—and was mesmerized by how bad a turn things took. I came across Boccaccio's *Decameron*—vividly lascivious stories that would have curled my mother's hair if she knew what I was reading—quite by accident, amazed that a book bound so importantly in hardcover could be so lurid.

It was on these shelves that I discovered art, too, in a supplemental volume that came with the *Encyclopedia Americana* my parents were suckered into buying when we were still in grade school. I can't say that we ever used the encyclopedia itself, but the supplemental stuff—a book of biographies of famous people, a book devoted to art and art history—ultimately proved to be an intellectual catalyst. I loved the art supplement, which became my pri-

vate devotional, a book of hours, with richly colored pictures on one page and explanatory text on the facing page.

Part of the spur, of course, was that if you opened the volume to certain pages, you would find fully detailed nude figures (this still remains a primal incentive for taking up the study of art history). In a book, you could look as long as you wanted, so long as you were prudent enough to flip the page if your sister or your mother came into the room. And, once you got used to the forbidden-ness of these images, you could not help but accept the essential nobility of the human figure. It's not far from Michelangelo's *David* and his *Pietà* to Peter Paul Rubens's lusty *Rape of the Daughters of Leucippus,* and not far from there to Titian's *Man with a Red Hat,* which though not a nude, was so sensuous in every other way, with its subtle warmth of skin against velvet, satin, cold brass, fur trim.

To this day, I remember where these pictures sat on the page, as well as the glossy texture of the paper, the blocky shape of the text, and the candle-warm color in the reproductions.

From that book I also learned art's capacity for indelibility, even if second-hand. It would be high school before I saw the inside of a museum, and college before I saw Italy, and another decade before I encountered contemporary art in fly-by-night experimental galleries and had to decide what I thought. But one realization has stayed true—a given work of art may be interesting, it may be beautiful, it may even be dramatic, but some art just clears the deck. It's almost impossible to say how or even why. It just *does,* and as a viewer you are made innocent by the encounter.

I mean "innocent" in the context of the nineteenth-century avant-garde, which sought, in what amounted to an overthrow of the hidebound "grand tradition" of academic theory, to bring to art the unschooled (hence unbiased, untainted) honesty of a child.

My first taste of this was the shock of seeing Jan van Eyck's *Adam* and *Eve* figures from the Ghent Altarpiece in that encyclopedia supplement, full-page and in color. Adam was buck-naked, with the black hairs showing against his pasty-skinned bony arms, with bluish veins in his hands, the gaunt awkward-ness of his body perched uncomfortably in a carved wooden niche. Eve stood shyly in her swelling pregnancy, with a plucked hairline, tiny plum-like breasts; remarkable in the delicate way she holds the fruit of her temptation.

These images still shock me every time. It's not their nudity, but the naked

truth of them. They just carry, even in reproduction. They are so honest, so ugly, so utterly, powerfully naked.

My eye is innocent again every time I look at them; they surprise me every time, compel me every time, and even after all these years have not lost the vividness of that first encounter.

Above all else, this is what I expect art to deliver.

Harvey Litvack

I was born in the ranks of the baby boomers. My parents grew up during the Great Depression; my father served in World War II in the Pacific; my mother's chief ambition in the post-war years was like so many others'—to build a family, to be a helpmeet.

Since I had always been a good student, it was assumed that I would go to college. But as was common in that time and place, no one in my family had gone past a high school education—nor did they have much of an idea as to how to go about doing so.

The vagueness concerning higher education was ameliorated by the public education system in California, whereby one went from elementary to high school, then from high school to junior college to state university in unquestioned sequence. I hadn't thought much about the transition from eighth grade to high school, certainly. It didn't occur to me to ponder what happens after high school graduation.

So it was a shock when, one day in February during my senior year of high school, as I was hanging out in the art room after school, my art teacher Harvey Litvack threw out to me, "So, Pat, where are you going to college next year?"

"I dunno. Modesto Junior College, I guess," was my reply.

"What, are you some kind of idiot?" he returned, dryly. "What do you want to do with your life?"

"Teach," I said.

"Then you should apply to Yale."

"Okay, if you're so smart," I responded, "what's the best art school in the country?" (One has such relationships with high school art teachers.)

"Rhode Island School of Design," he said.

That was enough for me. I marched down to the guidance office and asked

for the address to the "Rhode Island Art Institute"—which was not, of course, in the book.

"There's no Art Institute in Rhode Island, but there is a School of Design. Will that do?" the counselor asked.

"Sure," I said, taking the name and address.

So I wrote them. They sent me forms, and I applied. I was too late for scholarship consideration, of course, but still under the deadline for regular admissions. I hadn't realized the rigmarole for art school admissions—a drawing "test," a slide portfolio, essays, transcripts and so forth. My art teacher shepherded the whole process, and that was lucky, since no one else had a clue about how to do this.

I was accepted.

Then I told my parents.

Not that they had objections, but it was just that my father had lost his Grade-A dairy contract after a dispute with his shipper. We had moved into Turlock, to a corner lot abutting the high school. Dad had taken a job driving an elementary school bus while enrolling in a correspondence course in bookkeeping that he had learned about from a book of matches. My mother had gone to work for the first time since she was married—evening shift at the reception desk in the Emergency Room of Emmanuel Hospital. My only brother, two years older, had joined the army and shipped out for Vietnam. My next youngest sister (she was fifteen) was mooning after Mike Kellison, a high school dropout who was forbidden to set foot in our house and made do with circling our block in his souped-up pickup truck. She sat in a rocking chair in the front window, rocking and crying and watching him circle.

My littlest sister was in seventh grade.

This was not a good time to ask for money, or to ask my parents to consider the prospect of sending a daughter three thousand miles away to a private college.

I didn't really ask. I just kept filling out papers and trying to keep eligible. Harvey helped. He came to the house to tell my parents that they had a moral obligation to let me get an education. Even if they had to put a second mortgage on the house. Further, probably more importantly, he walked them through the process for obtaining student loans.

It was a conversation. As I say, they were not opposed.

Someone actually offered to buy one of my paintings for $25 the week that the matriculation fee—for that same amount—came due. I got a $150 dorm fee

request the same week my long-widowed great-grandfather found two $100 bills pressed in my great-grandmother's Bible. (As I think about it, I don't imagine her having a Bible—Tarot cards, maybe. Perhaps this was a bit of parental fiction.)

I graduated. School broke for the summer and I took every job I could find. I built exhibits for the county fair. I painted grocery store signs (LETTUCE / 3 HEADS FOR $1; BONELESS CHICKEN BREASTS 99¢ / LB) employing 3-inch indelible markers and learning that this was a job for people with a vast tolerance for alcohol fumes. I worked the night shift at the peach cannery, a job for which I had to join the Teamsters Union. I bunched baby's breath under long, corrugated-tin roofed sheds—piecework.

By the end of the summer, I had earned one semester's tuition. I had secured a student loan to cover room and board. Harvey loaded me up with art supplies: tubes of oil paint, brushes, a sketchbook. Later, he would send me other supplies, along with occasional batches of homemade fudge.

My mother took me shopping for clothes, and I picked out a blue, two-piece wool suit and a pillbox hat, which seemed like something Jackie Kennedy would wear. My mother ultimately dissuaded me, ever so gently, from taking the hat.

Please remember: this was 1967, and I was going to *art* school. I never wore the suit.

My parents scraped together the $75 cost of a one-way stand-by airline ticket to Providence, Rhode Island.

"If you can't get a scholarship at mid-year," my father said, "you may have to come home, but at least you'll have a semester under your belt."

They drove me to San Francisco International Airport and put me on the plane. I had been thinking so long about going, about whether I could go or not, how it was going to happen—it hadn't occurred to me that this also meant *leaving*. It wasn't until I saw my parents waving goodbye from the other side of the terminal window that I realized that going away to college meant leaving home.

I had never been on an airplane before, nor had I ever set foot outside the state.

My landing in Rhode Island was dramatic: there were hurricane warnings, black skies, strong winds, and sheeting rain.

I called home. My sister Beverly answered, breathlessly telling me that my parents weren't back from San Francisco yet and that she had hit an old woman with the car. She hung up.

I called Harvey. "You shouldn't be spending money on long-distance phone calls," he told me, still teaching, rushing me off the phone.

So there I was, on the East Coast, alone in my adventure, not knowing if the school was two minutes or two hours from my hotel, wondering what "bell service" was, and worrying about dragging my trunk down to the lobby the next morning.

The school, it turned out, was just a few blocks away, albeit straight uphill. I took my first cab. My roommate was a curious, languid girl from Marblehead, Massachusetts, who consulted her moods each morning to decide what colors to wear.

Years later, at our fifteenth class reunion, we passed through an exhibit of freshman self-portraits—huge drawings, full of art school depressiveness and dark, for the most part, as if the students had been out drinking with Franz Kafka and Edvard Munch the night before. Except for one drawing, an immense, exuberant face sporting a broad, toothy grin, completely out of synch with the rest. My old classmates turned in unison and looked at me.

Learning to Draw Badly

There is perhaps no better way to describe my experience at art school than to say it was a profound culture shock.

Like the majority of my classmates, I arrived eager and full of ambition, armed with an unblemished optimism about the character of my talent, excited about gaining admission to an extremely selective school (they made sure to tell us that we were the fortunate one out of ten applicants to be chosen for the class of 1971), and ready to settle in and work hard and make my mark academically. I was perfectly primed, consequently, for the comeuppance I was about to receive.

Later, in retrospect, we ascribed to ourselves the distinction of being the last class to enter RISD as clean-cut, wholesome-looking scions of middle America—in striking contrast to our grubby, long-haired, radicalized, drugged-out, and modishly hippy-fied exits. (And the next freshman class *came in* as hippies.)

I include myself in the collective "we" with some hesitation, since my relation to this dance was so out of step. Freshman year was difficult for me socially.

But this was really a great leveler for all of us, as everyone was clearly in urgent need of being disabused of any notion of self-worth. The trouble with an "elite" school is that in each course—figure drawing, nature drawing, two-dimensional design, three-dimensional design, even more technical courses like calligraphy and projection drawing—there were individuals so inescapably superior to the rest that the majority of the also-rans would drag home from critiques with a serious sense of self-disillusion.

Not only that; for many of us, the prospect of facing, day after day, a condition of invisibility was depressing. For me, this problem was exacerbated by the fact that I so wanted to please, and all my good habits, my investment, my need to like and admire my teachers (and have them reciprocate in kind) were not only ineffective, they were counter-productive. In my experience, no one in art school admires a "good student"—people are interested in the hard-nosed maverick, the miraculous technician, the mystic, the naïf, the gritty autodidact. And I was none of these.

Professors, the vast majority of whom were male, were not oblivious to the exceptionally beautiful young woman, of course—a quality (along with inherited wealth and parental celebrity) that RISD undergraduates seemed to possess in lopsided disproportion to the regular population. I struck out in those categories, as well.

There is a desperation to the expectations of those who are young and artistic in an environment like this. The pressure comes not only from on high, but also from intimidation by peers embroiled in a struggle for survival of the fittest. Places like RISD are a training ground for young artists who, if they don't already possess it, must learn to stoke a fire-in-the-belly determination to confront a world that most often couldn't care less. Such a dynamic isn't easy for anyone, much less the good-student/good-girl who doesn't know where to begin. In a climate that fosters and celebrates the extravagant expenditure of energy—"pulling all-nighters" was a badge of honor—reaching for extremes of ambition and stamina was a mark of merit.

For me, whose great adventure centered on a much more pragmatic arena—my struggle to earn the money to be there—this was a game I did not know how to play. I adored the onslaught of ideas, the demands of problem-solving, the excitement of the work going on around me, the proximity to people from places I had only dreamed of going, but by my junior year, I was working more than thirty-seven hours a week to pay my expenses. Even so, I never missed a

class, always sat in the front row, did my homework (all of it, even for the Art History and English courses that were the bane of most students' existence), and otherwise stood out like the proverbial sore thumb.

I smiled; I laughed at people's jokes (one of my professors remarked that I would "cackle my way to fame"); I helped anyone who would let me get them through Art History.

I did not shine, but then again I did not die on the vine. And yet I tried too hard. Other students largely shunned me, and my professors—other than an English professor who is a friend to this day—largely ignored me.

One glimmer of a turning point occurred in a sophomore drawing class.

Professor Richardson, an imposingly handsome artist with the most remarkable pewter-gray hair, was doing his best to browbeat us into improving. Each critique was an exercise in admonishment—"See this drawing," he'd say, "how it commands the page." Or, he'd say: "Now here's a work that sweeps everything away in the path of its mark-making."

Each week brought new examples to the fore, stars in the firmament of emphatic, personal style. Determined, I sought to up the ante: changing scale in search of the monumental; choosing blacker, messier, more dramatic drawing materials; generating more sweep, putting more elbow grease into the way I scrubbed my marks onto the page. Finally, I felt, I was getting to the very center of the matter.

Then came the critique.

"Okay, okay," he said in a weary voice. "I see what you're trying to do—you've listened to all that was said in the last critique and you're trying to replicate it here. I can appreciate the change in scale, the new drama of the marks, the more physical attack on the page. The thing is," he said, "I just don't like these marks."

Just that. The silence of his pause hit like a thud.

"You're trying hard," he said, "and it shows. But it doesn't work—I just don't believe you here.

"Look," he said (now he was not looking at me directly here; I'm not even sure that he knew whose drawing he was talking about), "you've got to get past this good-student business. I see what you're doing—what you're all doing—which is to pay close attention each week in critique and then try to psyche out the teacher. If I like gestural marks one week, you all bring me gestural marks the next. If I like large-scale drawings one week, you all show up with oversize drawings.

"It's pathetic.

"So here's what we're going to do," he said. "You're going to go out there and do the most terrible drawing you can think of. I want it to be awful—badly drawn, hideously composed, offensive, vile, obscene—I don't care. I just want it to be bad, as bad as you can make it. That's your assignment for the week."

Then, disgusted, he left the room.

Of all the assignments I'd had up to that point, this one knocked me farthest back on my heels. The upshot of it—a series of simply observed, languidly distorted line drawings of an oddball little dorm mate and a wilting tulip—met with unparalleled (and entirely unexpected) enthusiasm. Richardson even kept one of the drawings for the school's collection.

This time, the thud was on me. This time, I wasn't trying too hard. I was working unencumbered—drawing in ways now that involved me, using a charcoal pencil, a piece of paper, and people and objects I felt familiar with and affectionate about. Trying to be "bad" meant pushing the pencil with conscious awkwardness, forgetting about readjusting proportion a hundred times, bagging all that fuss about grand drama. I just let my *hand* draw, and I tried to stay out of the process for once. For the first time I quit mentally consulting the teacher (*all* my past teachers, all those years of art education) for the rules about what was "right."

They had taught me what was "good"; I had assumed that if it was just me drawing, it must be "wrong."

But what happened was that I got in touch with *me*, drawing. As simple as that. For the first time since I was a little kid drawing for myself, I got to feel what getting in touch was like. And this time, Professor Richardson "believed" me.

This was to be the pattern of my art education: struggle, failure (brick wall), anger (it can't possibly get worse than this), persistence (I'll show them), relinquishment (quit thinking so much), and then: insight.

I had found myself in a place where being a good student was not only unimportant, it was essentially despised. Now I could begin to learn from the professors who were willing to fight with me, who forced me back to that wall until I battered my way through, not because of what they taught me, but because of what I taught myself.

What I gained from my experience in art school was a glimpse of the truth that making art—real art—requires an entirely different compass. This took me years and a lot of contentious wrestling to figure out.

Pat Lipsky

My graduate school professor was lean and hard and very New York—that is, disinclined to pull any punches. She wasted no time in telling me flatly, after my first day, that no one had painted this way "since the '50s"—that one simply didn't outline and fill in a picture like that.

"Don't even try to fix it," she said. "Just pull the canvas off the stretcher, restretch new canvas, and start again."

So began a professional teacher-student relationship that constituted my introduction to modernism, one that not only filled in all the tiptoed-around gaps in my education as a painter, but also set some ground rules, and established certain parameters—including drop-dead, heart-stopping criticism—which would set me on my own two feet.

Not everyone liked Pat Lipsky—she did not tap you on the head and gently tell you that you were good at this or that was nice. She was an opinionated, outspoken, tough-minded and relentless critic; she engendered the same sort of student. As much as she embodied a particular perspective on art, her students' works—like their opinions—had this in common: they were gritty, independent, and vivid.

When I encountered her as a grad student, she had no mercy.

"You're too old," she said, "to be making this kind of beginner mistake."

But she also made me bring her everything I had from my undergraduate days as a painter—sat down with me and reconstructed those beginnings in her dry, businesslike manner. And, in her tough way, she found value in one or two pictures that I had secretly liked, that my undergraduate professors had ignored in their search for the splashier, more dramatic expressions of genius. Lipsky was never concerned with genius—she was interested in painting. Authenticity was more important to her than showmanship—a "good picture," no matter how simple, was more important to her than all the flashy trappings.

Importantly, her criteria were central and clear, and grounded in her color-field sensibilities as essentially as due north defines a compass:

- A painting should be *whole*—excise the diddly little doo-dads and get to the point.
- A painting must *lift*—step out to encounter the viewer rather than shrinking back in bruised hesitation.
- There should be no *holes* in a picture—no lapses of energy, no break in the skein.

- Likewise, a painting should *loft,* with no gridlock on the surface of a canvas—every touch of color must dance freely with every other.
- A painting is a simple thing, so quit showing off—keep it simple.
- A painting should be fresh, not labored—full of itself and not the painter's angst.

And that was pretty much it.

Pat did not teach you how to paint; she concentrated on teaching you how to look at painting. The discussion was always—and only—about painting, which to her was just about everything.

A critique with Pat was always a clean slate. The stakes were always high; but then again, if you didn't fail from time to time, you weren't trying hard enough. The painter's job was to paint and keep painting. Critique was when you stepped back, put on your eyes, and took a good hard look at what had happened while you were working. This was fully as necessary as the act of painting itself.

What I learned, ultimately, was that there was no more mystery to the process than that. Look and see if it's any good—that is, if it's whole, forward, fresh, unbroken. This is plenty enough for anyone.

Here was a language that I not only spoke, but understood. Here was a means to understanding that enabled me to become, finally, a painter.

There's one more part to the story, which involves an assignment and a trip to New Haven to the Yale Gallery of Art.

Pat Lipsky took us down as a class to see an exhibit of painting from the 1960s—her era. Most of the so-called second generation of abstract expressionists were represented, everyone from Helen Frankenthaler and Robert Motherwell to Jules Olitsky and Jeffrey Poons. Our task was to choose a picture we liked and then research that artist and write a paper.

I had a hard time choosing; there were many pictures I liked, but none that spoke to me—except one, a murky, grayish-green sort of painting, inert, spread on the surface like a kind of gelatinous ooze.

It bothered me. I didn't think I liked it, but I could not exactly let it go. The longer I spent in the gallery, the more I realized it was there, like an undertone, annoying because it had no real color and yet somehow it *seemed* to have color.

Finally I gave in, figuring that this work was puzzling enough for a paper. And I wrote down the artist's name: Walter Darby Bannard.

The surprise was to discover that Bannard was not simply a painter, he was an art writer, and my research revealed an extensive body of critical writings by him about the work of his contemporaries—essays as well as criticism, articles

about painting in general as well as paintings in specific. These writings led me to Clement Greenberg's writing (Bannard was part of Greenberg's circle), which led me to Greenberg's analysis of cubism.

This was hard stuff—essays about abstraction, words describing things that have to be seen to be understood, writing about "surface tension" and "picture dynamics." Difficult language, not the kind you can just "read," as one of my students once said, "but you have to reread and reread until you understand it." What was so startling was that I did begin to understand—as if a wall came down, a few bricks at a time, and I was standing in a room (the twentieth century) in which I found myself very much at home.

I had been stuck in the Renaissance, in a world where patented methodologies about perspective, anatomy, balanced composition, and color harmony held sway, and where the object of painting was the eloquently indiscernible illusion; where creating a credible fiction of truth was the object, and the "genius" of the artist was illusionism exemplified.

What I stepped into, as the dust settled, was a world so much more clear and factual—where *paint* is a reality, and so is canvas, and so is the way paint drizzles on canvas. One can "read" handwriting and discern the character of the hand that produced it; one can also "read" the imprint of a brush and glean insights and understanding.

By the time I finished "researching" Walter Darby Bannard I had become an abstract painter.

Once I "got it," there was no going back to mere drawing, to painstaking illusionism. I had discovered a means to art that did not involve translation from the real world to the fictive one, but was instead directly engaged with reality—a reality that included how I felt, muscularly and psychically, and how what I put down made me feel. I had come home in a way I have no other words to describe.

At the conclusion of this assignment, I actually met Bannard. My professor, impressed with my paper (and the transformation my painting had taken) invited the artist as a guest critic. I put up my pictures with a kind of confidence, secure that I had understood what Bannard had to say and that I had demonstrated what he taught me.

What I got instead, to my amazement, was his declaration that there was no way in hell that paintings like this could possibly "work." There was no way that such flat-out, high-key, fractured works could "make a picture." But somehow,

he said, they seemed to do just that. He kept referring back to this point—that these shouldn't work, but they somehow did.

He looked at the work of other students in the class, finding this or that kind of problem. Then he would mention my paintings again, by way of comparison, and mumble something about crediting "judgment" for making it happen. This was an astonishing experience, with equal parts acknowledgment and denial, affirming the work I had done but confounding my own sense of how I had come to it.

In the end, I had stopped being a student and found my own way. While I thought I was learning something, I had in fact made up the process from scratch.

ACKNOWLEDGMENTS

Thanks to:

Jeffrey Levine, who made the whole thing happen, and to Ellen Carey, whose professional advice and personal generosity pressed the effort along. Jeffrey's vision, persistence, and bolstering (not to mention his grant-writing!) buoyed this project through the long winter of its gestation. Ellen's bottomless can-do, her get-off-your-but(t) pep talks, and her brilliant spontaneity have been an inspiration for which I am deeply grateful.

My editors: Barry Schwabsky *(Arts)*, whose acceptance letter arrived like a miracle; Janet Reynolds *(Hartford Advocate)*, who first invited me to cover art in greater Hartford; Jayne Keedle, Alistair Highet, and John Adamian (also at the *Hartford Advocate)*, who continued the ongoing work of honing my voice as a writer; Michael Rush *(Art New England)*, who was not only a wonderful editor, but also an insightful and persuasive reviewer; Judith Tolnick Champa *(Art New England)*, whose warm encouragement keeps me going; Steve Starger *(Art New England)*, my colleague-in-arms, who covered for me more than once; Glenn Harper *(Sculpture)*, who continues to welcome my contributions; and, especially, Jim Schley (Tupelo Press), my perceptive and literate reader, whose finely tuned close reading has been a gift of the first order. Jim's care with the blue pencil is matched by such amazing sensitivity to my voice. Over these long months he has combed and sharpened my language and helped me clarify my points. More than this, his entertaining penchant for locating the inadvertent and egregious pun has likely saved me from a world of "ouch."

My early proofreaders, who volunteered to tackle the early manuscript: Meg Kasprak and Polly Zarella.

Those who contributed to the Tupelo Press silent auctions: Benny Andrews, David Borawski, Allegra Brelsford, Christine Breslin, David Brown, Katie Burnett, Ellen Carey, Colleen Coleman, William DeLottie, Ted Efremoff, Bryan Nash Gill, Jacqueline Gourevitch, Elizabeth Gourlay, John Groo, Zbigniew Grzyb, Sandra Guze, Nene Humphrey, Mary Kenealy, Janice La Motta, Sol LeWitt, Marcia Reid Marstead, Katherine Nicholson, and Greg Scranton.

Trout Brook Writers Group: Jim Cahalan, Laura Hansen, Alex Kraus, Rob Kyff, Gary Pandolfi, and Ann Serow.

My teachers: Harvey Litvack, Professor Richardson, and especially Pat Lipsky.

And, always: Neil, who makes it worthwhile.

See our complete backlist at www.tupelopress.org